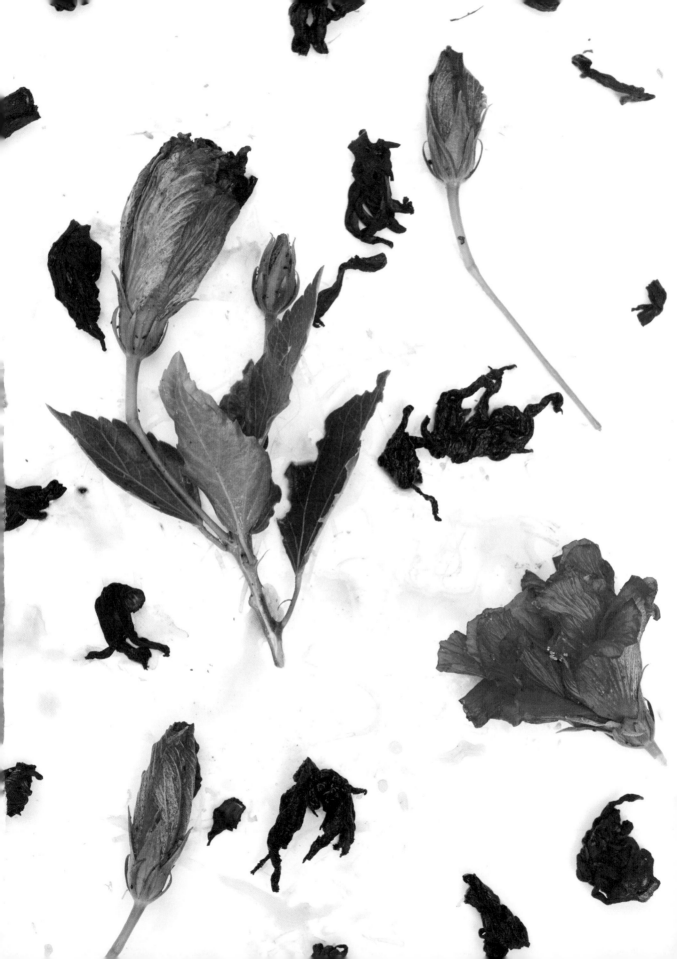

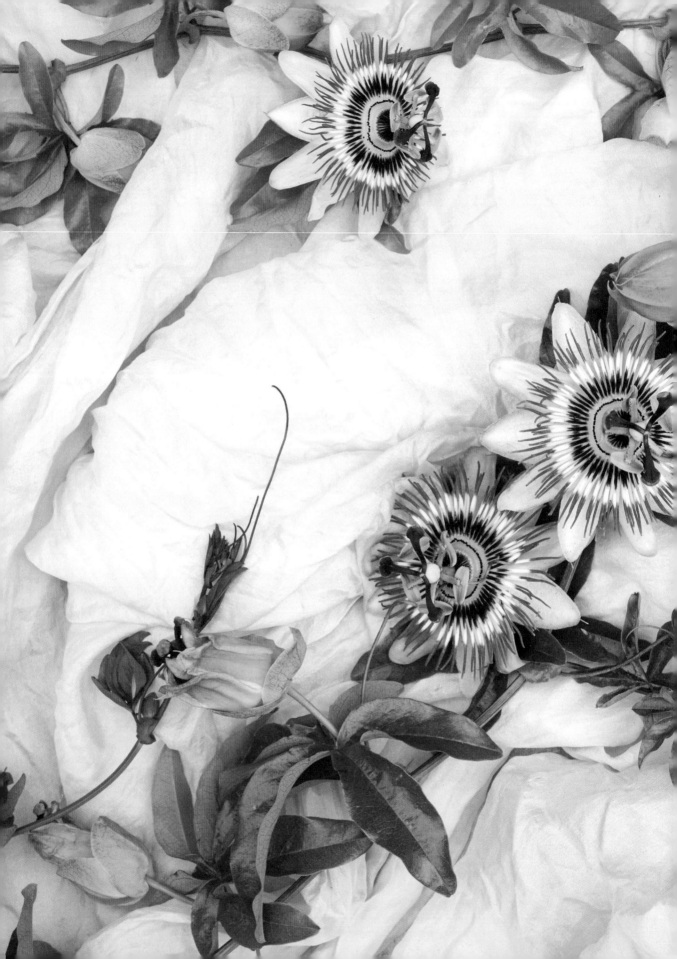

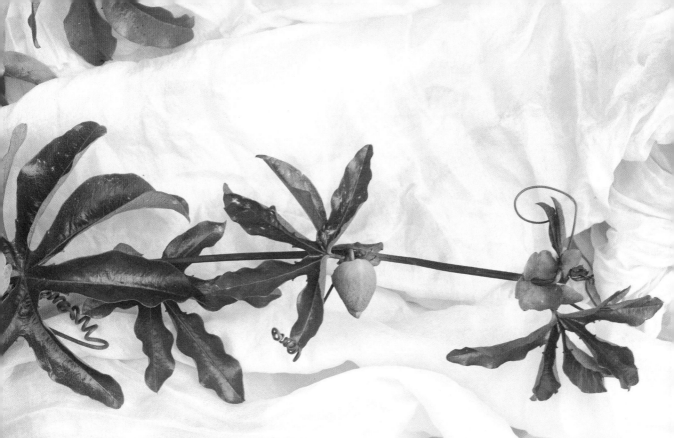

NATURAL COLOR

Vibrant plant dye projects for
your home and wardrobe

Sasha Duerr

PHOTOGRAPHY BY AYA BRACKETT

WATSON-GUPTILL PUBLICATIONS
Berkeley

CONTENTS

PROJECTS

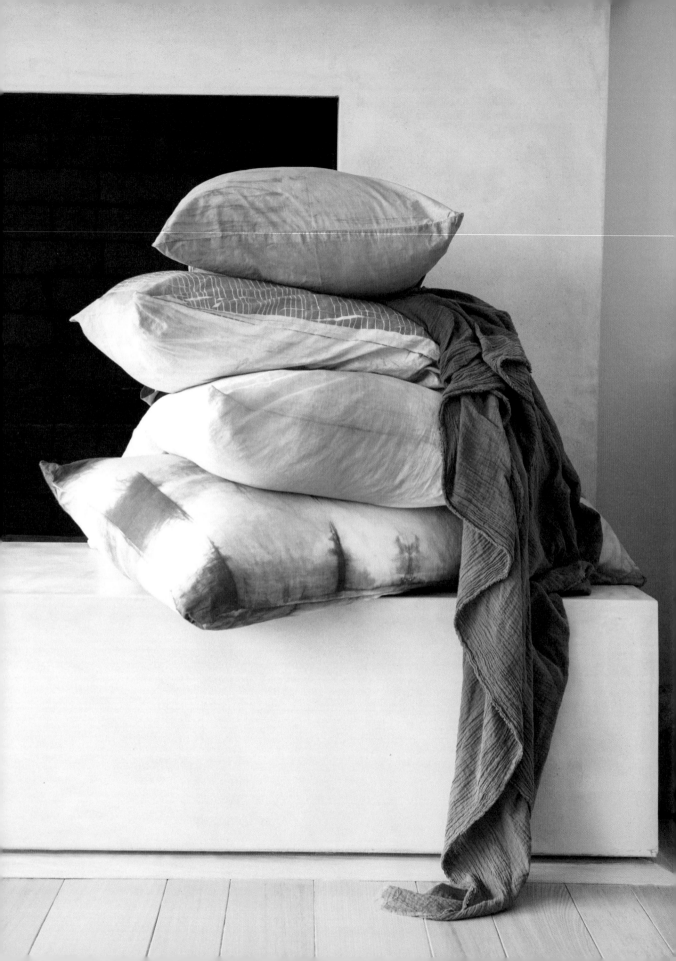

living color

AN INTRODUCTION

I grew up on both edges of the United States—on a biodynamic farm on the coast of Maine and on the volcanic black sand beaches and in the rainforests of the Big Island of Hawaii—and my outdoor play was an exploration and comparison of the biodiversity of plants and place.

Throughout my childhood, I was surrounded by an abundance of natural colors and textures: bright white snow, deep brown mud, cerulean blue waters, pink granite, porous black lava rocks. Green pinecones made streaks of fuchsia in rain puddles; avocados as big as my hand would drop from trees onto jungle pathways; aloe could be cut from bushes in our neighborhood to heal skin burned by too much sun. My younger years were enriched with forts in the mossy woods and bamboo forests; I made my own mineral-based eye shadows from a variety of granite rock deposits and my own shampoos out of awapuhi ginger and red hibiscus flowers. This natural bounty instilled in me the endless possibilities of nature and culture. It reinforced the practical purpose, creative opportunity, as well as wonder and awe of getting to know the plants and ecology around us.

In my early twenties, as an artist making oil paintings, I started to realize that my chosen medium was making me sick with headaches and nausea. Faced with these sensitivities, I began to seek alternatives to the paints I was working with. I asked my art professors, but none seemed to know the best way of creating my own pigments and colors. As most of the information on making natural paints that I found in library books was outdated and lacking in specifics, I started to investigate how to make my own plant-based paints. I soon realized that the answers to many of my questions lay not in painting but in textiles and fiber arts.

With newfound determination to make my own colors, from "soil to studio," at the end of my college years I traveled to Indonesia, India, Nepal, and Tibet. It was not easy finding sources for the how-tos of sustainable plant dye practices in my travels. (Since then, I have gained insights about where to go and how to find knowledgeable and reputable natural dye sources.) Returning to the United States, I looked to my own communities for insight into working with plant dyes, seeking out those I had grown up with in the back-to-the-land communities of Maine and Hawaii.

While setting up my postcollege life in San Francisco, experimentation with making natural dyes from plants found on my urban sidewalk, in my kitchen, and at the farmer's market opened my eyes to the accessibility of these nontoxic dyes. I fell in love with the variety and sources of plant-based palettes in our everyday lives. And I was greatly troubled that we had lost so much of this common information in just a few generations. When I first moved to San Francisco, I was working for an environmental nonprofit, Rainforest Action Network, and at several contemporary art galleries. I began to see how the world of design and art, environmentalism, and the urban agricultural movement was ripe for collaboration. With Northern California's year-round growing season and the Bay Area's focus on innovative art and design, the time was right for a plant-based color revival.

I enrolled in the MFA program in textiles at California College of the Arts in 2001, with the central purpose of deepening my connection to natural dyeing and the social practice that would support its revival. While a graduate student, I received a two-year natural dyeing grant with the Berkeley Public School Fund to teach and create curriculum in natural dyes from nontoxic sources at the Edible Schoolyard (a project founded by restaurateur and organic/local/slow food activist Alice Waters), where my sister and one of our best friends were working as garden teachers. Our work in making natural dyes from compost materials without the use of toxic chemical mordants—and specifically, the relationship between slow food and the need for slow textiles and fashion—became my MFA thesis and later, my vocation. As I worked with the Edible Schoolyard teachers and middle-school students, and in my studio with plant dyes, the close intertwinement of slow textiles and slow food became clear to me.

Just as many of us have lost the basic knowledge of food and cooking, relying instead on processed food, so too the basic knowledge and practice of making plant-based color for fashion and textiles have been lost to the practices of large synthetic fashion and textile conglomerates. As I realized this, my

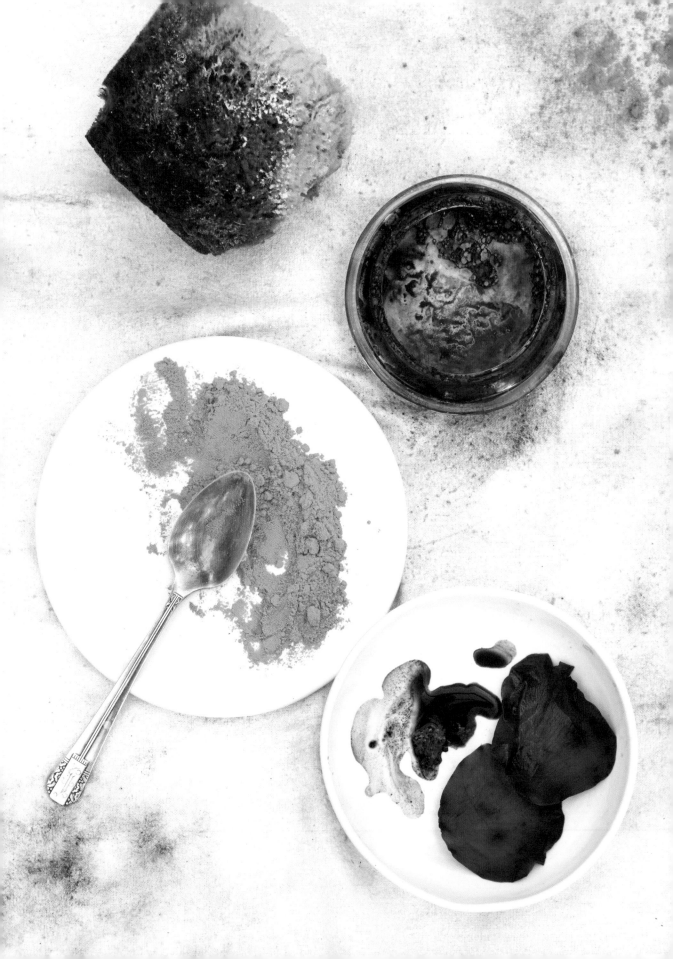

interest turned political; this was about the loss of our basic knowledge of healthy and sustainable color of the plant world itself. Most of our textiles and clothing come from mass-produced sources, without ethical and fair labor practices, and with immense environmental pollution inherent in the process.

In the modern age, we are often out of sync with the rhythms of our natural environment. The process of learning to identify plants, growing one's own food, and creating colors from nature are directly related to our ecological literacy. With the resurgent interest in plant-based color, we have an opportunity to make some new and healthier design choices and even adopt radically new practices for how we view color.

WHAT SLOW FOOD CAN SHARE WITH FAST FASHION

Toxic color comes at an enormous environmental and human cost. Many do not realize that although we do not eat our clothing and textiles, the same materials that go into making our garments and disposing of them become us. Residue from synthetic chemicals used to make dyes can be found in our air, water, and soil.

Many of these synthetic chemicals don't break down well, and the World Bank estimates that 17 to 20 percent of the world's industrial water pollution comes from textile dyeing and treatment. There are seventy-two toxic chemicals in our water that originate purely from the dyeing process; of these, thirty cannot be removed. As a January 11, 2013, *New York Times* piece by Dan Fagin details, our current methods of devouring fast fashion and synthetic dyes have us in "A Cancer Cycle, From Here to China." (See bibliography on page 254).

Manufactured fashion "seasons" move quickly and relentlessly. The term "fast fashion" suggests that an article of clothing may continue to be functional but is no longer perceived to be stylish or appropriate. Unfortunately, everyone, as well as the environment, pays for the bargain bin. As with fast food, there's little emphasis on the fallout of production or the negative social and environmental effects of rapid consumption.

When you are working with the plant-based color, in contrast, you're constantly aware that you are working on nature's schedule, not just your own. With plant dyeing, you can be directly involved with the plant and its life cycle and even the care and quality of the materials used to get a successful result.

Natural color can be sourced from renewable resources—like waste and weeds found in by-products of agriculture and even in urban centers. Many plants discarded from agricultural crops are also dye sources; these include cover crops, like fava bean leaves and stalks, California poppy roots, and gleaned by-products, like artichoke leaves and avocado pits, which make rich natural colors. And many everyday waste products from our urban, suburban, and rural kitchens, restaurants, and grocery stores—such as onion skins, carrot tops, and pomegranate rinds—can also be upcycled from waste bins to make beautiful natural colors and still be composted.

BIODIVERSITY OF COLOR

Plant dyes have a rich history in every culture on the planet. The quest to revive the practice of natural plant dyeing relies heavily on rediscovery and sharing information, as a vast amount of practical knowledge has been lost. Dyeing with plants means more than simply replacing synthetic materials with natural ones—it means changing the way we care for and interact with our natural environment.

Natural color is an immersive and fully sensory experience. Experimenting with fallen redwood cones is awe inspiring, from the color that emerges—deep mauve, purples, and blacks—to the smell of the dye bath, like a walk in a rainy coastal redwood forest. Making your own natural dyes awakens the potential for designing as nature does, with purpose and beauty.

The value of "living" color is to appreciate and treasure the inherent uniqueness of nature and, as with an heirloom fruit or vegetable, to ensure biodiversity for future generations.

PERMACULTURE AND PERMACOUTURE

Working from an approach of "stacking functions" (getting multiple uses from one action or material), I realized that my work with natural dyes fit very nicely into the framework of a holistic design movement called *permaculture*. Permaculture is an integrated approach to agriculture that considers the whole ecosystem. What I admire about permaculture is that when practicioners make design decisions, people and planet are considered equally.

Playing off of this philosophy, I founded Permacouture Institute in 2007 as a way of exploring responsible practices in fashion and textiles. Over the last decade, my dedicated colleagues Katelyn Toth-Fejel and Deepa Natarajan

and I, as well as collaborative partners and dozens of volunteers and interns, have experimented with plant colors and collaborated with chefs, farmers, perfumers, herbalists, florists, vintners, activists, and educators to explore modern social and environmental ways to reconnect
with and revive the use of natural color.

Permacouture has been a wonderful way to connect with communities and to experiment with plant dyes. Over the years we have fostered these connections:

- Organized social events about consumption called "Weeding Wardrobes," where we dyed unwanted textiles and clothing with weeds from urban community gardens
- Explored seasonal plant-based color by hosting "Dinners to Dye For" with chefs, bringing communities together through delicious seasonal meals and natural dye workshops using the by-products of those very same meals
- Created maps, tracing walks to locations of ordinary plants that you would never guess were colorproducing
- Tagged seeds in public libraries that host seed lending for fiber- or dye-producing plants

My work with Permacouture Institute has inspired me to look at natural color in holistic ways. It has deepened my work through collaboration with a wide range of artisans who share my love of working directly with plants. I have grown to love the social and ethnobotanical side of curating natural colors, tracing the origins of each color and how it translates to the individual and the community in which it was grown, harvested, and enjoyed. I am constantly inspired by the community of artists, makers, and educators I have befriended, and am ever inspired by the evolving conversation about natural color.

SEASONALITY AND NATURAL DYES

In my own practice of working with plant-based color, I forage for and grow dye plants in my neighborhoods of Oakland and Berkeley, California. As I often use whole plants rather than extracts, I need to be aware of their seasonal availability, growth cycles, and color potential. With this knowledge, I can develop a color palette specific to a time of year—much like planning a seasonal menu.

Knowing when plants are in season is especially important for plant dyes that are foraged and collected from wild sources. By dyeing seasonally, you have the ability to dye when the desired materials are most easily and "vitally" available. Paying attention to nature and to how nature designs, whether through brilliance of color or through form and function, can be an invaluable source of design inspiration and innovation in your own creative work.

Working with plant color is one of the easiest and most accessible ways of connecting with the cycle of our ecologies and applying that knowledge directly to your design practice—you can begin with the wayward white wool sweater in the back of your closet that you haven't worn and the leftover by-products of your favorite meal before they hit your compost pile.

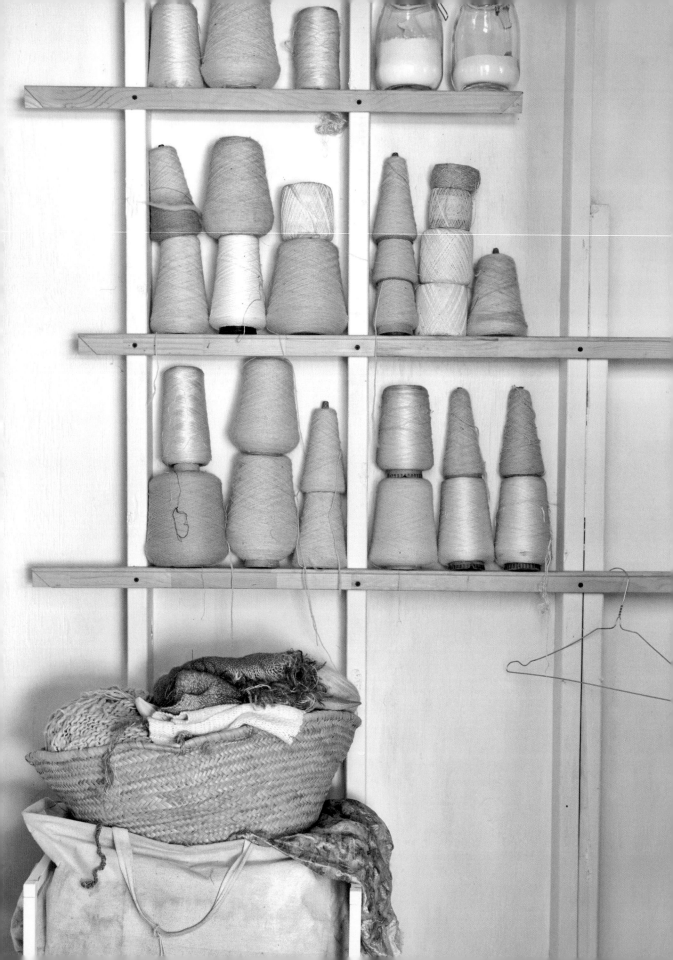

THE *practice of plant* DYEING

Making natural color from scratch is much like cooking—it's the same process of using recipes, finding the right ingredients, experimenting, and timing. Successful results often stem from knowing the elements you are working with and making sure that these elements synthesize. There are also other more nuanced aspects of working with natural dyes—the alchemy of plant material, the materials you choose to use, the water quality where you live, the fertility of the soil, and the time of year the materials are gathered all contribute to the beautiful colors that you can conjure in your dye pot.

The dye plants I've chosen for this book were curated to elevate seasonal weeds, food by-products, and common everyday plants that you may not yet realize yield gorgeous colors. Beyond the plants you may find in your own backyard, your kitchen, or at your local florist, I have also specifically chosen some recipes to encourage you to learn more about your own region and specific trees and plants that may be available where you live. The recipes and color palettes are only a sampling of the color-producing plant world, intended to inspire your own experimentation with natural color, as well as few traditional and ancient primary dye recipes. I've also included lesser-known and more experimental plant-based colors we've come to love over the past several years in my Soil to Studio course in the California College of the Arts textile program and through Permacouture Institute workshops and gatherings.

The interest in natural colors, the search for new natural color recipes, and fresh ways of designing with and applying them increases steadily every year. Consumers, designers, artists, and educators are hungry to learn how to color their lives with healthy, vibrant, and organic hues from smarter, healthier, and more sensory sources. Here in Northern California, blessed with a mild (though varied) climate, the environment has become our living learning lab as we work with the myriad types of plants that lend themselves to making natural dyes. But wherever you call home, you have unique color palettes available in your pantry, or just beyond your doorstep, that will amaze you.

You can make different shades and colors from the same plants at different times of year; the season, quality of the soil, amount of rain, and weather can all make an elemental difference in the colors that develop in your dye pot. Fully extracting the plant material allows the most potent and vibrant shades. Beyond the freshness and qualities of the plants you work with, the quality of both the fiber and the water you use also makes a difference. Tap water, rainwater, or ocean water each can have elemental benefits; some plant dyes will be brighter or darker or even change color depending on the "hard" or "soft" minerals in the water itself. Fibers can also take dyes more or less readily depending on the pH of the materials and the cleanliness and openness of the fibers to accept and bind with the dye molecules. You may need to wash your materials well and clean or scour to remove industrial effluents that could chemically alter or block the natural color from binding most successfully. You can use the same dye bath for multiple projects and even keep using the dye bath until it is exhausted to create multiple shades from the same plant source.

Becoming a seasoned natural dyer requires practice and patience. Some plants will reveal their color potency directly and immediately; others can take hours or even days to show their most colorful aspects. By carefully and safely choosing your plants, projects, and work space, you'll find almost anything is possible in working with and applying plant palettes. Let your practice with plant-based color inspire inventiveness as well as an appreciation and awe for the natural world. Gather with others to share the colors you make as well as to renew the hues of your favorite textile or garment seasonally, and connect with your textiles, your ecology, and your community.

NATURAL COLOR SAFETY

Just because it is natural doesn't necessarily mean that it is always safe or healthy for you. Although most natural dyes I work with are of the nontoxic variety, plants can be toxic in different quantities and to different people with individual allergies and sensitivities. A good rule of thumb is to wear heat- and water-resistant gloves, cover your skin when dyeing, and use only dedicated dye pots and equipment not to be used for cooking or eating. As people have plant allergies, and plant allergens can be concentrated through processing, choose your plants wisely, listen to your own body's relationship to the plants and mordants you work with, and always properly identify the plants you work with first before experimenting with their properties.

Many natural dye books from the past—and even some more modern ones—contain recipes that may include toxic natural dye plants or dangerous plant or metallic mordants (like tin and chrome). Always use common sense and double check what you are working with. The art and craft of natural dyeing is evolving as practitioners strive toward the smartest and healthiest ways of making and using natural color. In this book, we just work with alum and iron as mordants—please use caution and care when working with these binders. For further instructions on mordanting, see pages 212–227.

As with cooking, you will be working with water and heat, as well as potential irritants from plants and mordants and fine powders, so it is important to keep your dye practice as safe and as healthy as possible with your tools, equipment, and environment you create for working.

Do not pour spent dye and mordant baths down the drain if dealing with a septic tank, as the pH balance can be too delicate to monitor. It is best to dispose of leftover mordant (alum, tannin and iron) and dye baths in moderation throughout your yard and garden instead.

NATURAL COLOR BASICS

The process of extracting plant color generally entails the basic instructions that follow; just as with the culinary and herbal arts, each individual plant may call for different and diverse best practices for harvesting, preparation, and care.

Note that natural fibers love natural dyes. Work with clean, 100-percent natural fiber—silk, wool, cotton, linen, and so on. All can be worked with successfully, depending on the plants and the way the dyes are fixed to the fiber with mordants. It's important to know the difference between synthetic and natural fibers; this allows you to repurpose, gather, and glean for vintage and repurposed fabrics, yarns, and other materials to give them a colorful new life.

It is also often helpful and necessary to scour your fiber before it can successfully take up the dye color in a stable and even way. This is also effective to eliminate the effluents of commercial manufacturing processes (for example, like starches and other chemicals that can prevent best color results), thrift store debris from preowned garments, and general oil and grime from local wools (for in-depth scouring instructions, see page 36).

You can premordant the fiber with selected metallic or plant-based fixatives, or you can add a measured amount of mordant, based on the weight of the dry

fiber, to the premade plant dye bath, then add the fiber. This is different from premordanting because your fiber goes into the dye bath with the mordant—the mordant is not fixed to the fiber first before going in the dye. Follow each recipe's directions for proper quantities and precautions for successful results.

You can also add an additional mordant directly to your dye bath before adding the fibers—this is known as the all-in-one method, in which you dye and mordant at the same time in the dye pot.

Note: Some plants act as their own mordants, as they may contain biochemicals (like tannins) that yield strong, lasting color, in which case you do not need an additional mordant.

SETTING UP A STUDIO

I am a plant dyer, textile artist, forager, and urban farmer, so my work space must offer accessibility to locations to gather and grow plants, even in a city landscape, as well as the elements crucial to the natural dye process: outdoor ventilation, natural light, water, and a place in my garden to easily compost my plant materials. You may not have the same requirements as I, but be sure to include the following when preparing your natural color work space:

- A sturdy work table or two. Just as with cooking, having a counter area that is practical and easy to clean and wipe is a huge benefit. I love the durability of stainless steel countertops for this reason!

- High shelves or cabinets with doors where you can carefully store and label your materials out of reach of children, pets, and even roommates.

- Proper airflow and ventilation.

- Access to water—if outside a hose; if indoors, a sink.

- Access to heat or a safe place to have outdoor burners.

- A drying rack or line out of direct sunlight for hanging your projects.

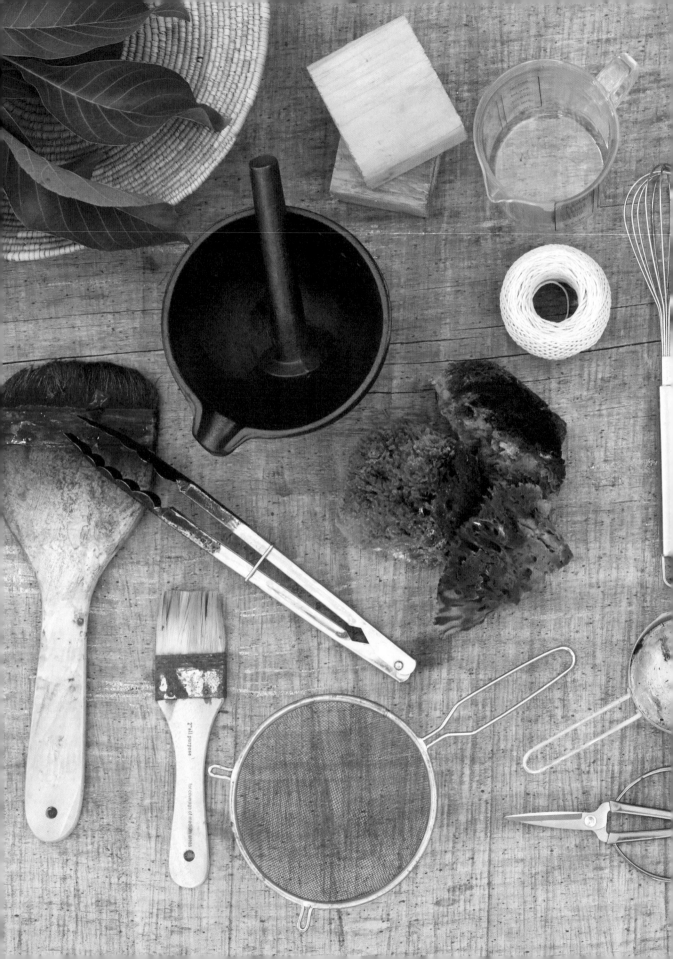

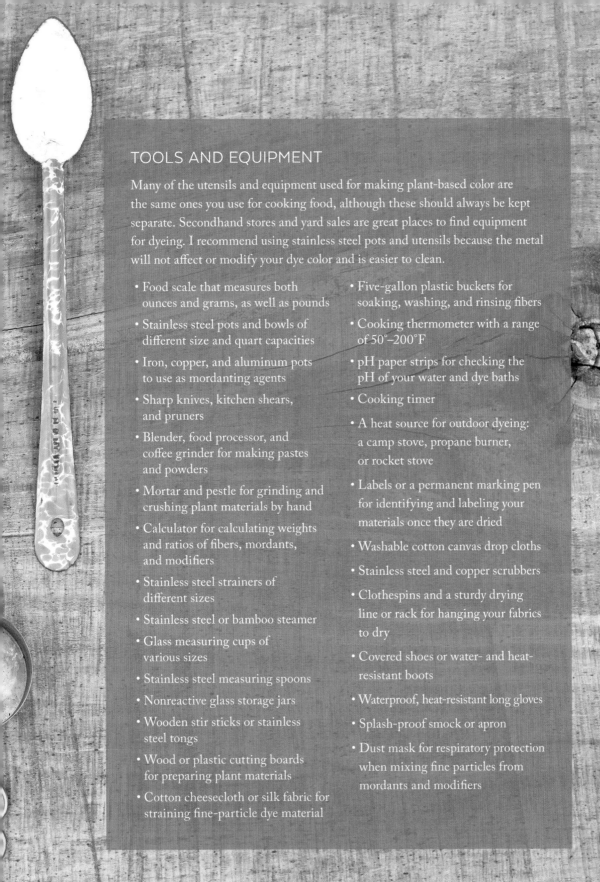

TOOLS AND EQUIPMENT

Many of the utensils and equipment used for making plant-based color are the same ones you use for cooking food, although these should always be kept separate. Secondhand stores and yard sales are great places to find equipment for dyeing. I recommend using stainless steel pots and utensils because the metal will not affect or modify your dye color and is easier to clean.

- Food scale that measures both ounces and grams, as well as pounds
- Stainless steel pots and bowls of different size and quart capacities
- Iron, copper, and aluminum pots to use as mordanting agents
- Sharp knives, kitchen shears, and pruners
- Blender, food processor, and coffee grinder for making pastes and powders
- Mortar and pestle for grinding and crushing plant materials by hand
- Calculator for calculating weights and ratios of fibers, mordants, and modifiers
- Stainless steel strainers of different sizes
- Stainless steel or bamboo steamer
- Glass measuring cups of various sizes
- Stainless steel measuring spoons
- Nonreactive glass storage jars
- Wooden stir sticks or stainless steel tongs
- Wood or plastic cutting boards for preparing plant materials
- Cotton cheesecloth or silk fabric for straining fine-particle dye material

- Five-gallon plastic buckets for soaking, washing, and rinsing fibers
- Cooking thermometer with a range of 50°–200°F
- pH paper strips for checking the pH of your water and dye baths
- Cooking timer
- A heat source for outdoor dyeing: a camp stove, propane burner, or rocket stove
- Labels or a permanent marking pen for identifying and labeling your materials once they are dried
- Washable cotton canvas drop cloths
- Stainless steel and copper scrubbers
- Clothespins and a sturdy drying line or rack for hanging your fabrics to dry
- Covered shoes or water- and heat-resistant boots
- Waterproof, heat-resistant long gloves
- Splash-proof smock or apron
- Dust mask for respiratory protection when mixing fine particles from mordants and modifiers

THE PLANT DYEING PROCESS

• Forage, harvest, or gather your dye-plant materials.

• Set up a workstation that is properly equipped for dyeing (see page 17 for equipment and tools).

• Select a natural fiber or fabric that is compatible to your dye and project. (Always start with small samples and tests and take great notes on process before beginning large projects!) Calculate your dry *weight of fiber* (WOF) so you can carefully measure proper ratios of dye material, mordants, and modifiers.

• Wash and scour your fibers.

• Premordant your fibers and fabric, if necessary.

• Place the plant material in a pot with enough water to safely cover it (not too full) and to allow the fabric you plan to dye to move freely in the bath.

• Bring the water with plant material to a boil.

• Turn the temperature down to a simmer. (Avoid high heat, as it will kill the living color molecules, making the hues just as dull and unappealing as overboiled vegetables!)

• Simmer your dye-plant material for at least twenty minutes, and often longer. For most plant colors, letting the plant steep overnight will enable maximum dye extraction.

• For the most even color, strain the plant material from the dye pot, allowing just the liquid to remain.

• When the dye bath is ready, immerse the fiber for twenty to forty minutes, depending on the desired saturation. Stir gently to distribute the color evenly on your fiber. For darker colors, you can turn off the heat and let the fibers steep in the dye bath overnight or even longer.

• Care for your naturally dyed fabric by washing with a pH-neutral soap and dry out of direct sunlight.

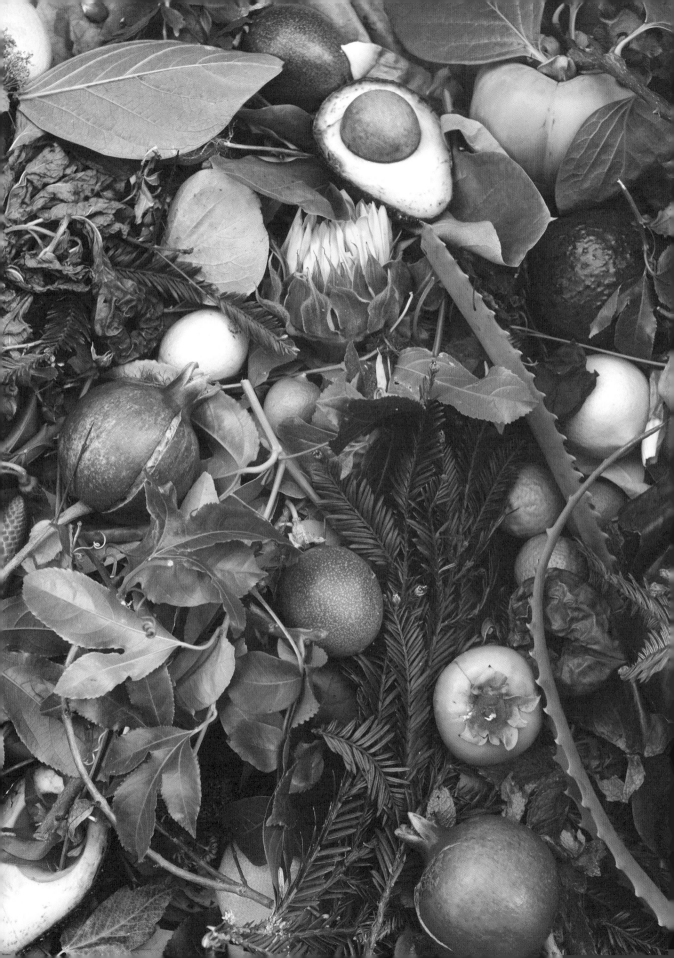

NATURAL FIBERS

You can apply and dye with plant colors on multiple surfaces and materials—there are endless possibilities for natural dye application. Pay attention to the fibers you like to work with and even local ways of obtaining them, sourcing vintage and supporting fair trade and local businesses in the process whenever able.

Here is some basic information about the most common types of fibers you can color naturally.

ANIMAL-BASED FIBERS

Protein fiber refers to animal-based fibers, as in sheep wool of various kinds, angora, alpaca, cashmere, leather, and silk. Animal fibers, especially wool and silk, take most natural plant dyes extremely well and are great for beginner dyers as well as for more experienced dyers who want to work with experimental plant color sources. There are many different types of animal-based fibers you can enjoy dyeing with—these are just a few!

Alpaca The alpaca is a domesticated South American camelid that resembles a small llama. Alpaca is a supersoft, luxurious fiber that is also warm, lightweight, and durable. It accepts dyes well, making it a favorite of many natural dyers. Unlike wool, alpaca fiber does not contain lanolin and therefore requires less preparation for dyeing. Alpaca is a supple fiber that can easily be turned into yarns used for weavings, knits, rugs, and other textile items.

Angora Angora from an Angora rabbit is a supersilky, cloud-soft fiber and is a favorite for knitting as well as weaving and especially soft for baby garments. Angora fiber can be dyed, and it also blends well with other fibers. You can even raise your own Angora rabbits for fiber (I have a very sweet Angora rabbit on our urban farm; they are compact, curious, and cuddly creatures). Angora rabbits will eat your compost and create more for you, which makes them excellent companions for your garden, helping to increase your plant yield while also adding style to your closet.

Cashmere Cashmere is the ultimate fiber, both supersoft and fine. Most do not know that cashmere is harvested from the belly of the cashmere goat. Cashmere goats live in the high-altitude regions of central Asia—one reason for the high cost of this superfine fiber.

Silk The most common type of silk comes from the cocoon of the mulberry silkworm, but there are hundreds of types of silk both cultivated and wild. Cultivated silk is often smooth, fine, and white in color. Wild silk is derived from hundreds of kinds of silkworms that eat a diversity of leaves, and thus the fiber is coarser and darker in color. The wide range of silks available provides an abundance of interesting options for natural color as silk takes plant dyes at their most saturated and is exceptionally easy to dye in a wide range of colors with little additional processing.

Wool This is a favored fiber to dye because it binds to a wide variety of natural dyes. Wool is the easiest and most successful fiber to work with if you choose to forgo a mordant. Wool fiber can vary in strength, color, texture, and weight, depending on the animal and the part of the animal it comes from.

PLANT-BASED FIBERS

Plant-based fibers are also called cellulose fibers. The wide biodiversity of plant-based fibers is wondrous. Here is a sampling of just a few plant-based fibers we can use for natural dyeing.

Cotton The cotton plant is native to tropical and subtropical regions around the world, including the Americas, India, and Africa. Cotton fiber most often is spun into yarn or thread that is woven into a soft, breathable textile or fabric. Besides coming in cream and white, cotton can be grown in a variety of heirloom colors from green to brown, and even dark reds.

Hemp Hemp is an amazing fiber. The hemp plant grows quickly without pesticides because it does not attract pests. Hemp fibers are processed from the plant stalk; they are longer, stronger, and more absorbent than cotton fibers. Fabrics made of at least 50-percent hemp block out the sun's rays more effectively than other fiber. Hemp fiber can used for many types of fabric as well as paper, twine, and thread.

Linen This textile is made from the fibers of the flax plant. Linen textiles are some of the oldest in the world, going back many thousands of years. Linen is valued for its exceptional coolness and crispness in hot weather. It is spun from the long fibers found just behind the outer layer of the multilayer flax stem. This cellulose fiber from the stem can be spun and is used in the production of linen thread, cordage, and twine. Household linens (a general term for sheets

and pillowcases) made of linen become more supple and soft to the touch with use. That's why linen has long been a preferred bedding material.

Nettle Nettle is a very versatile plant. Not only is it excellent as a dye, it can also be eaten and contains medicinal properties. Nettle is related to flax and hemp and in turn can also create a fine, linenlike cloth. Evidence of nettle fibers used in Europe even date back to the Bronze Age.

Piña I love piña fiber, not only because it is made from the leaves of the pineapple plant (*piña* means "pineapple" in Spanish), but also because it's one of the finest plant-based fibers we know of. Piña cloth shimmers with a sheen as beautiful as silk as it is naturally white and glossy. Because it is so lightweight and translucent, piña is the fabric choice for weddings in the Philippines. Piña also takes natural dyes beautifully.

Ramie Ramie is a plant fiber in the nettle family that has been used by civilization for at least six thousand years. Ramie is one of the strongest natural fibers that we know of and exhibits much strength when wet. Ramie is similar to linen in its feel as a fabric.

Sisal Sisal comes from the crushed leaves of the *Agave sisalana* plant, a type of agave native to southern Mexico, although now widely cultivated around the world. Sisal is a stiff fiber often used in ropes, baskets, hats, and cloth. It was used by both the Aztecs and the Mayans to make cloth and paper.

Other materials used for applying and working with natural color can include leather—a protein fiber—as well as wood, straw, and raffia, just to name a few, all in the cellulose fiber category.

Shell, bone, paper, and wood can also be dyed, as well as many types of porous papers, grass, and fabric-based wallpapers and even matte-finished stone and walls, like plaster and even drywall.

WATER WISE

The minerals present in the water you use to create your dye bath—be it tap water, rainwater, ocean water, or something else—can affect the chemistry of your dye bath. A good way to test your own tap water is to use pH strips, available at any hardware store, to know just where your water lies on the acid-to-alkaline range. You can easily amend the water to neutralize a highly acidic or alkaline dye bath—by adding vinegar or lemon juice to make it more acidic, or calcium carbonate to make it more alkaline. If you are having trouble getting the colors you are hoping for, using rainwater or distilled water can be a great option.

HARD WATER

Hard water has a high mineral content, and some minerals can affect or interfere with getting the dye color you want. For instance, water with high mineral content will often be more alkaline or contain calcium carbonate or magnesium, which can modify some plant colors; other plant dyes actually benefit from it—like weld, which produces a brighter yellow in harder water. Tap water is often hard, containing a high content of minerals like magnesium and calcium. In dyeing, the minerals can combine with the washing soda, creating soap scum, which could, in the case of exceptionally hard water, cause problems such as spotting on your dyed fabric. To make your hard water softer, you can use water softeners in your tap water, or you can use distilled or spring water as your dye water.

SOFT WATER

Soft water is surface water that contains low concentrations of ions and, in particular, is low in ions of calcium and magnesium. Soft water occurs naturally where rainfall is collected as well as where river basins are formed. Collecting rainwater and using it for your dye practice is a great way to capture soft water and to use it for the benefit of clear colors for those plants that may be affected by pH or calcium carbonate and other hard minerals.

RAINWATER

By collecting rainwater, you are wild-gathering all the components for making your color. You can anticipate a storm and put buckets out, or you can invest in proper rainwater catchment systems, which many cities are even willing to subsidize. Water is a limited resource—as we are learning from recent severe

droughts and groundwater depletion. Collecting rainwater is a sustainable way to use nonpotable water and not overuse this precious resource. Rainwater is an excellent water supply for dyeing, because it is soft water: it contains few minerals, making it ideal for achieving vibrant, clear color.

SALTWATER

Saltwater (i.e., sea water) can be used in natural dyeing. It is a renewable natural resource, and if you are fortunate enough to live near the ocean or a bay, it may be easy for you to collect. The slight alkalinity of saltwater (pH 8) can offer interesting results for many dye experiments. Over the years I have been fortunate enough to share dyeing with ocean water with students and friends, right on the beach over open fires—even, with Park Service permission, using collected invasive coastal plants such as ice plants and cape ivy to make color palettes.

WATER CONSERVATION

As a natural dyer, you should give thought to not only the source of your water and its pH, but also to reducing waste in your usage; this means, when you are through dyeing, that you neutralize it, or make sure it has the right pH, to pour into your garden safely. Water conservation is also key to making natural color sustainably; consider this in particular for large projects and even small, independent production runs. Regulating the amount of water you use, what you put into it, and how you dispose of the dye bath are all important considerations. When you are through dyeing, you can pour out the dye bath in your garden as long as you have used a pH-neutral nontoxic soap (such as Ecover or Seventh Generation) to rinse and the dye water and mordant are beneficial and not harmful to the plants you water with it. For instance, some plants crave alum and iron depending on the pH of the soil. Plants that like alum and iron are azaleas, hydrangeas, blueberries, and even trees like citrus and oak. Other plants—like citrus trees—do well with iron. If you don't have a garden, the dye bath should be neutralized and poured down the sink with an equal amount of water.

If you want to conserve water further, you can consider a water-wise dye garden with succulent plants, cacti, and other low-water plants like rosemary and lavender that are drought tolerant and also provide beautiful colors in the dye bath.

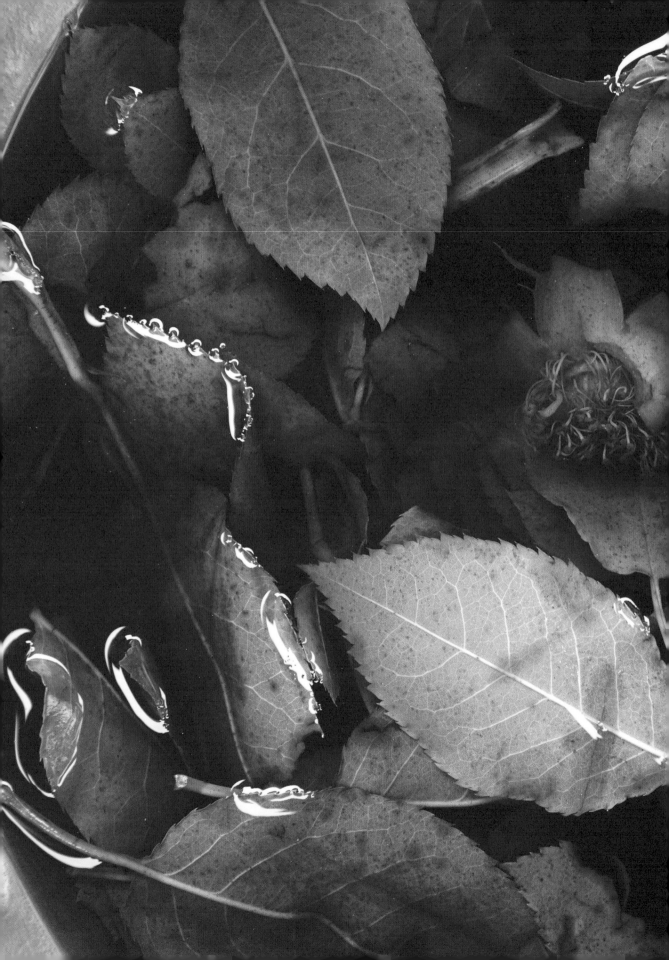

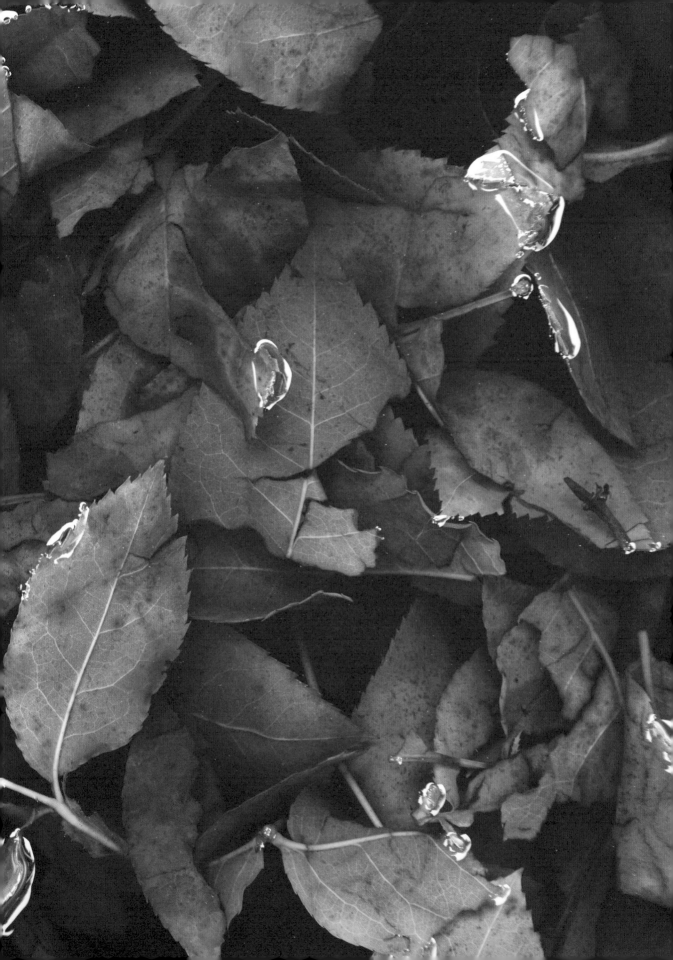

EXTRACTING NATURAL DYE COLOR

Extracting dye colors can be as easy as brewing tea. In the extraction process, you place the plant material in a stainless steel container with enough water to cover the fiber you wish to dye: one gallon of water for every quarter pound of fiber should give it plenty of room. The more dye material you have to weight of fiber (WOF), the more concentrated color you will have. You can reuse your dye baths until your dye has been completely absorbed, or the dye bath is "exhausted."

Your plant dye materials, especially if freshly picked where they are grown or foraged in an urban area, can also benefit greatly from being washed thoroughly to remove pollutants, dust, dirt, and other kinds of urban grime. The same goes for cleaning food by-products like avocado pits and pomegranate rinds well before use, as additional food and waste in the dye bath can interfere with the color's ability to connect most directly. This helps prevent unwanted spotting and staining.

You can process dye plants either with or without heat, to bring out the dye— although most plants and dye processes are immensely improved with heat. The choice of cold-water (temperate) or hot-water extraction is often based on the plant material you're working with. With almost every dye plant, even if it can work in room-temperature water (cold baths), you will achieve the greatest depth of color (and most light- and washfast results) with a hot-water process of extracting, just like brewing tea.

Some botanical dyes, however, don't need heat to yield color and can be processed successfully in cold water, though they might need a long soaking to yield color. With bark, for example, it can take one to two weeks before enough dye is extracted for colorful results. Plants that will work well in cold-water dye baths include sour grass flowers (oxalis) and eucalyptus bark.

You can also extract color with heat through the solar method (see "Solar Dyeing," page 33). This method saves energy, because you are using the heat of the sun, and it is quicker than cold-water processing for most plants.

Plant color can also be extracted onto your textile through direct application. This can be as simple as pressing your dye plant into the cloth or beating the plant material into the premordanted cloth using a mallet hammer or a smooth rock.

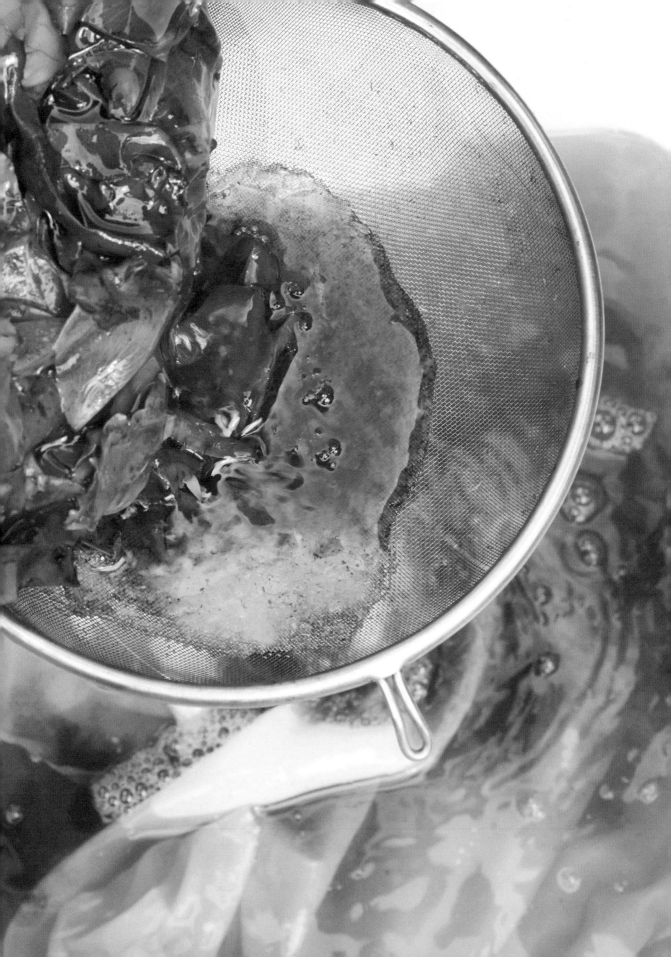

You can also steam your dye plants into your fabric for incredible direct imprints of your dye plants and patterns difficult to achieve in other ways. (See page 242 for printing instructions.)

No matter what color extraction method you use, when moving the fiber from one solution to another, make sure the dye bath or water temperature is similar to avoid shocking the fiber: move the fiber from a simmering dye bath to a hot-water rinse, not cold, and move it from a cold-water dye bath to a cold-water rinse, not hot. Then gradually move the fiber to solutions from warm to cool, or cool to warm, water temperatures.

COLD-WATER DYEING

Many plants can be processed for dye with very little heat. Cold-water dyeing can be more successful when the concentration of plant material in the water is strong. If your recipe calls for heat extraction, you can use cold water but you will need to use more plant dye material in proportion to water for the extraction process.

Finding just the right temperature for your dye is important. Some plant dyes may not yield their true color without heat. In addition, some dyes may yield different colors with hot-water dye processes than with cold-water ones. Madder root is a good example: with a low simmer, madder can create true reds, but with too much heat, the color can turn more brown than red.

Cold-Water Dyeing of Animal Fibers When working with protein fibers, first soak the fiber for at least one hour or even overnight to prepare it for color absorption. Then place the fiber in the cold dye bath, making sure it is submerged and there is plenty of room for it to dye evenly. You can use an old ceramic plate to weight the fiber and keep it submerged. Let the fiber soak overnight to see how much color is absorbed. For darker color, you can let the fiber soak for up to several days. Check on the fiber and gently stir occasionally. When the fiber is dyed the color you desire, wash it in cool water with a gentle pH-neutral soap, rinse thoroughly, and hang to dry.

Cold-Water Dyeing of Plant Fibers Cellulose fiber can dye really well at room temperature. For best color results, soak plant fiber in the cold dye bath for several days or longer. To check for color results, wash the fiber with a pH-neutral soap, and rinse well. If you'd like the fiber to be darker, return it to the dye bath and let it soak again for several more days then rinse again.

(Remember that your fabrics and fibers will always look more saturated when wet and lighter when dry.)

HOT-WATER DYEING

When you begin to experiment with hot-water dyeing, it's important to place the wet material you are dyeing into warm liquid gradually (so as not to shock or shrink the fiber), and then slowly raise the heat under the dye pot to a low boil (205°F) and then lower to the simmering point (185°F). I recommend using a thermometer when you're starting out with hot-water dyeing; once you've gained some experience and more confidence, you can rely on the bubble indicator—some dyes are very sensitive to heat, like madder root, and to get the best results you'll want to make sure that you watch the temperature carefully. Of course, as with cooking, you can gauge a dye pot's readiness to simmer by watching for the first signs of bubbles and then quickly reducing the heat to a low simmer.

Simmer the fiber in the dye bath for twenty to thirty minutes or until the fiber has taken on the color you desire. Occasionally give the fiber a gentle stir so that it absorbs color evenly. When dyeing wool skeins, stir them with care so as not to mat the fibers.

When the color reaches the desired shade in the hot dye bath, lift the fiber out of the water and, wearing heat-resistant rubber gloves, gently squeeze the excess dye back into the dye pot. Then wash the fiber gently in warm water with a gentle pH-neutral soap and rinse thoroughly in cool water. Hang the fiber to dry out of direct sunlight.

Any leftover dye can be saved for later use: pour it into jars with tight lids, label, and store in a dark place.

SOLAR DYEING

In addition to conserving water, it is also important to consider where your energy or heat is coming from if you are using hot-water methods of dyeing your projects. Solar dyeing is a fun and easy way to experiment with alternative energy sources for dyeing needs—in this case, using the sun's natural, totally renewable energy to heat the dye bath and draw the color out of the plants. When you heat a dye bath with sunlight, you are truly connecting to the source in every step of the process (think of the sun's role in growing both plants and animals!).

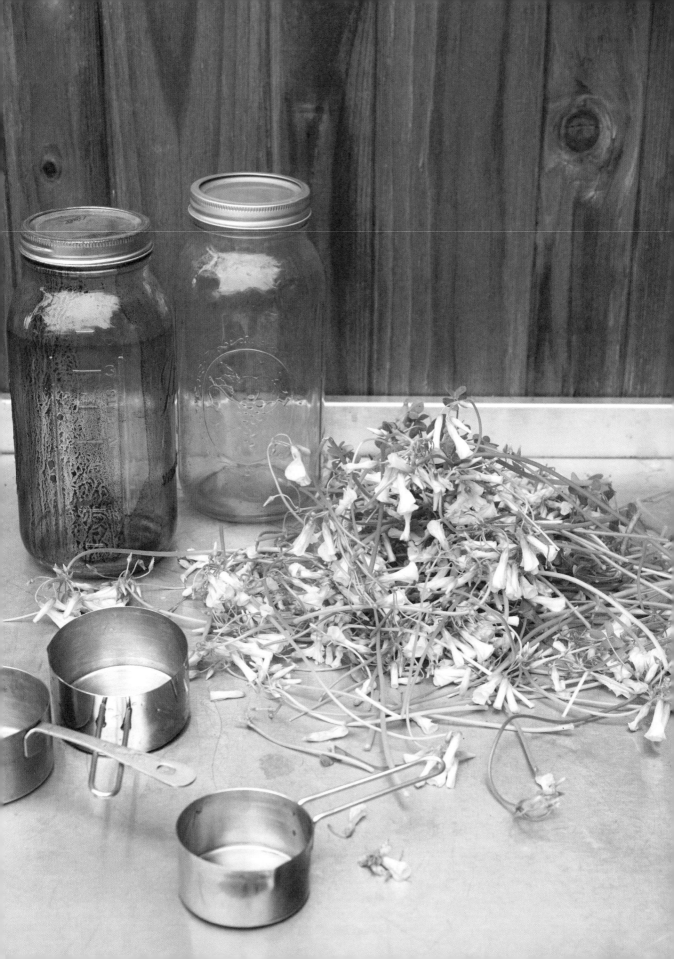

Solar dyeing with plants is essentially the same process as creating a sun tea. Simply leave your dye material in a big bowl of water in a warm, sunny spot, out of reach from kids, pets, and wildlife, or in a sealed large glass mason jar big enough for your dye materials and plants. In the summer months or in warmer climates, solar dyeing is often the obvious way to go, since you can easily capture the heat of the sun's rays. Whether you are an artisanal dyer or working to support greener ways of producing textiles, solar dye projects and experiments are simple and satisfying.

KEEPING A RECIPE AND SWATCH BOOK

Because there is so much variability in the natural dyeing process, it is much harder than with commercial synthetic dye processes to accurately repeat a color. As is true of any brilliantly cooked dish, there are many steps and combinations needed to achieve true artistry with natural color. Successful color results with plant-based dyes depend on the length of time in the dye vat, heat, parts of the plant used and its freshness, type of water, dyeing method, type of mordant, type of fiber, and the overall alchemy of these combined factors. I record each of my plant color experiments by keeping careful notes, taking dye samples, photographing the colors and processes, and collecting swatches.

Following is a general list of factors to document in your natural color recipe book:

- Date that you created the dye
- Plant dye material used and complete ingredients of your dye bath
- Tools and equipment used
- WOF (weight of fiber) and WOG (weight of goods)
- How the fiber was scoured
- Type of mordants and modifiers used
- Type of water and its pH
- Temperature of dye bath
- Length of dye extraction
- Length of time fabric spent in dye bath
- How fabric was washed at end of dyeing process

You will also want to save a sample of each material you dye and place it in your recipe book as a visual color reference. Eventually this careful documentation will free you to confidently undertake the process and begin to experiment with plant dyes and their incredible color ranges and possibilities.

BEFORE YOU START: PREPARING YOUR FABRIC

Cleaning and scouring your fibers, fabrics, and plant dye materials optimizes the chances that the fiber and dye molecules will bind successfully, so it is a crucial step for obtaining stronger, long-lasting colors.

Vintage garments, wool from your local farmer's market, and new store-bought fabrics all benefit from being properly washed, cleaned, and prescoured to remove chemical effluents, dirt, grime, and oils. You will want your fibers to be at their cleanest and most open to accept the dye and to bind evenly.

SCOURING ANIMAL-BASED FIBERS

The first step for scouring animal fibers is to place them in a big pot of lukewarm water. I use 1 tablespoon of pH-neutral eco-friendly gentle dishwashing liquid or 1 tablespoon of pure natural olive oil soap with no additives to scour 8 ounces of wool.

The fiber should be rinsed several times in cool or warm water until the water runs clear of any dirt or soap residue. After scouring and rinsing, soak the fiber overnight in clear water before dyeing it. This step will help the fiber to accept full, even dyeing. Otherwise, different parts of the fiber will absorb dyes or mordants at different rates.

Animal fibers like wool and silk are sensitive to sudden changes in temperature; they can shrink or mat and felt with hot water or rapid changes from hot to cold water.

Depending on the specific textile or fiber you are working with, you may need to do more cleaning. In some cases, silk may need to be *degummed* before you dye it. Many commercial silk yarns are sold fully degummed, but it can be advisable to degum your silk yarn or wild silks especially, just to make sure before dyeing. Removing the gum from the fiber improves its sheen, color, hand, and texture.

Degumming is traditionally done with a pure castile olive oil soap known as Marseille soap (which can be found at many bath and body stores).

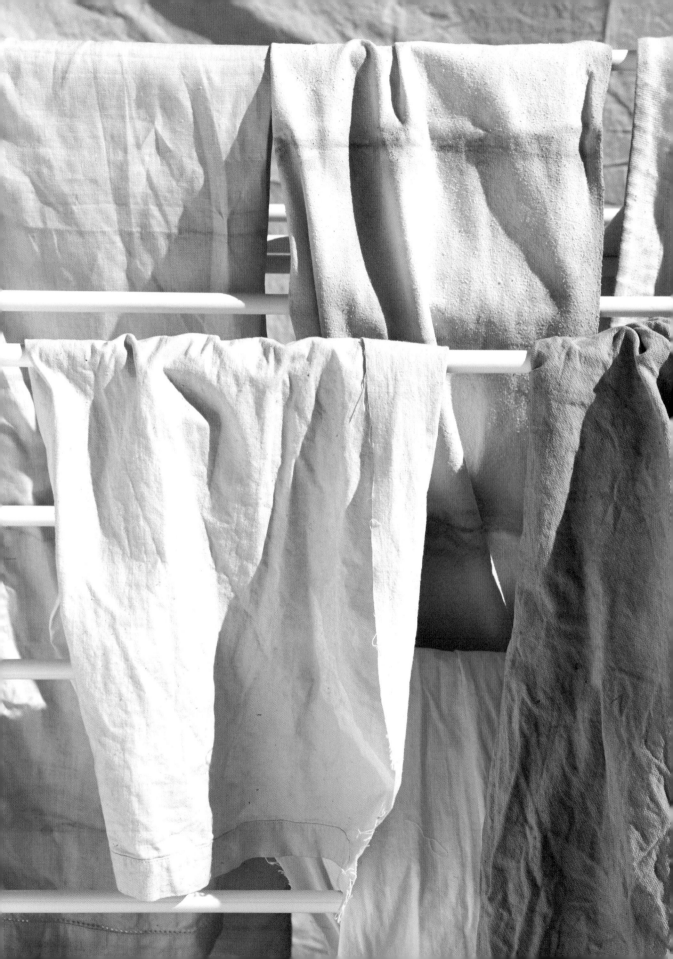

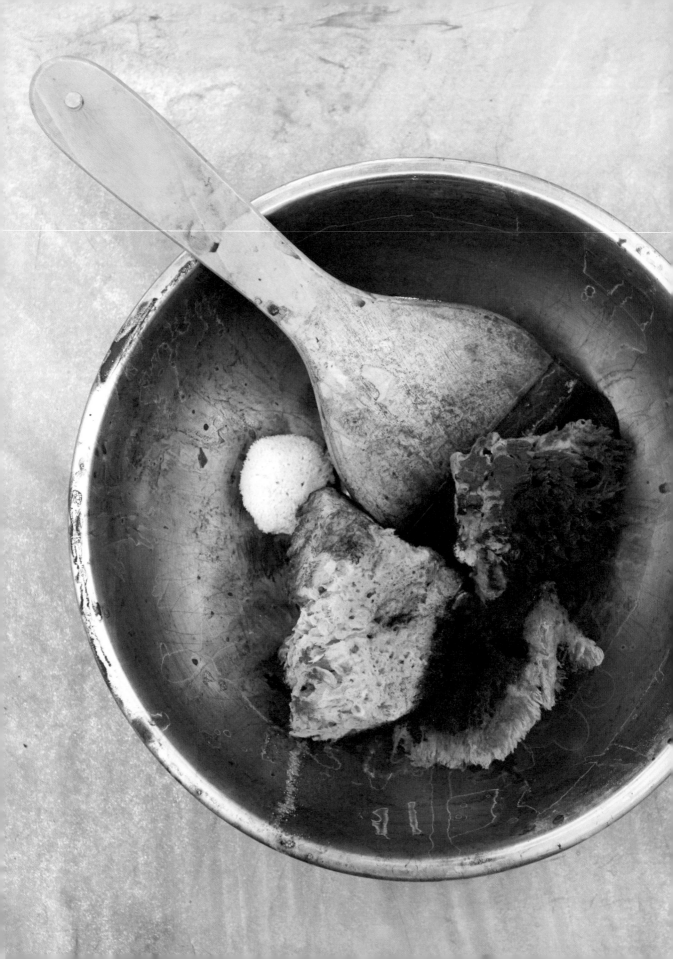

Use a ratio of 25-percent soap to weight of fiber. Combine the fiber and Marseille soap in a big pot of water. Simmer the fiber for 2 hours. Wash with pH-neutral soap and rinse. Your fabric is now ready for mordanting and dyeing.

SCOURING PLANT-BASED FIBERS

To clean cellulose fibers, I use 1 tablespoon of washing soda for each gallon of cleanser. Cotton contains lots of built-up waxes and oils, so a longer, more rigorous treatment should be used to remove the oils and other debris from the fabric. Linen contains less wax and fewer filaments than cotton, so it does not need to be treated so thoroughly.

To fully clean plant-based fibers such as cotton and linen, simmer for one to two hours with Marseille soap and washing soda. You can find washing soda (also known as soda ash or sodium carbonate) in the laundry section of most grocery stores; you can also order it directly from a textile dye supplier. Soda ash is caustic and on the high-alkaline side; it helps to wear gloves when working with soda ash to prevent dry hands and irritation.

NATURAL COLOR MORDANTS

The term *mordant* comes from the present participle of French *mordre*, "to bite." When working with natural color, we use mordants to help the plant materials "bite" into the fiber or fabric, chemically binding them together. This creates a more color- and washfast dye. There are many different methods and materials you can use to mordant. Learning about each plant dye and its characteristics, as well as creating your own notes and recipe book as you go, can help you determine which materials, dyes, and mordants work well together and ultimately yield the best results. Most plant dyes can be fixed to either plant- or animal-based fibers as long as proper washing, scouring, and mordanting for each fiber and dye combination has occurred. In your own natural color notes, you can start small and do lots of experimenting and then scale up your plant dye projects as you hit upon successful results.

Some plant dyes already have qualities that bind their color to fiber without any additives. For instance, avocado pits, loquat leaves, eucalyptus bark, and pomegranate rinds contain significant amounts of tannin to readily bind their dyes to both plant and animal fibers. For such materials, iron will act as a modifier, shifting the colors from warm and light to cool and dark shades.

Some natural dyes work well on protein fibers (but not plant fibers) without the use of a mordant; other dyes are easily compatible with plant-based fibers.

For plants that require mordants, there are metallic sources, such as alum or iron salts, and plant-based sources that contain a substantial amount of tannin, such as oak galls, acorns, or pomegranate rinds. Mordants have also been made from proteins like milk or soy, and even from plants that absorb metals like aluminum through their roots, like the *Symplocos* tree; its leaves, in powdered form, can be weighed and used as a substitute for alum. Choose the mordant wisely; this is one of the primary ways that you can create a more sustainable dyeing practice and get better, more satisfying results in your art and craft of natural color making.

WORKING SAFELY WITH MORDANTS

In the 1960s and 1970s, when many of my textile and natural dye mentors were working with natural color, they included chrome, tin, and copper mordants in their natural dye practices at home, often working without proper protection. Many metal mordants—such as these three—are suggested in old natural dye books as well as in a few recent ones. We now know that these metal mordants are toxic and should be avoided for the dyer's health as well as the health of those close to the dyeing process and those who will use the dyed products. Many modern natural dyers have made pacts for themselves and others to work only with alum and iron as metal mordants, since those are considered the safest with which to work; however, these should still be treated with extreme care and caution as they can be irritants and, in the case of iron, toxic in larger doses, especially to small children and pets. Be mindful and safe when working with any metal mordants; keep everything labeled and secured in storage jars, well out of the way of others who may not know their dangers. With awareness and proper precautions—gloves, lids on pots, and dust masks—you can work with these materials safely, effectively, and efficiently.

USING MORDANTS

There are three main ways to use a mordant to help bind the fiber and dye molecules to each other on the fiber or fabric:

- Premordanting: The material to be dyed is treated with the mordant and then dyed.

- All-in-one mordant: The mordant is added to the dye bath itself.

- Postmordanting/after-bath mordanting: The dyed material is treated with a mordant after the color is added.

Typically the surest way to know that your materials have been properly prepared with a mordant is to premordant the clean, prescoured fiber. Materials can even be mordanted in bulk, labeled, and stored for later use— even as a way to "cure" the materials for eventual darker and brighter versions of fiber saturated with dye color.

The percentage of mordant to WOF (weight of fiber) is important for a few reasons. For one, there needs to be enough mordant to properly bind the dye to the fiber but not too much mordant to affect your fibers negatively (too much iron can deteriorate your textiles over time and too much alum can make your fiber sticky). For the mordanting recipes in this book, I have mordants at the minimum you would need for both alum and iron; this gives you the leeway to adjust mordants as you may need in your own practice with natural color. I also use a recipe containing cream of tartar in addition to alum salts when mordanting. The cream of tartar acts as an assist for the uptake of alum mordant to the fibers, leaving little to no mordant left in the dye bath. For more information on mordanting and mordant recipes, see page 212.

SPRING

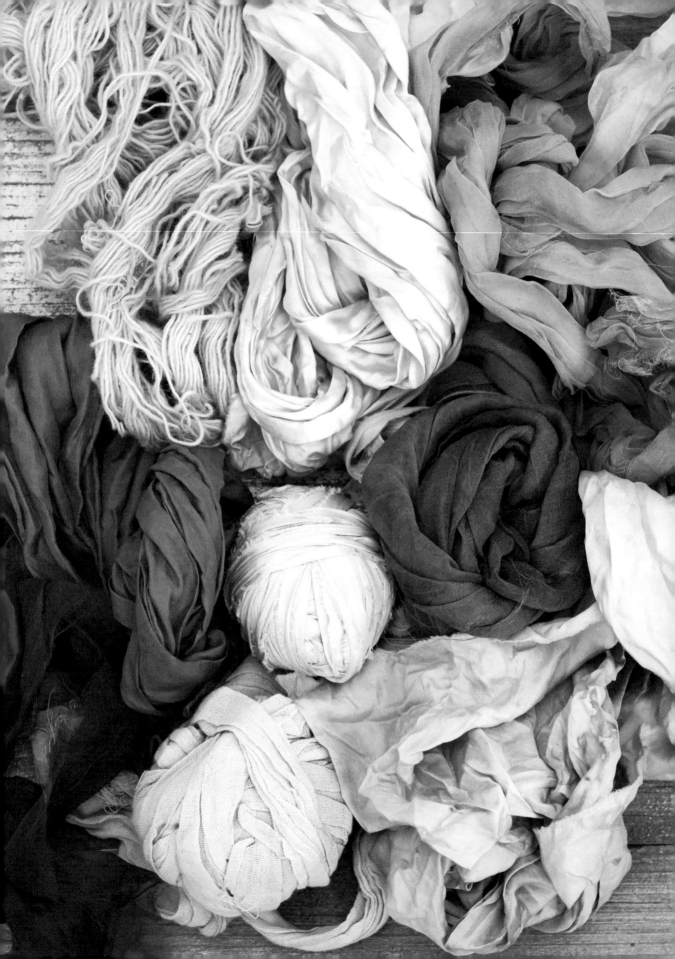

THE SPRING PALETTE

AVOCADO PIT · ROSE PETAL · PLUM BRANCH · MINT · OXALIS · CALENDULA

Springtime is known as a time of renewal and growth, and for the natural dyer, the landscape begins to bloom with new color potential. The emerging lush greenery awakens the senses—fig leaves unfurl in gardens, woods green with new foliage, and backyard and sidewalk trees blossom with plum, cherry, and quince flowers. This is the perfect time of year to experiment with fresh and verdant natural color.

You may expect spring to create softer, pastel plant-based palettes—and it certainly can—but spring plants are also rife with deep purples, dark inky blacks, and even fluorescent yellows and greens from abundant garden weeds like the persistent oxalis. You can also use this as a time for pruning your fruit and nut trees, or using your clippings saved from late winter is also a wonderful way to appreciate the bounty of tending to the landscape in the early spring.

Spring is also a great time to forage for a variety of green herbs, like various types of wild mint, as well to experiment with shorter-season edibles such as wild comfrey and nettle for color sources. Farmer's markets will also begin to liven up the produce offerings, many of which make great dyes, like spring avocado pits and rinds, carrot tops, and artichoke leaves.

Later in the season, wild and cultivated roses begin to blossom, and you can use the petals from cut branches or spent floral bouquets to create stunning imprints on fabric. With roses, you can use the whole plant to make a wide range of colors—the stems and leaves make yellows, greens, grays, and blacks. Dark pink, purple, and red flowers make beautiful jewel tones, creating a broad spectrum of color from one bouquet.

Rainwater is considered some of the best water for dyeing, and spring is a great time to collect it for your dye practice. You can also pour out your leftover dye water in your garden to mark the beginning of a vital new growing season.

SPRING
DYE PLANTS

FIG LEAVES

FRUIT TREE PRUNINGS

MINT

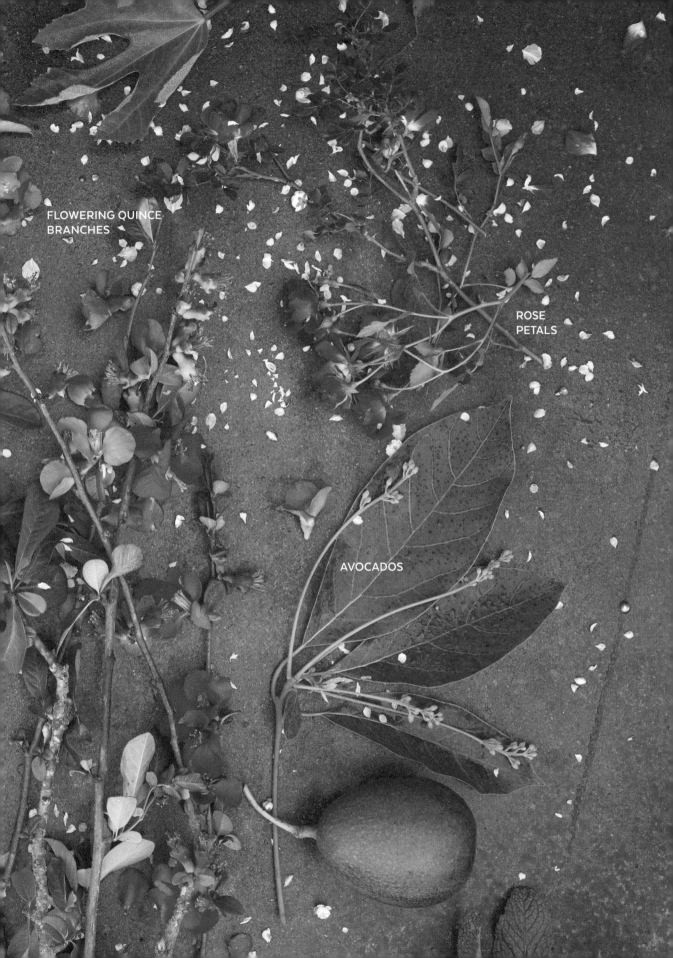

FLOWERING QUINCE
BRANCHES

ROSE
PETALS

AVOCADOS

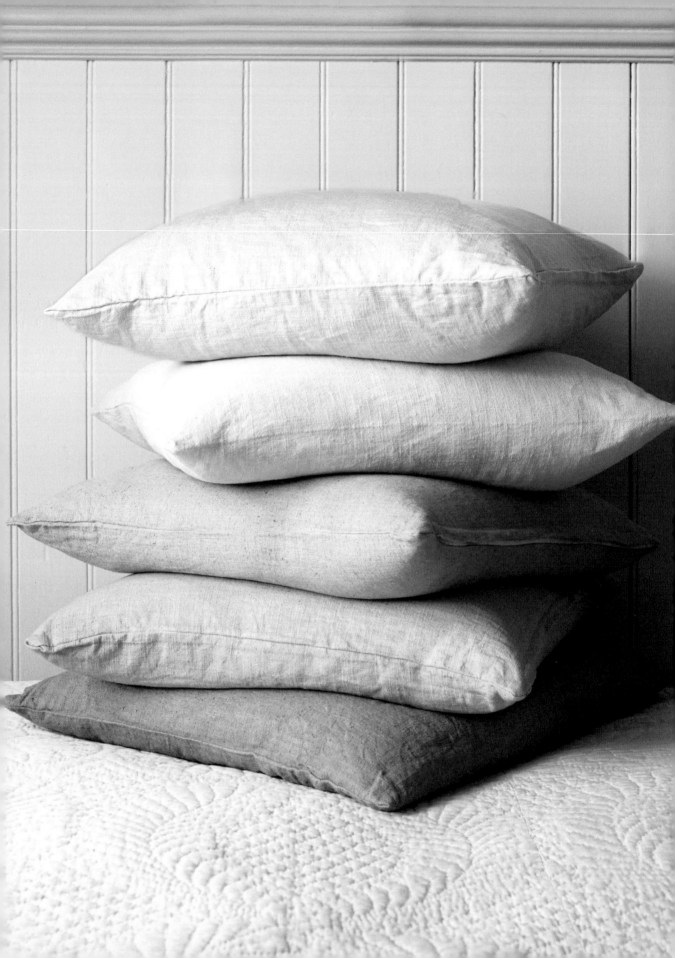

avocado pit

PILLOWCASES

Natural color sources can be gleaned directly from your green bin or compost. A perfect example of a plant dye that applies gorgeous color and transforms common culinary waste into wonder is the avocado pit. As a resident of the San Francisco Bay Area for the past fifteen years, I have probably consumed hundreds of California-grown avocados, but little did I know that my kitchen compost could yield a rainbow of hues.

Avocado pits produce light to deep pink shades and russet reds with no mordant added. When an iron solution is added, the color transforms into inky blues, purples, and blacks.

This avocado pit dye project uses linen pillowcases and highlights the diversity you can achieve from just one natural dye bath. The more pits you include, the darker and richer the hue and intensity of color will be. Avocado pits have a built-in tannin mordant, which helps to bind the dye. It's the reaction of those tannins when you add iron to the dye bath that produces the deep, dark colors.

PILLOWCASES

5 square linen
pillowcases, 20 by
20 inches (2½ pounds)

10 fresh, well-cleaned
avocado pits

1 teaspoon iron powder

pH-neutral soap

EQUIPMENT
Dust Mask

Heat- and water-
resistant gloves

Large stainless
steel pot with lid

Stainless steel tongs

Measuring spoons

Scour and soak your pillowcases (see page 36).

Fill a large stainless steel pot two-thirds full with water, making sure there is room for the pillowcases to move freely.

Add the avocado pits. Bring the water to a low boil and then reduce the heat to a simmer.

Simmer until the avocado pits turn the water bright red. This will take approximately 30 to 60 minutes.

When your water has become bright red, remove the pits with tongs and add the pillowcases, maintaining a low simmer. To achieve varying shades, leave your lightest pillowcase for at least 10 minutes for a secure dye bond with the fabric. The longer your pillowcases soak in the dye, the darker the peach and pink colors will be.

When the pillowcases reach your desired shade, remove them from the dye pot with stainless steel tongs and set aside.

Rinse two pillowcases in warm to cool water with pH-neutral soap. Hang them to dry out of direct sunlight.

For the remaining three pillowcases, use your measuring spoon to add the iron powder to the dye bath. Let the pillowcases soak in the iron solution for at least 15 minutes. The pink and peach shades will turn to lavender, deep grays, and steel blues, depending on the length of time in the dye bath and strength of the solution.

Rinse your iron-modified pillowcases with pH-neutral soap and keep separate from the pink and peach pillowcases until fully rinsed and dry. Hang them to dry out of direct sunlight.

CREATING COLOR FROM COMPOST

In the quest to have a sustainable approach to our three basic material needs—food, clothing, and shelter—only food has made great strides. This has been a boon to the slow, organic, and local food movements. We don't consume textiles and color quite so literally as food, but we still use the same resources that are required to grow food: dedicated space, water, air, and soil. For these reasons it is important to recognize that we are equally what we wear as much as what we eat. Stewardship and collaboration of these precious resources are necessary for both sustainable food and fashion.

One of the reasons I first started working with natural color was to make my own dyes from plants that connected me to my environment. This is an ancient and inspiring practice, one that reminds us that color was once as regional and seasonal as cuisine.

Learning to truly cook real, whole foods can also sharpen and season your skills for "cooking" masterful natural dye colors. Many of the same rules used in cooking apply to dyeing: the freshest and healthiest ingredients also can make the most vital colors. Like creating natural color, cooking involves trusting your own sensibilities, not being afraid to experiment, and being patient; your skills as a dyer will emerge and improve over time.

Many by-products from your own kitchen and garden, can also be excellent sources of natural color. Some of my favorite dyes are made from common seasonal fruits and vegetables—pomegranate rinds, red and yellow onion skins, black beans and lentils, artichoke leaves, carrot tops, citrus peels, and avocado pits—all discards from cooking, many of them scraps that most of us wouldn't think twice about tossing. Once you've used these natural dyes, your spent plant dye can even go directly back into your garden or compost pile to encourage the growth of more food and, in turn, more color.

Over the past decade, my Permacouture Institute colleague and dear friend, Katelyn Toth-Fejcl, and I have hosted Dinners to Dye For with multiple chefs both in the United States and the United Kingdom, in urban restaurants and at wineries and local farms and gardens, sharing the fascination and deep potential of creating a color palette with seasonal and local plants. It has also been interesting to see that the flora available in London produces a range of colors quite different from those created in San Francisco. This is because the food prepared by the chefs and the by-products, as well as the conditions in which the plants were grown—the acidity and alkalinity of soil, the water, and the time of year—differ significantly in each city. These dinners opened our eyes to the many variables of these plants and the colors the food by-products

produce. Participants often recount their pleasure and wonder for the deepened sense of participation through the shared meals and color palettes.

Learning about dyeing through culinary plants directly shows us how seeking out a biodiversity of ingredients in our food and our dye pots creates livelier tastes and colors and, in turn, livelier ecologies and communities. One of my greatest friends and mentors is Kelsie Kerr, former chef of Chez Panisse in Berkeley, California and an incredible advocate for biodiversity and expanding our seasonal repetoire. Kelsie loves to experiment with heirloom edibles, and she knows the power and potential of taste to expand all our senses and connect us with the full range of available ingredients.

In 2012, Kelsie and I embarked on a yearlong series of Seasonal Color and Taste Palette workshops, exploring experimental and environmentally connected recipes for both food and dyes. We were able to discover and document the commonality of expanding our participants' taste and color palettes and introduced them to unique place-based colors from the same biodiverse sources. We hosted this series of workshops at Gospel Flat Farm, in the coastal farming town of Bolinas, California. As the chef for these events, Kelsie created dishes saturated with colors and flavors, with carefully selected ingredients sourced from friends and farmers. We offered our students a wide range of tastings based on twenty varieties of heirloom apples in the fall, a wide array of winter citrus, and a range of summer stone fruits. Simultaneously, we learned about the nuances of working with pruned heirloom apple branches as natural dye sources, and how Meyer lemons and Satsuma peels have varying differences in taste and qualities. We were also able to work with tastes and colors directly from Gospel Flat Farm throughout the year, incorporating gleaned farm crops like artichoke leaves (a traditional color source in Provence) when the farm's artichoke crop was done and being rotated from the fields to the compost pile. Our ethnobotanist, Deepa Natarajan, took students on "weed walks" in the fields and creek beds, collecting various weeds to place in the dye pot at different times of year—including rampant oxalis in the winter, wild fennel in the summer, and overgrown blackberry brambles in the fall.

Just as with food, color palettes that follow the seasons are also a celebration of the time of year and their locality. Our workshops and dinners with Permacouture allowed guests to experience the nuanced yellow of wild fennel on silk and then the taste of the wild fennel in a caramelized fennel quiche, and the deep hues of acorn-dyed linens and the richness of freshly baked acorn-flour bread. These collaborations revealed the vastly underutilized and unacknowledged versatility of the plant world.

Natural colors are like fruits and vegetables—once you have tasted a locally grown heirloom peach and dyed your textiles in the luminescence of their pruned branches, it's hard to go back to supermarket peaches and chemical dyes.

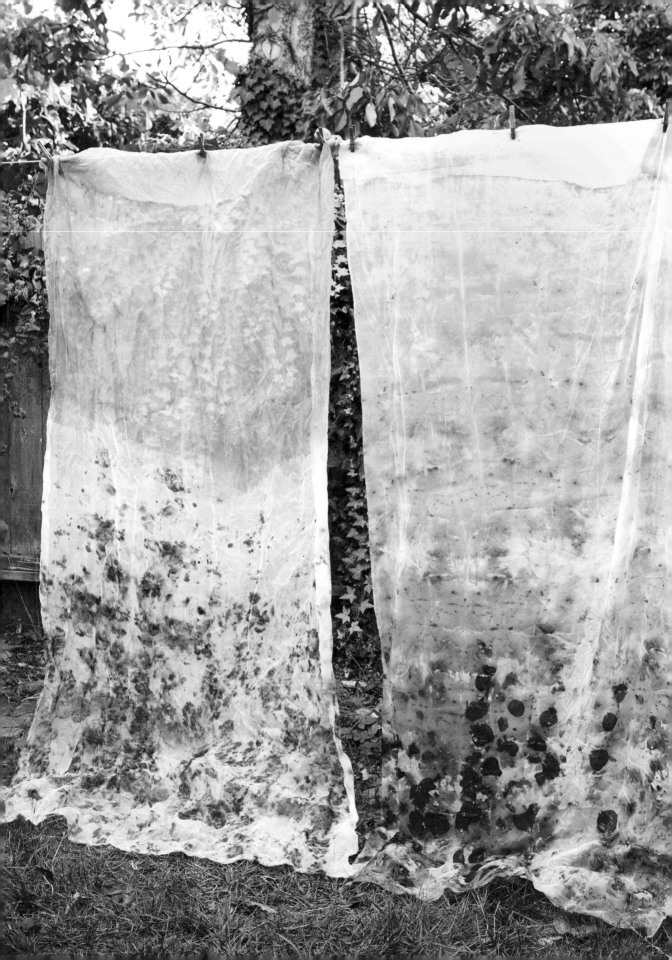

rose petal
CURTAIN

Spring is always a renewal of the senses: take time to smell the fresh spring roses! After you sweeten your home with a bouquet, the spent rose petals make a great dye material. Pink, red, and purple roses of all varieties have incredible color potential. And so do all parts of the rose plant, including the leaves and, later in the year, the ripened rosehips. By simply adding modifiers and mordants, you can vary the colors extracted from rose petals from fuchsia to purple, indigo, and even black.

You can collect rose petals as they fall off the rose bushes in your garden or after you've fully enjoyed a fragrant spring bouquet. Try connecting with your local florist to salvage blooms that are past their prime but perfect for the dye pot.

Steaming the imprints of rose petals directly onto fabric is an especially satisfying way of using roses. Steaming makes a dense concentration of color as the plant material's hue transfers directly onto the material. For this project, I use silk organza, which is a crisp and semisheer plain-weave silk. It takes natural color amazingly well and looks beautiful with light coming through. It can also withstand high heat and still hold its shape. This project layers rose petals on the lower third of the fabric, leaving the rest uncolored to later dip-dye in a rose petal reduction that is created at the same time as the fabric is steamed. The top two-thirds of the fabric is then dip-dyed, creating an ombre effect.

CURTAIN

3 yards of silk organza fabric, 54 inches wide, (about 4 ounces)

pH-neutral soap

1½ teaspoons aluminum sulfate

1½ teaspoon cream tartar (optional)

Petals and leaves from 1 dozen dark red, purple, or pink roses

EQUIPMENT
Heat- and water-resistant gloves

Cotton twine

Bamboo or stainless steel steamer

Large stainless steel pot with lid

Small drop cloth

Strainer

Stirrer

Wash your silk organza in pH-neutral soap. There's no need to scour the fiber—that would make the organza lose its stiffness.

Premordant your fabric with aluminum sulfate and cream of tartar, if using (see page 214).

Lay out your fabric on a flat surface and arrange 2 cups of the petals in your chosen pattern in the middle section of the bottom third of your fabric; the design can be as spacious or layered and dense as you wish. When finished, fold each side of your fabric to cover the petals at the center. Press down on your petals with your hands or carefully tap them with a mallet for clearer imprints.

Starting with the short edge of the curtain, carefully roll your fabric tightly around it. As you roll toward the petals, be careful to keep them in place. When the entire curtain is rolled up, secure it lightly with cotton twine on each end, which allows the steam to penetrate the layers of fabric. Wet your bundle and place it inside a stainless steel or bamboo steamer.

Fill a large pot one-third full of water. Add the remaining rose petals to the water. Bring the water to a boil, then reduce heat and let simmer.

You can pour water over your bundle in the steamer for extra steaming that will help speed up the process.

Baste the bundle with water and turn it every 15 minutes for even steaming; steam the rolled curtain for at least 1 hour, making sure that your rose petal water underneath never boils down too low. Then turn off the heat and let the bundle cool down and steep overnight with the lid still on. Let your rose petal water steep as well.

Remove the bundle from the steamer basket when patterns in dark pink, purple, and blue have emerged significantly.

Remove the cotton twine and unroll your steamed bundle onto a small drop cloth onto which you can catch all the plant material and compost.

Your pattern should have strongly emerged at the base of your curtain and trailed slightly upward in the process, creating an ombre effect of patterned rose petals.

Rinse your fabric in pH-neutral soap and let the fabric soak in clean water while you prepare your rose water dip-dye with the reduction you made.

DIP-DYEING WITH ROSE PETAL REDUCTION

Strain the rose petals that have been steeping at the bottom of your steam pot, and compost. Add water to the remaining dye liquid so that the dye pot is now half filled. Bring your dye bath to a low simmer and add the top two-thirds of your fabric to the rose petal dye bath to create overdye and ombre effect that fades into your petal imprint. Carefully holding your fabric away from the edge of the hot pot so it doesn't burn, let your dip-dyed fabric simmer on low for 10 to 15 minutes. If you desire deeper and more saturated color, turn off the heat and let one-third of your fabric saturate longer—40 minutes or more.

Remove and rinse the fabric with the pH-neutral soap and let it air-dry. Once dry, your fabric is ready to be made into a curtain!

SEWING YOUR ROSE PETAL CURTAIN

To create a channel for a curtain rod on your rose petal fabric, fold over the top 4 inches of your fabric and stitch through the folded edge—either with a sewing machine or by hand. Add a wooden dowel or curtain rod.

For longest-lasting rosy color, hang your curtain in a place with indirect light.

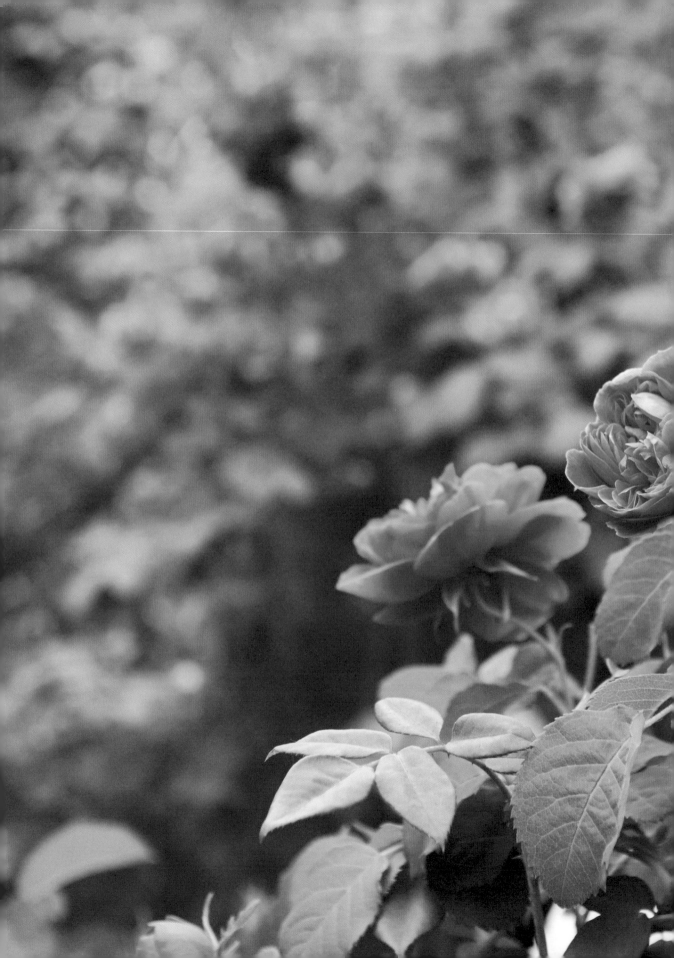

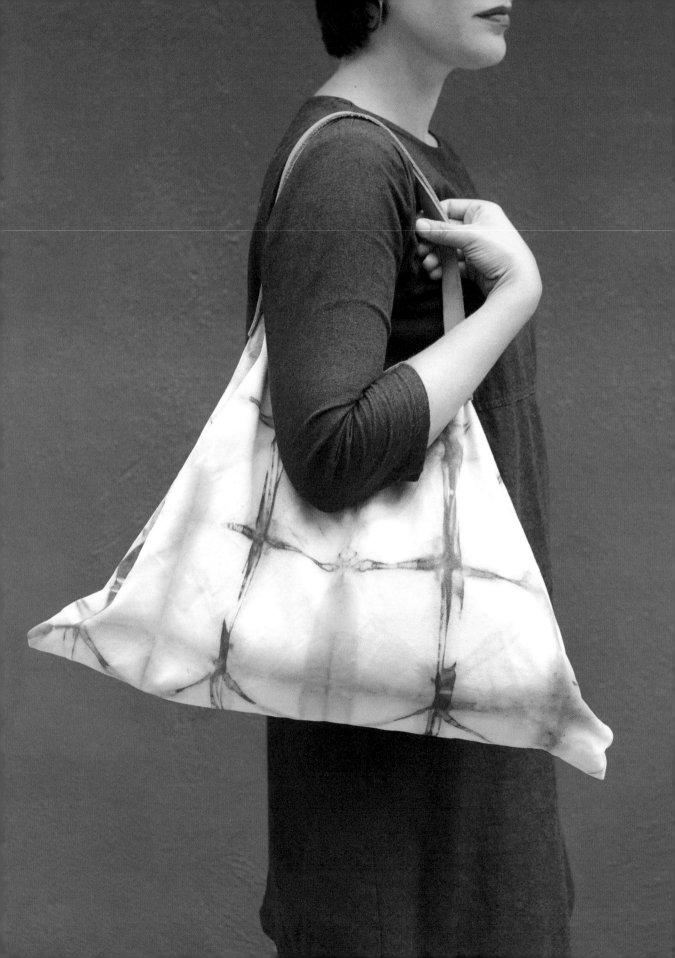

plum branch

LEATHER CARRYALL BAG

The prunings from fruit and nut trees in your yard can produce an astonishing spectrum of natural color. In my urban backyard, we have golden yellow and purple plum, heirloom apple, black walnut, peach, and cherry trees—all of which make excellent plant dyes. Depending on the type of fruit or nut tree prunings you use, you can create colors ranging from red, green, and peach to darker purples, mauves, greens, and blacks.

Winter into early spring, when the trees are dormant, is an excellent time to prune. You can create natural colors from your fruit tree prunings immediately or save the branches and use them throughout the year.

For this project, I used purple-leaf plum tree branches (*Prunus cerasifera*), which produce some of the first blossoms of spring (or late winter, in mild climates like California's). The prunings from this tree make a wide array of beautiful colors—gorgeous plum, black, and mauve—and they can be easily modified to dark greens, blues, grays, and blacks, depending on the mordants used and the pH of the dye bath. Plum tree prunings already contain tannins as a built-in mordant. For this project I used a square piece of light-colored leather, folded using the itajime shibori method, and then sewn into a bag. (Shibori is a Japanese resist technique for creating patterns on textiles; see page 236.)

LEATHER CARRYALL PAG

½ yard clean,
(white, cream, or beige)
100 percent untreated
leather (8 ounces)

pH-neutral soap

1 pound purple-leaf plum
tree branches, cut into
1-inch lengths

1 tablespoon
aluminum sulfate

1 tablespoon cream of
tartar (optional)

1 teaspoon iron powder

EQUIPMENT
Heat- and water-
resistant gloves

Medium stainless steel
pot with lid

2 square wood blocks
of equal size at least
½ inch thick (about
4 by 4 inches)

Cotton cooking twine or
thick rubber bands

Stainless steel tongs

Dust mask

Old ceramic plate

Wash your leather with pH neutral soap and let air-dry completely. Set aside.

In a medium stainless steel pot set over a burner, add the plum prunings with enough water to cover the leather and allow it to move freely, and bring to a low boil.

Simmer the branches until the water turns reddish purple. Add the aluminum sulfate and cream of tartar, if using, to the dye bath to make the color brighter and more purple-mauve.

Fold the leather into 4-inch-long sections, using the blocks and twine, following the instructions for itajime shibori (see page 236).

Soak the folded leather in lukewarm water with pH-neutral soap for at least 20 minutes. Keep folded and rinse in lukewarm water.

Add the folded leather to the dye bath and reduce the heat to low. Simmer the leather for approximately 20 to 40 minutes, until the leather is your desired color. Use tongs to remove the leather and set aside. Wearing a dust mask, add 1 teaspoon of iron powder. Stir vigoriously. Return the leather to the dye bath and let it soak overnight, using an old ceramic plate to keep it fully submerged so that your pattern dyes evenly.

Wash the leather with pH-neutral soap to remove excess dye. Remove the twine or rubber bands, unfold the leather, and admire the radial pattern you've created.

Gently rinse your dyed leather in lukewarm water with pH-neutral soap. Lay the leather out flat to dry out of direct sunlight.

SEWING YOUR CARRYALL BAG
Fold the dyed and dried leather in half and stitch up the sides, either on a sewing machine with a leather setting or by hand. I used a sewing machine and added a lining of naturally dyed hemp-silk fabric. I also added thicker leather handles by poking four holes in a square on each end of the two straps and then used a sharp embroidery needle and strong embroidery thread to secure the straps.

Variations Cotton canvas, linen, and hemp fabrics all work well for this project as tannin is already in the branches and can help bind to the plant based fibers. Prunings from other types of plum trees as well as apple, peach, and pear trees, will also work as color sources, but the color results will vary.

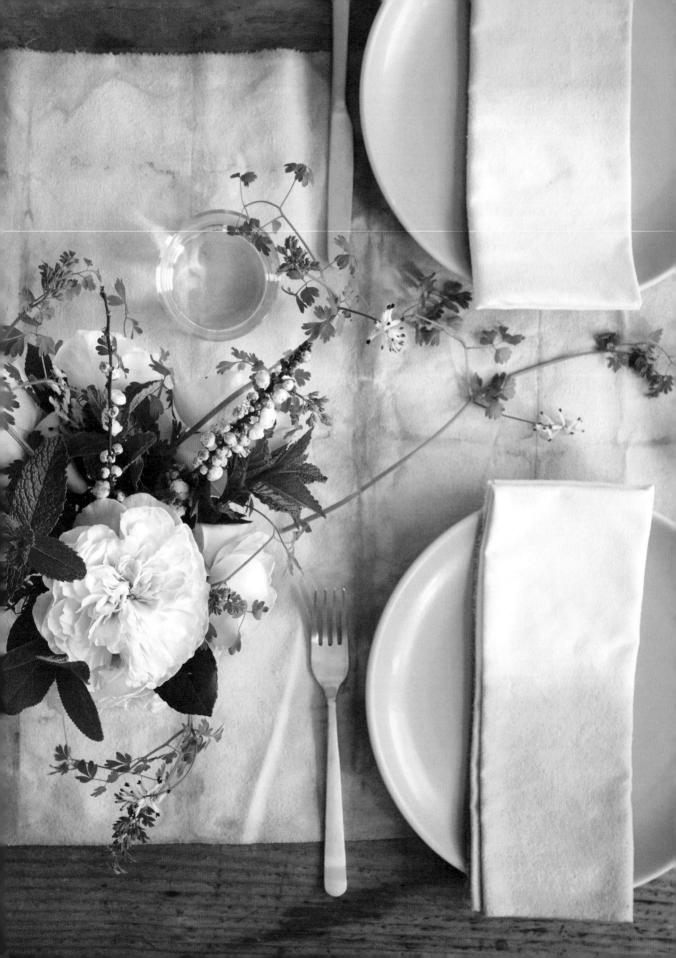

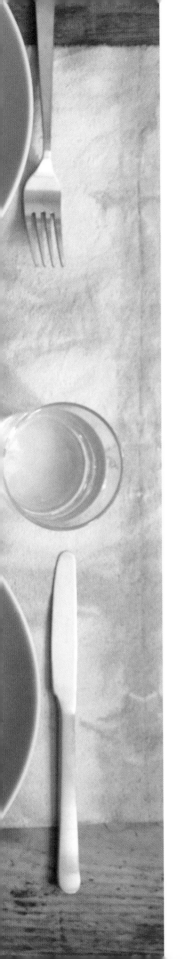

mint

TABLE RUNNER AND NAPKINS

Mint (*Mentha* species) is an aromatic perennial herb popular as a flavoring in cooking, baking, tea, and an abundance of body care and beauty products. Mint thrives in cool, moist climates and grows rapidly by means of its underground runners. Mint can grow wild, and can even become a problem in a garden because it can quickly take over, which makes it an excellent candidate for the dye pot.

When gathering mint (cultivated or wild), harvest just the leaves and stems if you wish the plant to continue to grow, or use the entire plant, including the roots, if you hope to eradicate it from that area.

Mint creates a fresh (minty!) blue-green dye color with alum salts and an iron modifier, and it smells wonderful while steeping in the dye bath.

In this project, raw silk and fresh mint dyed using the itajime shibori technique create a table runner and matching dip-dyed napkins, a perfect base for a spring dinner party—or any occasion.

TABLE RUNNER AND NAPKINS

1½ yards raw silk
(silk noil) fabric
(4 ounces)

4 ounces mint leaves and
stems chopped

1½ tablespoons
aluminum sulfate

1½ teaspoons cream of
tartar (optional)

½ teaspoon iron powder

pH-neutral soap

EQUIPMENT

Heat- and water-
resistant gloves

Strong twine or
rubber bands

2 rectangular wooden
blocks, at least ½ inch
thick (about 4 by 8 inches)

Medium stainless steel
pot with lid

Strainer

Dust mask

Scour the raw silk fabric (see page 36) and let air dry.

Cut the raw silk fabric lengthwise down the center and set aside one-half for the table runner. Cut the other half into six equal pieces for matching napkins and set aside. Fold the fabric for the table runner following the instructions for itajime shibori (see page 236). Bind the folded bundle with the block and strong twine or rubber bands.

Leave your fabric and napkins to soak until your mint dye bath is ready.

In a stainless steel pot large enough to hold the fabric, place the mint leaves and stems in water and slowly bring to a low boil. Simmer for 20 to 40 minutes.

When your mint dye bath looks greenish yellow, strain out the leaves with a stainless steel strainer. Wearing heat- and water-resistant gloves and a dust mask, add the aluminum sulfate, cream of tartar, if using, and the iron powder to the dye bath and stir well. The color should turn a brighter teal-green. Add the wet runner bundle to the dye bath and bring to a low simmer.

Simmer for at least 40 to 60 minutes, or turn off the heat and let the fabric soak in the dye overnight to achieve the desired mint green color.

Dip-dye the napkins all at once for consistency. Dip 4 to 6 inches of the napkin edge in the dye bath for at least 10 to 15 minutes for stable results and good dye bonding.

When the desired fresh-mint shade is reached, remove the napkins and the bundle from the pot with stainless steel tongs. Remove the twine or rubber bands and the wood pieces from the runner.

Wash the runner and napkins in lukewarm water and pH-neutral soap. Let your runner and napkins dry out of direct sunlight.

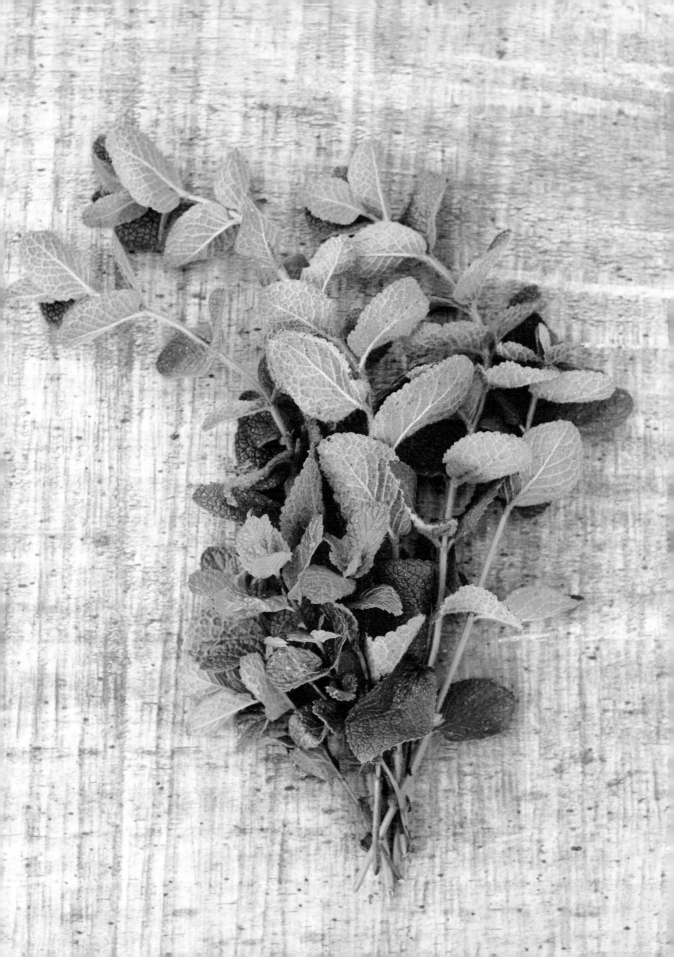

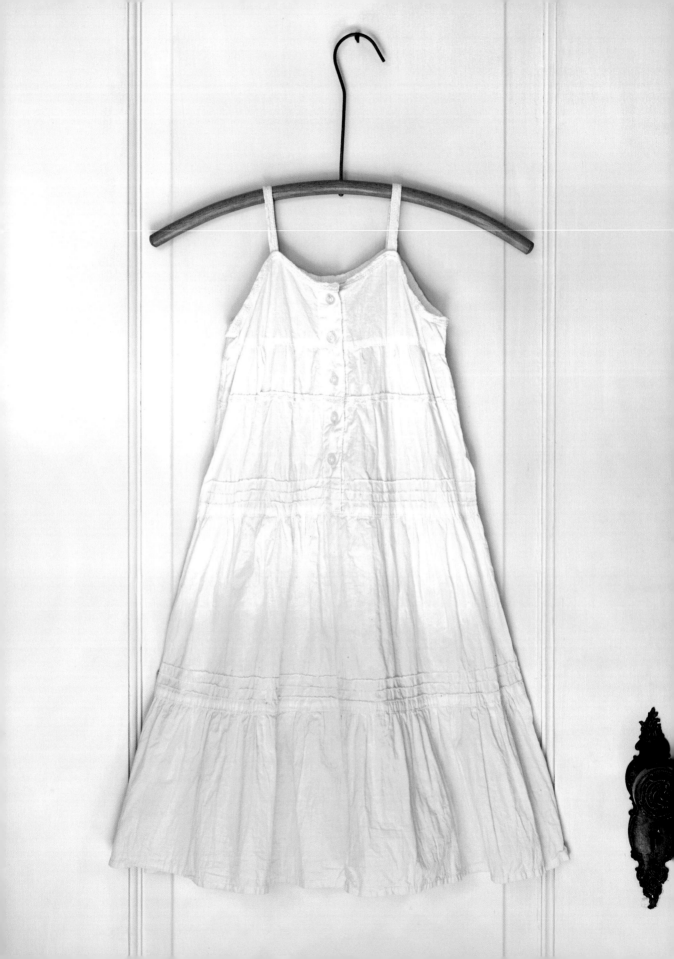

CHILD'S DRESS

Oxalis (*Oxalis pes-caprae*), commonly called sour grass, is a wild (and often invasive) plant in the wood sorrel family (*Oxalidaceae*), found around the world. Oxalis has cloverlike leaves and bright yellow flowers that are a great source of a vibrant yellow dye. Many members of the genus *Oxalis* contain oxalic acid, which gives parts of the plant a pleasant sour taste. Because oxalic acid is a natural mordant, when using sour grass as a dye material it's optional to use an additional mordant to achieve bright colors. This dye works well with silk, wool, and cotton, creating a brightly saturated, summery yellow.

You can extract dye from sour grass flowers and leaves with both the hot-water and cold-water methods. The cold-water method makes this an especially easy dye for small children to work with you on. A higher proportion of oxalis plant material to the weight of the fabric will provide even more saturated color on fabric.

Oxalis also makes a lovely natural-dye paint and paste to work with.
(See pages 248–249 for print and paste recipes.)

In many countries, oxalis blooms are truly a sign of spring. Where I live in California, sour grass season follows the winter rains, and fresh flowers usually bloom from late February to early May before they wither in the hot, dry summer months. Gathering sour grass flowers and leaves while they are in full bloom and creating your color with the fresh plants is the best way to ensure a bright, vibrant yellow.

CHILD'S DRESS

100-percent cotton
white or cream dress,
(about 4 ounces)

4 ounces oxalis flowers,
leaves, and stems, torn or
chopped into small pieces

pH-neutral soap

EQUIPMENT
Heat- and water-
resistant gloves

Medium stainless
steel pot with lid

Strainer

Large glass jar or bowl

Scour the dress (see page 36).

HOT-WATER DYE METHOD

Fill a medium stainless steel pot two-thirds full of water,
enough to cover the dress and allow it to move freely in the
dye bath. Add the oxalis pieces. Bring the water to a simmer
and let the plant material simmer for 15 to 20 minutes,
or until the plant material loses its color. With a strainer,
scoop out the plant material. Place the dress in the dye bath,
simmer for 15 minutes, and then remove, or steep overnight
to achieve a more saturated color.

COLD-WATER DYE METHOD

Fill a large glass jar or bowl, big enough to hold the dress,
two-thirds full of water. Add the oxalis. Place in a sunny
spot until the water starts to turn yellow. Immerse the dress
and let it steep for as long as it takes to get your desired
shade. Scoop out the plant material with a strainer.

DIP-DYED DRESS

Lower the bottom one-third of the dress carefully into the
dye liquid and let the dye saturate it for at least 15 minutes—
the longer, the stronger your color. You can rig up a support
for a clothes hanger or wood pole through the sleeves and
suspend the dress while the hem soaks in the dye. See page
240 for further instructions on dip-dyeing.

For all methods, remove the dress from the dye bath and
wash with a pH-neutral soap. Rinse thoroughly and hang
to dry out of direct sunlight.

To care for your oxalis-dyed dress, hand wash cold in
pH-neutral soap as the color can be sensitive to alkaline soaps.

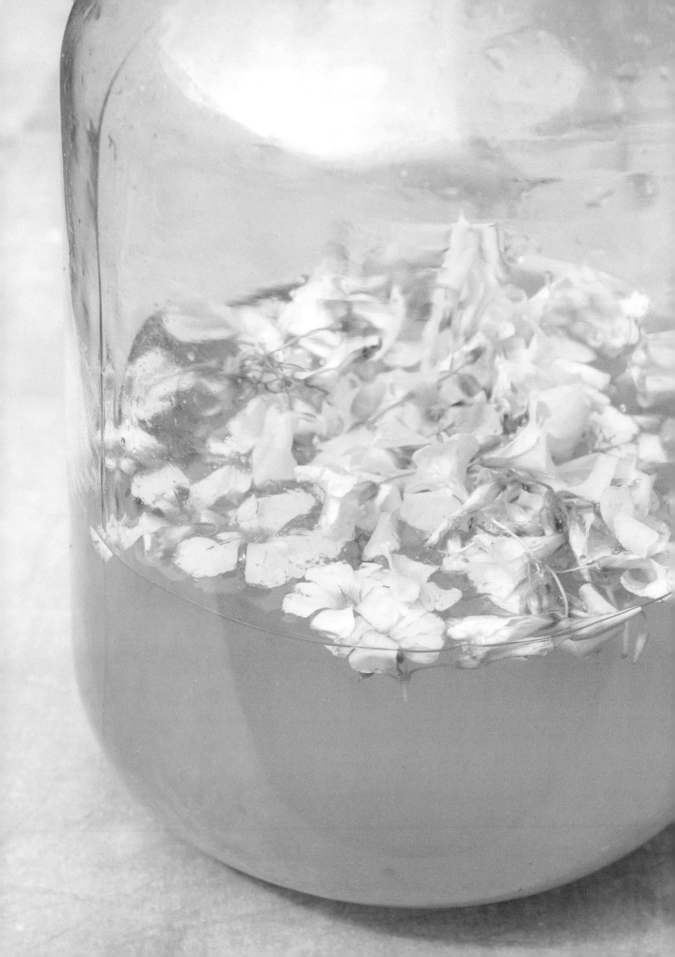

DYEING WITH

calendula

The genus name *Calendula* is a modern Latin diminutive of *calendae*, meaning "little calendar" or "little clock," as the flowers follow the path of the sun throughout the day. Calendula is an extremely useful plant; the petals are edible and can be used fresh in salads or dried and used as a replacement for saffron to naturally color cheese or other edibles. Calendula is also used to make healing salves and balms for treating wounds and inflammation. It can also be taken internally to treat a range of disorders.

I recommend premordanting your fabric to achieve the strongest shades— aluminum sulfate will bring out glowing yellow; iron, fresh green-yellow and soft greens. This recipe uses aluminum sulfate. Calendula yields the brightest colors on animal fibers like silk and wool.

4 ounces silk or wool fabric

1½ teaspoon aluminum sulfate

1½ teaspoon cream of tartar (optional)

4 ounces fresh calendula flowers

pH-neutral soap

EQUIPMENT
Heat- and water-resistant gloves

Medium stainless steel pot with lid

Strainer

Scour your fabric (see page 36) and premordant with aluminum sulfate and cream of tartar, if using (see page 214).

Fill the stainless steel pot three-fourths full of water, add the calendula flowers, and bring to a simmer. Gently simmer for up to 1 hour, then strain out the flowers and add the premordanted fabric.

Simmer the fabric for 20 to 30 minutes, until your desired color is achieved. Remove from the heat. For more saturated, glowing colors, turn off the heat and let the fabric steep in the dye bath overnight.

Rinse the fabric in temperate water with pH-neutral soap. Hang it to dry out of direct sunlight.

SUMMER

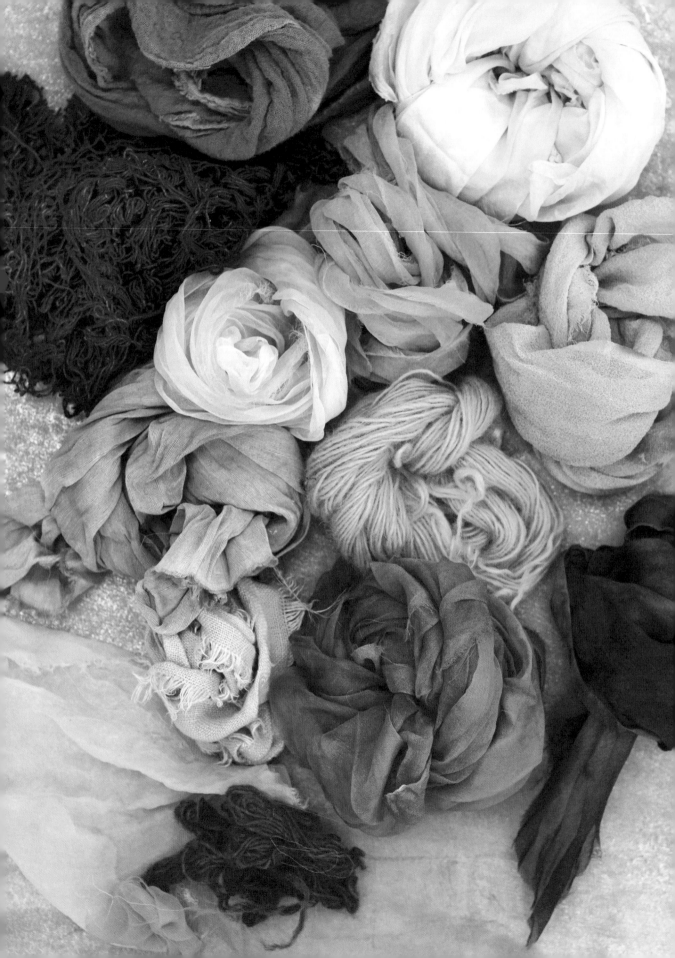

THE SUMMER PALETTE

ALOE · BOUGANVILLEA · INDIGO · EUCALYPTUS BARK · PASSIONFLOWER LEAVES
AND VINES · LOQUAT LEAVES · HIBISCUS · WILD FENNEL · WELD

For me, living in coastal Northern California, summer is a time of adventure and exploration. Experimenting with using saltwater as a medium for dyeing with coastal succulents or collecting layers of fallen eucalyptus bark on walks high in the hills are wonderful ways to connect to the landscape and then translate it into unique colors through the alchemy of water, heat, and time.

In the summer, many fruits ripen, and local foraging offers new flavors and tastes. Shiny evergreen loquat leaves make beautiful pinks and corals; with iron added, the dye bath can even shift to dark grays, purples, and blacks (see the picnic blanket project, page 115). Loquat fruit is also a unique treat growing throughout the San Francisco Bay Area, especially in the foggy avenues out by Ocean Beach.

In the summer, community gardens are also in full swing, with members harvesting an abundance of flowers, herbs, produce, and even ancient primary dye plants, like Japanese indigo for fresh turquoise, or weld flowers and seeds for true-hued yellows. Backyard gardens and urban spaces are also at their peak for gathering.

An outdoor work space can be an awesome studio for the natural dyer, and summer is the time to begin large textile dyeing projects—like renewing your linen and cotton bedding with fresh summer color, as well as dyeing outdoor tablecloths, beach wraps, and even summer sun hats. The weather makes it easy to dry dyeing projects outside in the fresh air, especially the large linens. There is nothing like gathering with friends and enjoying an outing by the coast, relaxing on a naturally dyed picnic blanket, and enjoying the summer air scented with saltwater breezes.

LOQUAT
LEAVES

SUMMER
DYE PLANTS

WILD FENNEL

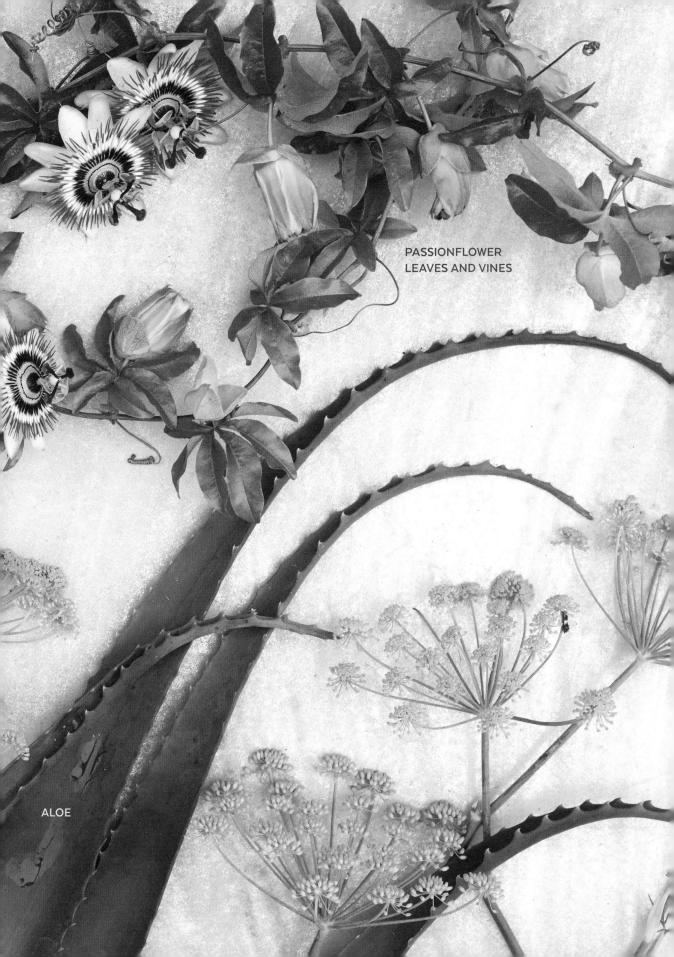

PASSIONFLOWER
LEAVES AND VINES

ALOE

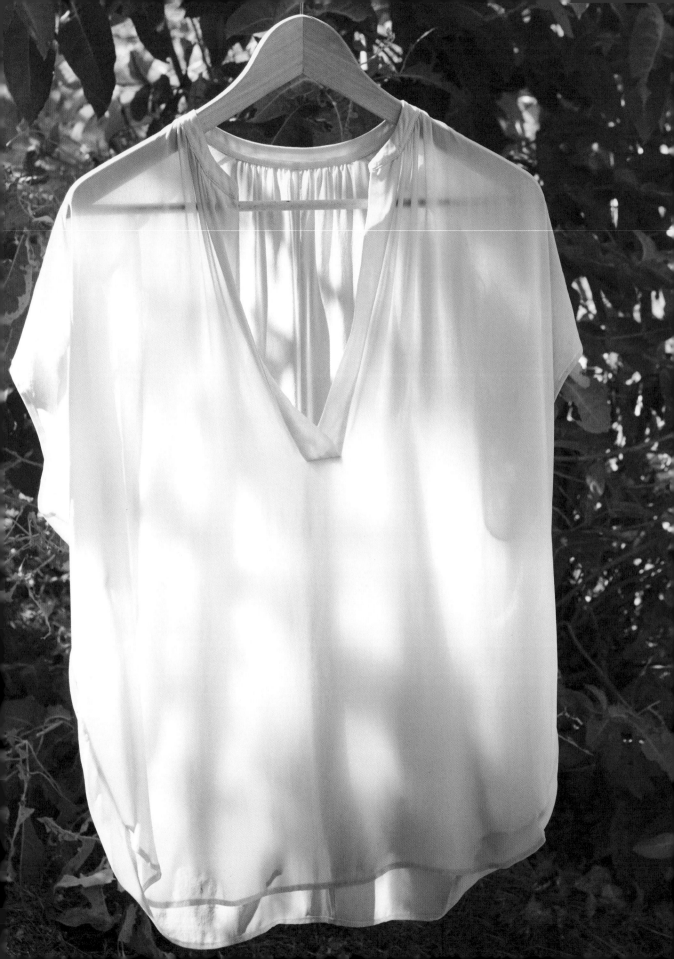

TUNIC

Aloes are medicinal healing plants, originally from South Africa. The most popular, *aloe vera* ("true aloe"), provides a skin-soothing gel after you've spent time in the summer sun.

However, there are over five hundred species of these flowering succulents in the Aloe genus, many prized as drought-tolerant ornamentals. They love dry, sunny weather, but gardeners in colder and wetter climates can also grow aloe quite easily indoors. I grow a South African species, *Aloe cryptopoda*, also known as yellow aloe. Many aloe varieties can be used to create awe-inspiring dyes. Depending on the parts of the plant used and the species, you can create shades of yellow, peach, red, brown, and even mauve from aloe leaves. Many traditional dye recipes in South Africa also use the roots of aloe to create deeper reds, earthy browns, and purple.

The shades you get will depend on the pH of the dye bath; with more alkaline water, the aloe dye turns from shell pink to coral red. No mordant is required to achieve glowing colors; aloe alone can create peachy yellows.

This tunic is a stylish summer cover-up in soft sunset shades of yellows, corals, and delicate pinks. This is a great project to do with alternative water sources, like saltwater gathered on a seaside day—adding extra poetics to the source of your col or and offering an alternative to tap water.

TUNIC

Clean, undyed silk tunic (about 2½ ounces)

pH-neutral soap

2 fresh aloe leaves, (approximately 8 to 12 inches long and 2 inches wide), chopped into ½-inch pieces

1 teaspoon soda ash or wood ash

EQUIPMENT
Heat- and water-resistant gloves

Medium stainless steel pot with lid

Strainer

Old ceramic plate

Soak the tunic in lukewarm water and pH-neutral soap for at least 20 minutes to overnight (scouring isn't necessary and it may shrink your fabric). Rinse and keep wet until ready to dye.

Fill a medium stainless steel pot two-thirds full with water. Add the aloe leaves. Bring to a boil, reduce the heat, and simmer for approximately 20 to 40 minutes, until the water begins to turn a bright yellowish, pink, or peach color.

Using a strainer, scoop the aloe leaves from the dye liquid and discard or compost.

Add your still-wet silk tunic to the dye liquid and bring the dye bath back up to a low simmer.

For more saturated yellows and pinks, turn off the heat and let the tunic steep overnight, weighted with an old ceramic plate to keep the tunic submerged and to dye it evenly.

To change the yellowy peach hue to coral and create an ombre effect, add the soda ash or wood ash to the dye and dip the tunic to create a soft sunset range of colors (see page 240 for more on dip-dyeing).

Gently wash with pH-neutral soap, rinse thoroughly, and hang to dry out of direct sunlight.

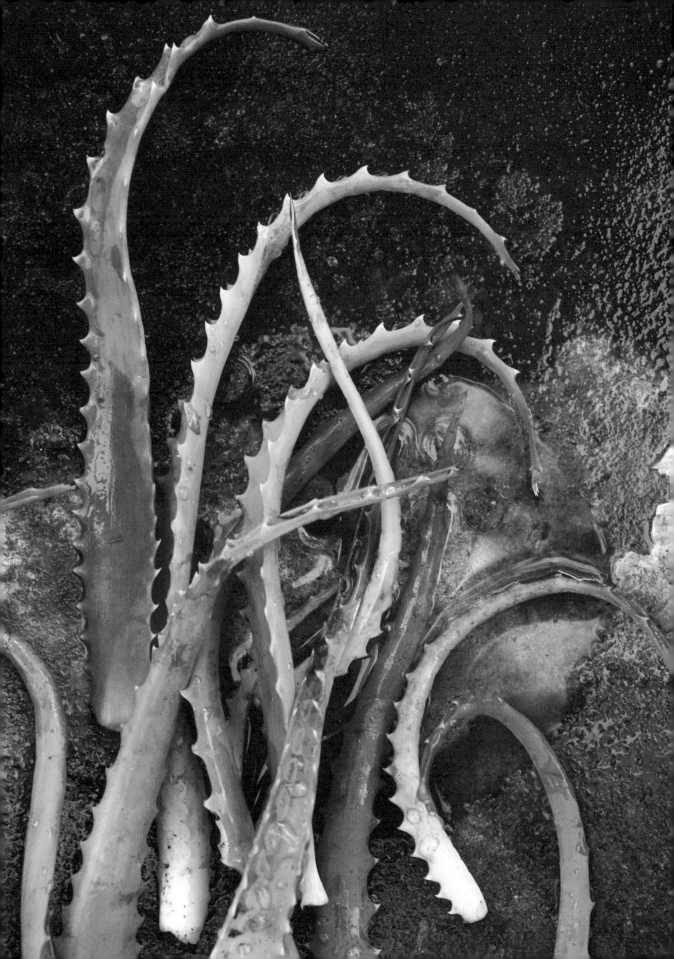

bougainvillea

Bougainvillea is native to South America from Peru to Brazil and south to Argentina. This thorny ornamental vine is well adapted to many tropical and temperate areas of the world. It is evergreen in areas where rainfall is plentiful, and deciduous in dry climates. Bougainvillea needs at least five hours of direct sunlight for the best blooms. Like poinsettia, bougainvillea's "flowers" are really colorful papery bracts; the real flowers are inconspicuous.

4 ounces silk
or wool fabric

1½ teaspoons
aluminum sulfate

1½ teaspoons cream
of tartar

2 cups bougainvillea
"blossoms," pulled apart
into separate "petals"

pH-neutral soap

EQUIPMENT
Heat- and water-
resistant gloves

Mortar and pestle

Strainer

2 medium stainless steel
pots with lids

Scour your fabric (see page 36) and premordant with aluminum sulfate and cream of tartar, if using (see page 214). Let soak while you prepare the dye bath.

Mix the bougainvillea flowers with 1 cup of water. In a mortar and pestle, pound the mixture to release the flower's juice. Add this mixture to a medium stainless steel pot half full of water.

Bring to a low boil and simmer for 20 minutes. Strain out the liquid into another medium stainless steel pot and discard or compost plant material. Return the liquid to heat.

Add the soaked fabric and let simmer for 20 to 40 minutes.

Turn off heat and let steep overnight. Remove the fabric from the dye and rinse with pH-neutral soap in lukewarm water. Hang to dry out of direct sunlight.

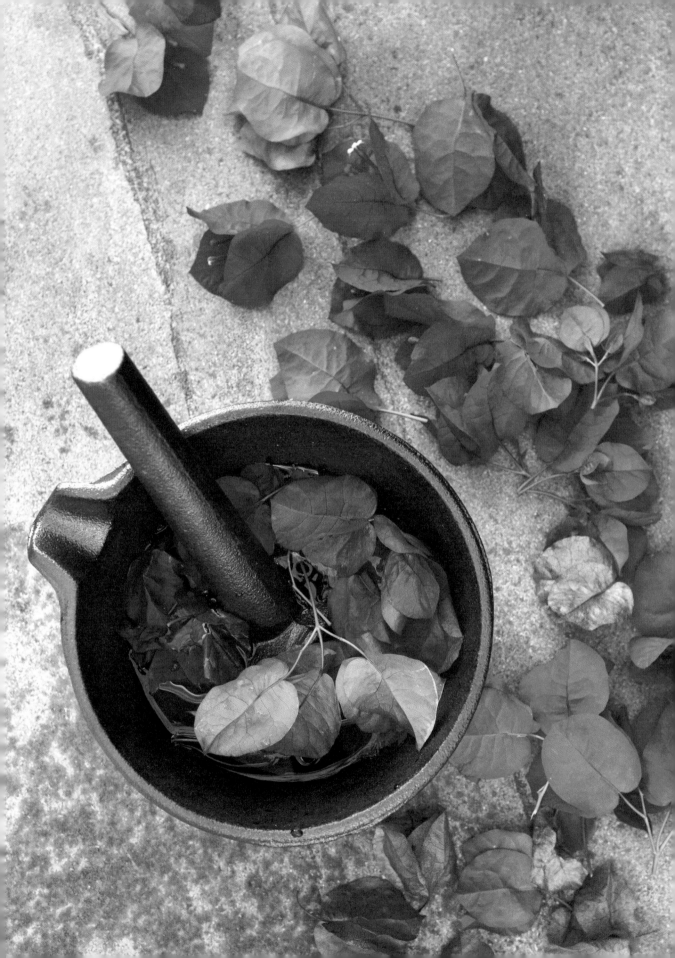

THE ANCIENT PRIMARIES: MADDER, WELD, AND INDIGO

On my journey to creating natural color, I was deeply inspired by a workshop I took in my early twenties at Darthia Farm in my hometown of Gouldsboro, on the rural coast of Down East Maine. These artists and farmers were growing the traditional ancient primary dye plants of madder, weld, and indigo, saving their seeds, and sharing them. I'm forever grateful to have received my first madder seeds and indigo starts from the very community I grew up in.

This primary inspiration has led to nearly twenty years of my own dye-plant cultivation and I continue the practice of saving and sharing important dye-plant seeds and starts. Identifying which plants you would like to work with for dyeing and deciding how to integrate them into your own garden is also a satisfying addition to the usual landscaping and gardening. Growing your own ancient primary dye plants also provides you with staple natural colors that have been used for thousands of years. When used in their fresh form, these ancient primary dyes can produce surprising color vitality. This is especially true of weld—when made with dried plant material, the color is still a very vibrant yellow; but when weld is harvested fresh, the color is an even more fluorescent lemony and clear golden hue.

RED MADDER

Madder (*Rubia tinctorium*) is a perennial herb native to the eastern Mediterranean and central Asia. It is also the most important source of "true" red in plant dyeing. Madder root has been used as a natural dye color for over five thousand years and was cultivated as early as 1500 bce. Madder was used as a coloring source by the ancient Persians, Egyptians, Greeks, and Romans, as well as generally for all red textiles before it was supplanted by synthetic dyes in the early twentieth century. Traces of madder used as a dye plant have been found in King Tutankhamen's tomb as well as in ancient burial grounds in Scandinavia, and even the ruins of Pompeii and ancient Corinth. The first American flags were most likely dyed with madder root or a combination of madder and cochineal—a beetle-sourced red dye originating in South and Central Americas.

Madder is very easy to grow—it has an excellent germination rate from seed and it is especially drought tolerant; it has done well in my garden with little watering. It takes three or more years for the roots to reach peak maturity and yield their full color potential on extraction. When I harvest the root, I keep some for dried stock to use in my studio throughout the years, and use the rest fresh.

Madder is a long-lived perennial of the family *Rubiaceae*, the same family as coffee. In late autumn, the plant's long tendrils and leaves begin to wane, the berries dry, and the seeds look like black peppercorns. In cold climates, fall is the opportune time to harvest the roots as well as save the seeds before the ground freezes over, as the plant is already dormant and you don't have to pull off the sticky vine leaves. It's also a good idea to plant your madder in two different beds so you can harvest them in rotation from year to year, as I do, so there's always fresh madder root available. Large madder harvests from your garden can be dried and stored indefinitely.

Madder root color is sensitive to temperature and to the mineral content of the water. It works best with slightly hard water, and adding a tab of calcium carbonate (chalk) or even an antacid tablet to your dye bath is enough to achieve clearer reds by making the water more alkaline.

Madder root is a safe, nontoxic red—a claim that's very difficult for synthetic reds to achieve. Its biochemical components include *alizarin*, the main chemical compound that produces the red color, and more than twenty-five other coloring agents. The vitality and vibrancy of madder red far surpasses that of synthetic chemical reds. Ironically, the alizarin in processed madder root was the first natural pigment to be synthesized in 1868; by 1871, it was known that alizarin could be extracted from coal tar. The synthesized version of this dye led to the collapse of the long-standing, tried-and-true market for madder red from the Middle East to Europe and the New World.

YELLOW WELD

Weld (*Reseda lutea*), also known as dyer's mignonette or dyer's rocket, is a biennial the form of which undergoes an interesting transformation, from a large rosette in its first year to a tall spike in its second. After blooming, the foliage of the weld plant may turn the same pale yellow as its flowers had been. Weld is the oldest dye plant used in Europe. It grew in the south of Sweden, and was also in North Africa and west Asia. In early Britain (where it was a staple) and Europe, weld was apparently plentiful as a native plant and used widely. It has been naturalized in some states in the United States, including Colorado.

Weld has a very long history as a yellow dye and is still grown commercially in many parts of Europe—most significantly in Normandy. The pure, bright, and yellow color is almost impossible for synthetic dyes to match.

Weld was the Romans' color of choice to dye the ancient robes of the vestal virgins, keepers of the hearth of the Roman Empire. Robin Hood's famed green outfit was dyed in a sequence—first weld, then European woad for blue—to make the distinctive solid green. Weld is also historically significant in many artistic masterpieces throughout the ages. Vermeer's "Girl with a Pearl Earring" was painted with a background of black and then a mixture of indigo and weld to create the glassy depth that helps make the image so stunning. Since weld as a color has some transparency, it is also an ideal pigment for glazing.

Using weld's vital green and fresh yellow flowers and seeds produces vibrant yellows, especially in slightly hard mineral water—so I often add a bit of chalk (calcium carbonate) to my water. The dye bath also has a spicy and peppery smell, and the brightness of the yellow the plant creates in the dye bath is mesmerizing. Harvesting weld from your garden can also be extremely rewarding in terms of yield of color. Once, after harvesting a full armful of fresh weld leaves and flowers, I used the same weld dye bath for over six weeks straight.

BLUE INDIGO

Plant-based indigo is one of the oldest-known natural colors. Indigo has had a major resurgence in recent years, and for very good reason. As a natural color, it is nontoxic and medicinal, and the many shades of this intriguing blue color are colorfast and gorgeous.

Indigo has huge advantages as a natural dye. It works readily on plantbased fibers like cotton, hemp, and linen, delivering washfast and lightfast color, and as it naturally covers stains with its deep blues, it is highly utilitarian.

Indigo is grown and traditionally used in many cultures and areas of the world. The sources of the plant and the methods and recipes to extract the color are diverse, as are the application. Throughout history, a variety of plants have produced "indigo blues." The strongest concentration of the color comes from the tropical genus *Indigofera*. The indigo that I grow in my garden and in the Dye Garden at California College of the Arts is Japanese indigo (*Persicaria tinctorium*), which is particularly well suited to the temperate Mediterranean climate of the Bay Area.

After production of synthetic indigo began during the Industrial Revolution, the use of natural indigo decreased drastically around the world. The manufactured colorant in natural indigo and synthetic indigo was identical, and synthetic indigo was so much cheaper to produce that Europeans began using natural indigo less frequently. As synthetic indigo production increased, cultivation of the natural indigo plants decreased in Africa and Asia as well.

Fortunately, although using natural indigo entails a more expensive process, many cultures around the world (especially in Japan and Africa) appreciated the immeasurable value of keeping farms, recipes, and traditional techniques of working with natural indigo alive. Thanks to this dedication and practice, we still can see the vibrant natural indigo in contemporary design applications today, not just in relics of antiquity.

Growing natural indigo is currently a healthy and exciting movement in regions and economies across the United States as well as other areas of the world. Textile artist and educator Rowland Ricketts has helped revive indigo in the Midwest, and Rebecca Burgess of the Fibershed movement—which connects farmers, designers, and consumers to local dyes, fiber, and labor—is growing natural and biodynamic indigo as a harvestable crop in California. This movement is localizing in other regions throughout the United States and around the globe.

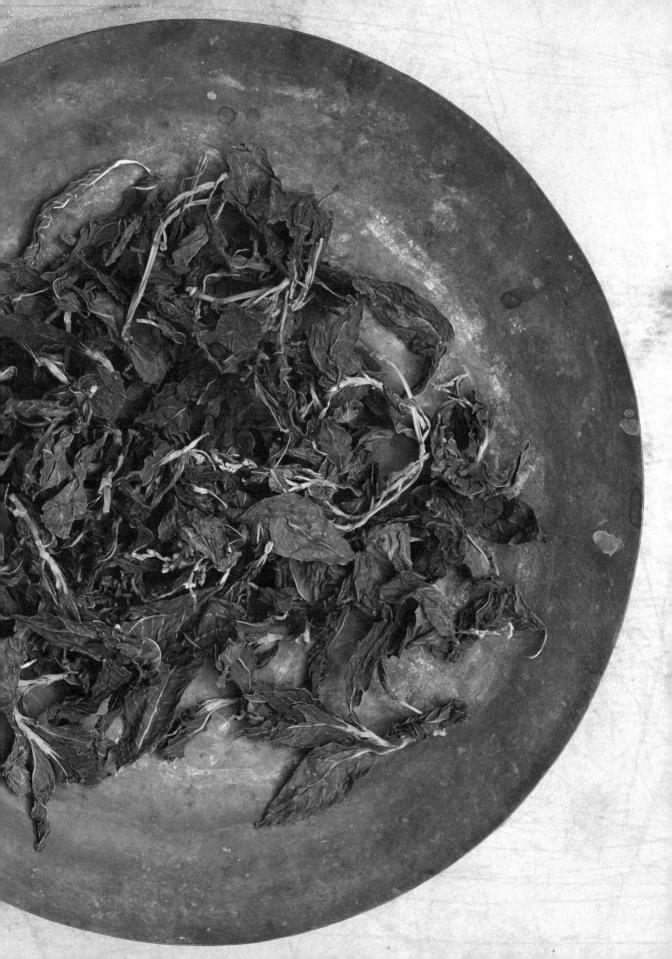

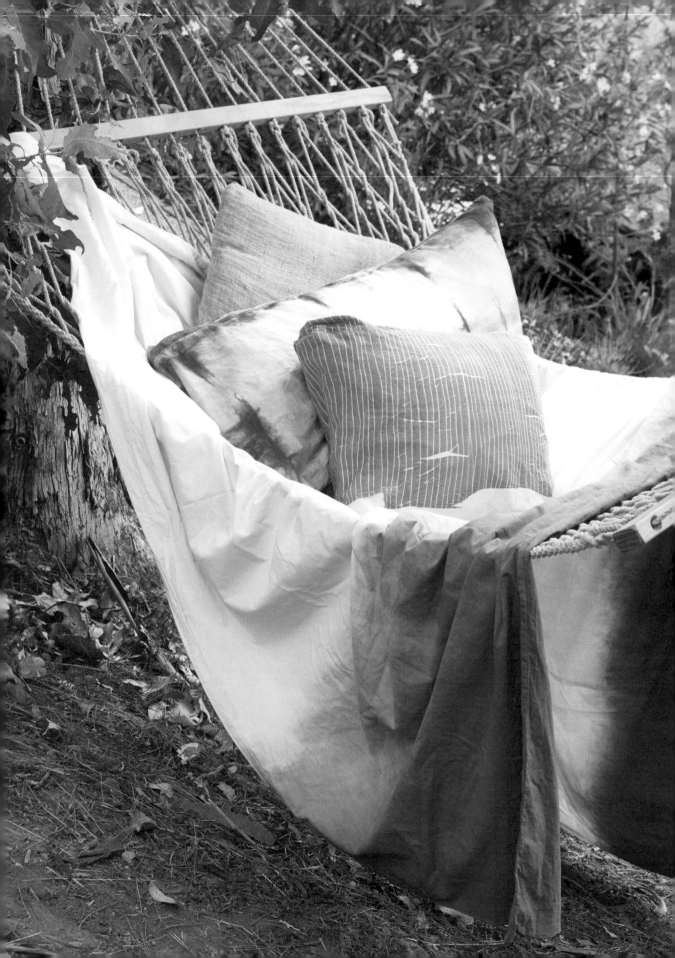

indigo
BEDDING

Many varieties of plants contain the prized indigo blue. Japanese indigo (*Persicaria tinctorium*) is an annual that is easy to grow in temperate climates and reseeds for new growth year after year.

You can use fresh indigo, which creates a turquoise color (see page 106), but the dark blue pictured here is achieved through a process of fermentation.

There are many varieties and sources of indigo pigment in the plant world. There are also many recipes and methods of creating indigo dye vats; however, my favorite comes from Michel Garcia, a renowned French natural dyer, who has done much to bring to light and modernize a very easy way of working with indigo in a simple organic vat. Based on Moroccan indigo dyeing methods, he uses indigo, lime, and fructose powder (this can come in the form of ripe or even overripe fruit, which is often a common waste material in many households) to create his indigo vat. I have come to love working with this method for making easy vats at home, and I, as well as many other natural colorists, can attest to its simplicity and vitality. Once you've made your vat, it requires little more than room temperature to keep it viable, along with regular "feedings" of fructose powder (see page 103 for more information on caring for your vat).

Indigo may be one of the best possible natural colors for dyeing bedding. Not only is it a steadfast and durable color, it is also dark, so it hides stains, and it can withstand the high washing temperatures. Indigo is also a healing, calming color and can be a beautiful medium for making interesting shades and patterns using simple shibori resist-dyeing techniques.

This recipe makes one dip-dyed duvet cover, one arashi-dyed pillowcase, and one itajime-dyed pillowcase and enough left over dye to use for additional projects. For large dyeing projects like this, purchase a nonreactive durable rubber trash bin (with lid) to use as a larger outdoor or studio vat.

As duvet covers can be bulky and heavy, you will be working outside—you may want to work with a friend who can assist you in holding the duvet, making sure that it doesn't get any unwanted dye splashes and wringing it out as you lift it out of the dye vat.

If you are working solo, you can protect the duvet cover from splashes and dirt by simply stowing the end you want to keep white in a strong plastic leaf bag and then securely fastening the bag opening with rope or rubber bands to make it water- and airtight, leaving the portion you want to dip-dye—in this case, the top quarter of the cover—out for dipping.

Working with a fermented indigo dye vat requires caution and safety. Be sure to wear a dust mask to avoid inhaling small particles, and take normal safety precautions when working with dyeing materials.

If you hate to see the remaining indigo dye in the vat go to waste, you can dip or dye the bottom sheet from the duvet set. You'll get a beautifully harmonizing lighter shade of blue.

This recipe makes enough for 2.2 pounds (enough for dip-dyeing a queen size duvet and two large pillowcases) of fabric and creates very dark indigo.

BEDDING

½ cup organic
indigo powder

1½ cups fructose powder

1 cup pickling lime

1 queen-size duvet
(approximately 1 pound)

2 pillowcases
(approximately
8 ounces each)

pH-neutral soap

EQUIPMENT
Heat- and water-
resistant gloves

Dust mask

Thermometer

2-quart glass jar

Stirrer

Large stainless steel
pot with lid

Log book (optional)

Nonreactive 5-gallon
bucket with lid or
large rubber trash can
with lid, or other
nonreactive vessel

2 rectangular wood
blocks of equal size, at
least ½ inch thick
(about 4 by 4 inches)

Strong twine or
rubber bands

4-inch-diameter
pipe or pole

Wearing gloves and a mask, make the stock solution, or "mother." Use warm water to form a paste with 1 cup of indigo powder. Add 2 cups hot water (120°F) to a 2-quart mason jar. Stir well to make a very dark blue mixture. Add the fructose powder in small increments to the jar and stir until evenly distributed. Make sure there are no lumps.

Add half the pickling lime in small increments, stirring well after each addition until thoroughly combined. Make sure there are no lumps. Add enough hot water to fill the jar. The solution will look greenish yellow and clearer as the solids rise to the top but still a bit murky.

Allow at least 1 hour for the chemical reaction to occur. Placing the jar in a pot of hot water will help speed the reaction. Stir the "mother" stock solution every 15 minutes and then let it settle again. Each time you stir, the solution should become more clear and yellow-green or even brownish red, which means that the reaction is working.

After 45 minutes, give your jar a final stir and let the liquid settle for 15 minutes.

Your indigo mother is ready when a purple-blue indigo "flower" (a circular foamy and bubbly crust of dark blue and purple color) forms at the top of the solution and the rest of the solution below the "flower" remains yellowish green. There's also a clear distinction between the liquid lower in the jar and the flower and sludge at the top of the jar.

Once your indigo mother is ready, fill a stainless steel pot two-thirds full with hot water—at approximately 120°F. Gently pour your indigo stock, including bottom sludge into the dye pot, and stir. When the indigo flower has reemerged and the top is blue and coppery and just underneath is green, your vat is ready. You can let this solution cool down and then carefully pour into a large nonreactive bucket or rubber trash can, adding more water so that your vat can submerge larger items.

DIP-DYED DUVET

Scour your fabric (see page 36) and soak.

Lower the bottom one-third of the duvet carefully into the vat, allowing it to move freely for even dyeing, and let the dye saturate it for at least 30 seconds and up to 3 minutes. For more information on dip-dyeing, see page 240. Gently lift your item out of the vat and squeeze out excess dye—I use the vat lid to collect the liquid. Then pour dye back into the vat so as not to waste the indigo. When you lift your fibers out of the vat you, will begin to see them turn from green to teal to blue as the indigo is exposed to air. This is a wondrous process to watch. Allowing your fibers to be opened up and to oxidize for at least 5 minutes, and up to 30 minutes between dips will allow for best results. Each time you dip and expose your fibers, they will get darker blue. When you're happy with your color, remove the duvet from the dye bath and wash with a pH-neutral soap. Rinse thoroughly and hang to dry out of direct sunlight.

ITAJIME-DYED PILLOWCASE

Follow the folding instructions for itajime shibori using the blocks and twine or rubber bands (see page 236). Dip several times in the dye vat, each time leaving for 30 seconds, and up to 3 minutes, allowing time for the pillowcase to oxidize from green to blue between dips. Remove the pillowcase from the vat and wash with pH-neutral soap to remove excess dye. Remove the twine or rubber bands, and then rinse in lukewarm water with pH-neutral soap. Hang the pillowcase to dry out of direct sunlight.

ARASHI-DYED PILLOWCASE

Wrap the scoured pillowcase lengthwise around the pipe or pole and then follow the instructions for arashi shibori, (see page 239). Once you are happy with your pattern, remove the twine and then rinse in lukewarm water with pH-neutral soap. Hang the pillowcase to dry out of direct sunlight.

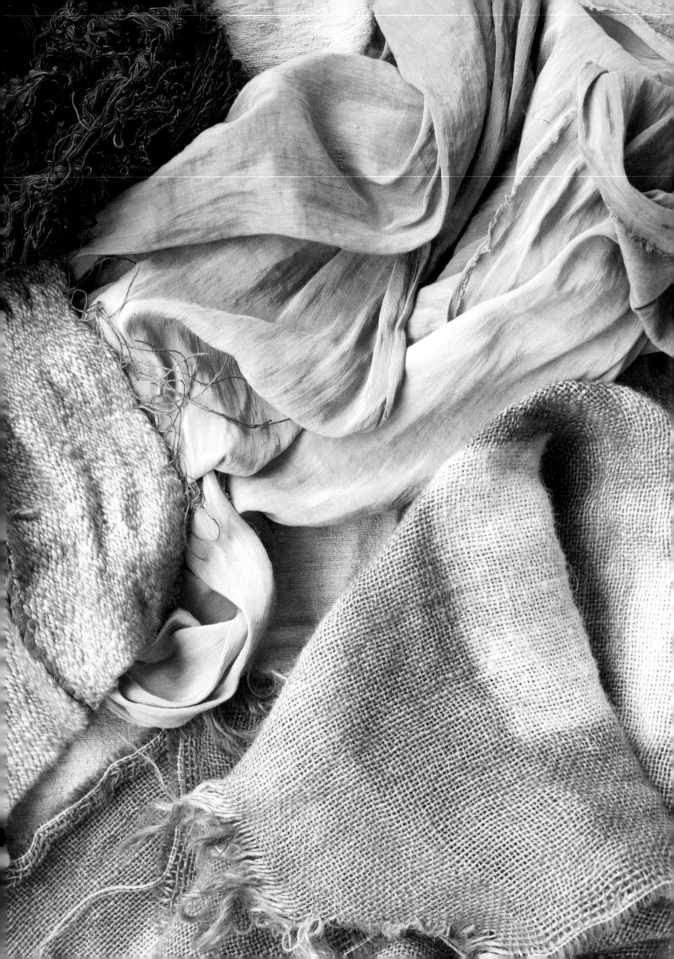

CARING FOR YOUR INDIGO VAT

REBALANCING THE VAT

The proportions in the vat will need rebalancing when the dye liquid turns entirely blue: that is, not green below the surface or when you dip in your fibers because properly working indigo changes from green to blue when it oxidizes. When this happens, remove your current indigo liquid from its vessel, place in a large stainless steel pot and heat gently to 120°F, and add ¼ cup fructose powder. Wait 15 to 30 minutes for the vat to return to a yellow-green state. If it remains blue, add 1 tablespoon of pickling lime, stir, and wait. You may need to repeat this process for the vat to rebalance. When you put in test strips of fabric and the tests come out green and then oxidize to blue as before, and the liquid looks green but the indigo "flower" has returned to the surface, it is considered rebalanced.

REPLENISHING THE VAT

Once you have finished your current project, it is time to replenish your vat to allow for new projects. Keeping an active indigo vat log helps you make sure that you have the right amount of dye-to-material ratio at all times and will not "kill" the vat by adding too much fiber to the dye. Replenish the vat and add it to the existing vat per WOF you wish to dye.

STORING THE VAT

If you are working with smaller quantities of indigo, you can store your smaller indigo vat in a nonreactive 5-gallon bucket with a lid; for larger projects and a greater amount of natural indigo, you can keep it in the large rubber trash can with a lid. Label your organic indigo vat. You will need to rebalance it the next time you use it. See directions above.

DISPOSING OF THE VAT

You can neutralize the alkalinity of the indigo vat by equalizing the vat's pH. Add 1 to 2 cups of white vinegar, and pour the cold contents down the drain or in a wild part of your garden or yard to water plants that will appreciate the lime (alkalinity) as a soil amendment.

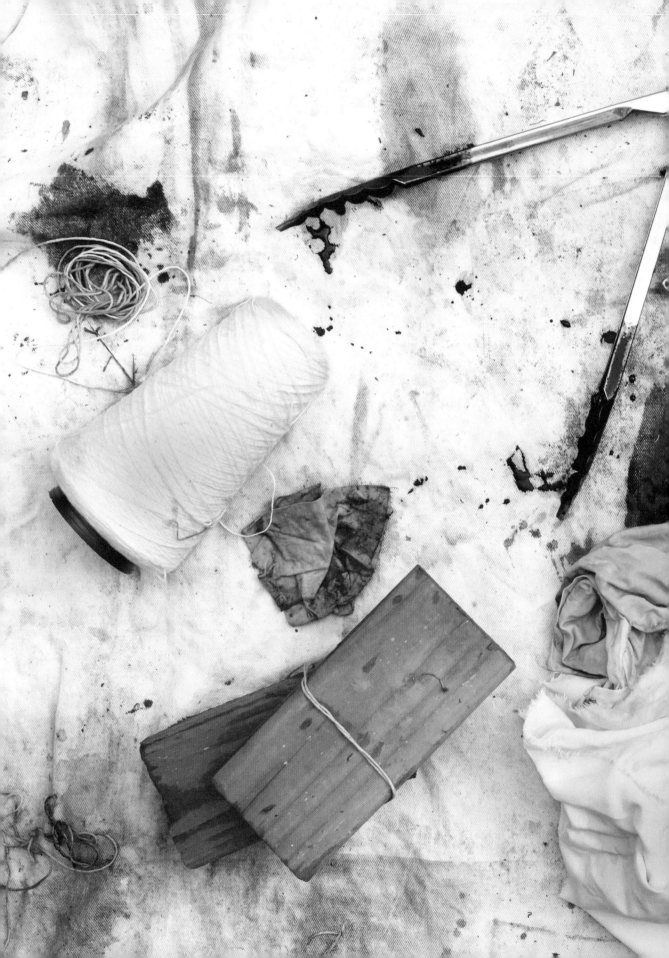

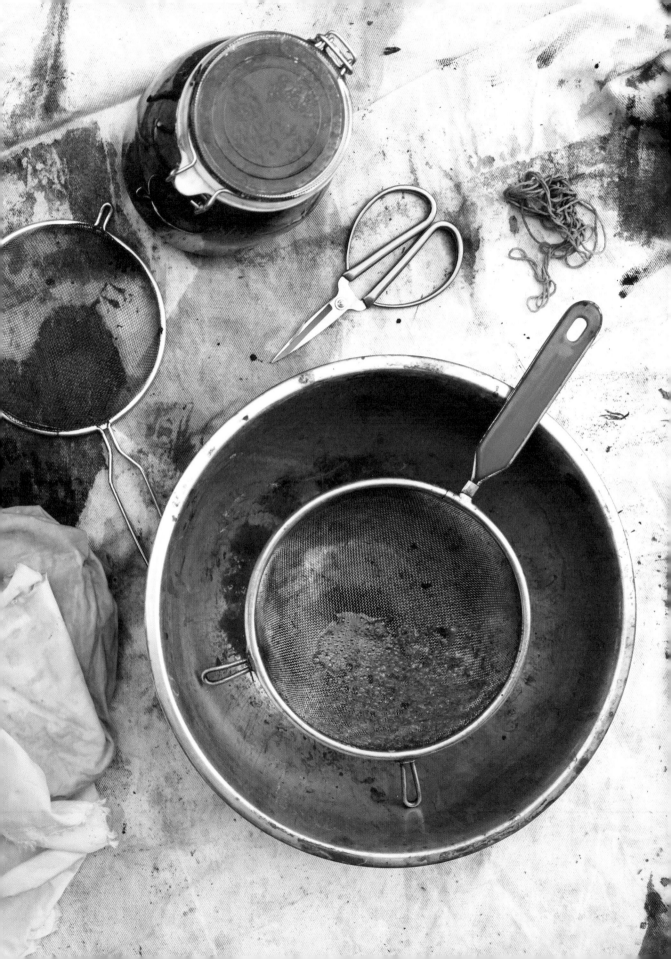

DYEING WITH
fresh indigo

I love working with the very simple recipe of fresh green Japanese indigo leaves and water. It's as easy as making a pesto with the fresh-picked leaves from your garden. This method makes shades of brilliant turquoise colors on silk. This recipe is so easy that I use it with my small children, and they can easily do the dyeing on their own, as no heat and no additional chemicals are required to get this brilliant turquoise. Because this method does not reduce the indigo pigment from the chlorophyll without further reduction agents, turquoise and medium blue is as bright and dark as it will get. But the color is well worth it—so little effort to achieve such a strikingly vital turquoise, one you can't make in any other way.

8 ounces silk fabric

1 pound fresh green Japanese indigo leave

pH-neutral soap

EQUIPMENT
Blender

Medium stainless steel or nonreactive bowl

Scour your silk fabric (see page 36).

Using a blender, blend the leaves along with ½ cup of water until it creates a pesto. Add the pesto mixture to a medium pot filled three-quarters with water. Stir to combine.

Submerge the fabric into the water and move around to ensure even dyeing approximately 3 minutes. Pull the fabric out and let the indigo oxidize in the air for another 3 minutes. You'll see the fabric begin to get brighter blue or turquoise. Keep submerging the fabric with additional dips until it reaches the desired color saturation (usually takes 2 or 3 dips).

The leaf pesto may stick to your fabric, so once you have completed your last dip in the dye bath, rinse the fabric carefully to remove any debris. Rinse your fabric with pH-neutral soap and hang to dry out of direct sunlight.

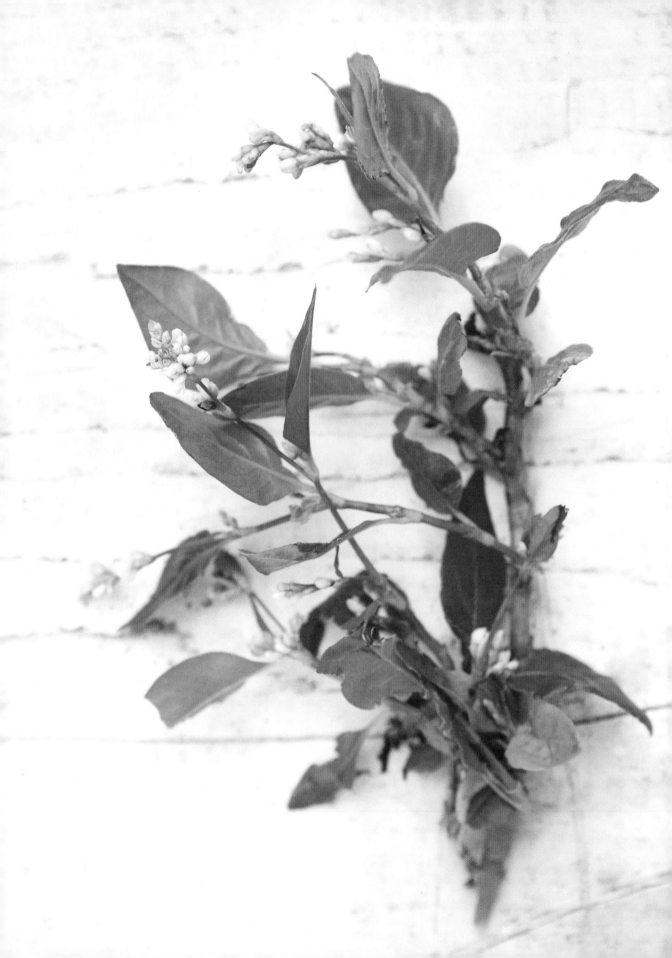

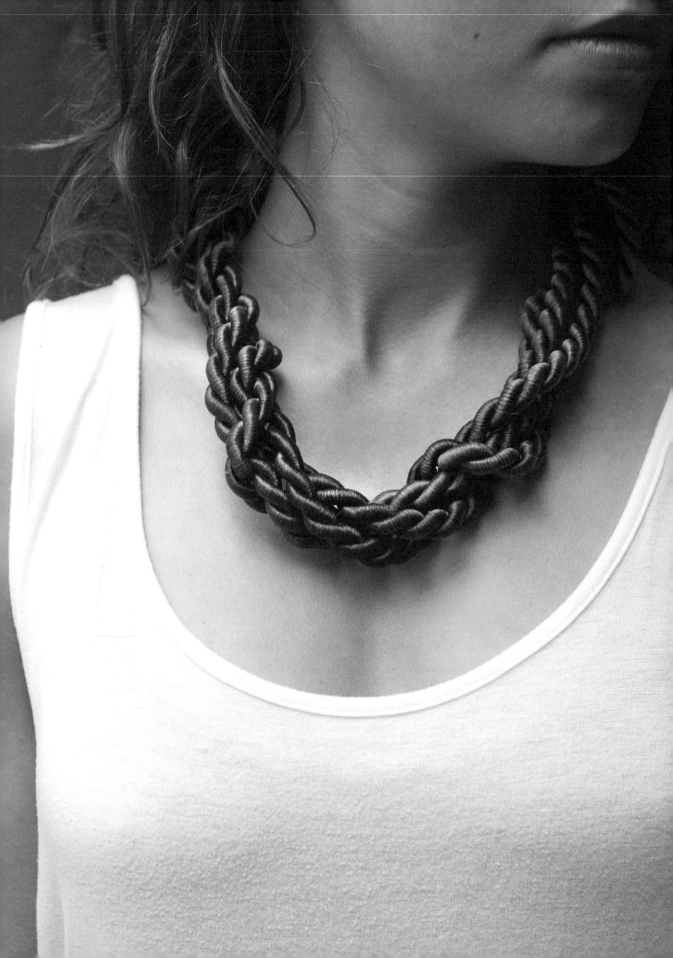

eucalyptus bark

NECKLACE

There are more than seven hundred types of eucalyptus, and only fifteen of them occur outside of Australia. For those who live close to long-established imported eucalyptus, as we do in California, the bark is easily collectible; many eucalyptus trees shed their bark naturally and in large quantities.

All parts of the eucalyptus tree can be used to make lightfast and washfast dyes that work well on all fibers. Potential colors range from yellow and orange through green, tan, chocolate, and deep rusty red. The material remaining after processing the eucalyptus can also be used safely as a mulch or garden fertilizer.

Certain varieties of eucalyptus leaves are known for making brilliant shades of coral, orange, and deep reds, but I have also come to deeply appreciate the eucalyptus tree's abundant and beautiful bark for an easy, no-fail way of creating natural blacks. The black dyes used in synthetic dye production are often very toxic and at the same time difficult to stabilize, so being able to make black easily and readily from a safer, organic source is a gift.

Eucalyptus bark carries lots of potent tannins that help the dye bind to both plant-based and animal-based fibers. With iron added, the eucalyptus bark dye goes from caramel to inky gray, blue, and black.

This recipe is for blacks and silvery dark grays on rayon rope to make a twisted rope necklace.

NECKLACE

8 ounces eucalyptus
bark, shredded into
2 to 3-inch pieces

1 yard rayon rope
(8 ounces)

pH-neutral soap

1 teaspoon iron powder

EQUIPMENT
Heat- and water-
resistant gloves

Dust mask

Small stainless steel
pot with lid

Stirrer

Strainer

Clean and soak your eucalyptus bark to remove any dirt
or other residue from foraging.

Wash your rayon rope with pH-neutral soap and then soak
in lukewarm water (scouring isn't necessary).

Fill a small stainless steel pot two-thirds full of water, add
your cleaned and shredded eucalyptus, and bring to a low boil.
Lower the heat and gently simmer the bark for 30 minutes to
1 hour until the dye liquid is a rich caramel brown.

Wearing a dust mask, stir in the iron powder. Your caramel
eucalyptus bark dye bath will now be inky black. Strain the
eucalyptus bark out of the dye bath and set the liquid back
on low heat and add the lid.

Twist and wrap your rope into a necklace of desired length
and then add it to the dye bath.

Gently simmer your rope necklace for at least 20 minutes.
When the desired color is obtained, remove the material
or, for a darker color, turn off the heat and let it steep in
the dye bath overnight.

Rinse your necklace with pH-neutral soap. Hang it to dry
out of direct sunlight.

Your eucalyptus bark necklace is ready to wear!

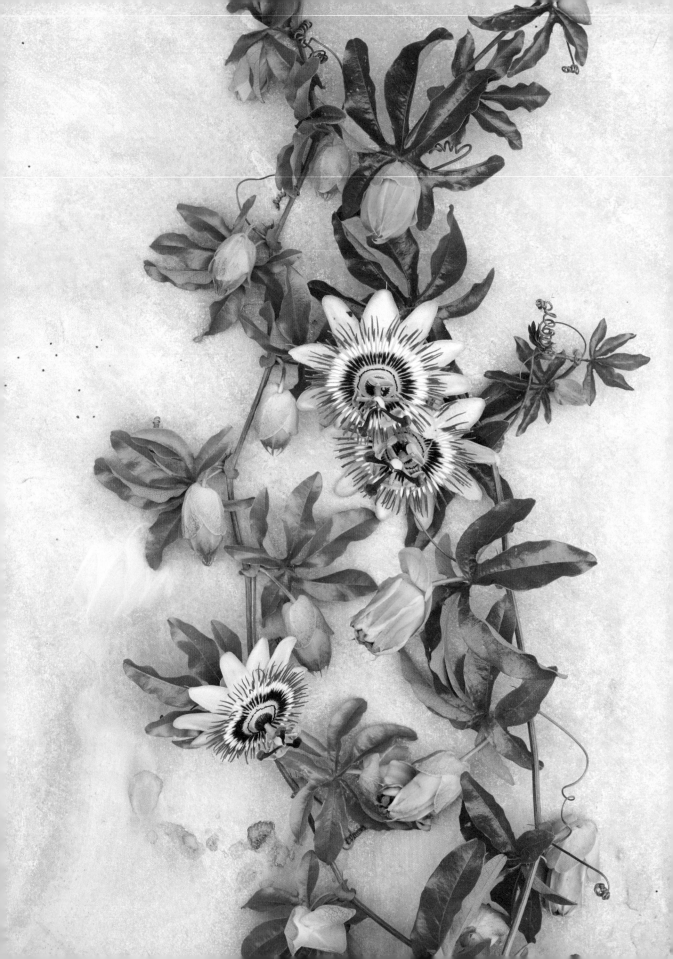

DYEING WITH

passionflower

LEAVES AND VINES

Passionflower (*Passiflora edulis*) vines can grow quickly, making them an excellent candidate for an easy natural color source. Depending on the variety, the plant also produces a yellow, pulpy, delicious fruit (one of my favorite juices!). Native to the Americas, the Cherokee people used the fruit, flowers, and leaves as food. In the nineteenth century, the dried leaves and stems were widely used to treat insomnia and anxiety. Passionflower is still a popular herbal remedy today. The exquisite purple flowers are also one of my favorites, especially for their exquisite color and pattern inspiration. The colors passionflower leaves and vines produce range from golden yellow to earthy greens.

4 ounces passionflower leaves and vines, chopped into 1-inch pieces

4 ounces silk or wool fiber

1½ teaspoons aluminum sulfate

1½ teaspoons cream of tartar (optional)

pH-neutral soap

EQUIPMENT
Heat- and water-resistant gloves

Medium stainless steel pot with lid

Scour your fiber and premordant with aluminum sulfate and cream of tartar (see page 212).

Place the chopped passionflower vine and leaves in a medium pot full of enough water to cover the fiber. Bring the water to a simmer, and simmer for 20 minutes. Turn off the heat and let the dye bath steep.

Scour your fiber (see page 36), then add it to the dye pot and bring it back up to a simmer. Simmer for 15 to 20 minutes. For more saturated color, turn off the heat and let your fiber steep overnight.

Remove the fiber from the dye bath.

Gently wash with pH-neutral soap, rinse thoroughly, and hang it to dry out of direct sunlight.

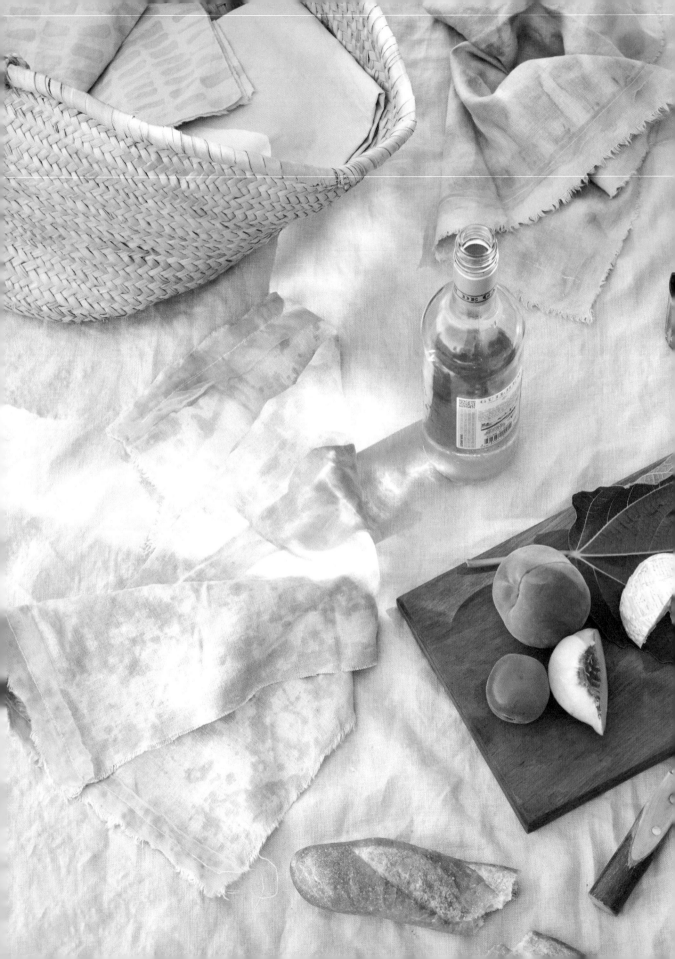

loquat leaf

PICNIC BLANKET AND NAPKINS

Glossy, bright green loquat leaves (*Eriobotrya japonica*) make beautiful coral pinks and reds without an additional mordant; with iron added as a modifier, they make stormy dark purples, grays, and even blacks. Loquat trees are evergreen and produce leaves throughout the year; the leaves are used as a medicinal tea in many parts of Asia. The small yellow fruits are fleshy and sweet (much like a kumquat), with beautiful round, shiny brown seeds—another great reason to plant a loquat tree in your own yard. Loquats grow prolifically throughout the San Francisco Bay Area where I live. Although the trees are evergreen, the leaves do change color dramatically and fall to the ground, not only in autumn; capturing the leaves in different states has been an interesting experiment in achieving a range of shades.

One of my favorite colors emerged from an experiment with fallen loquat leaves that had turned yellow—the dye color they made was a fluorescent peach. Several years later, the dyed hue remains just as bright and mesmerizing.

This loquat-dyed blanket also makes a beautiful summer seaside tent to shelter early dinners outside.

PICNIC BLANKET AND NAPKINS

2¼ yards clean
100-percent undyed
natural linen fabric
(1 pound)

20 fresh loquat leaves,
washed and chopped
(8 ounces)

¼ teaspoon iron powder

1 tablespoon lemon juice

pH-neutral soap

EQUIPMENT
Heat- and water-
resistant gloves

Large stainless
steel pot with lid

Stainless steel tongs

Dust mask

Cut 2 yards of the linen and set aside for the blanket. Cut the remaining piece in half for the napkins.

Scour your linen fabrics (see page 36), then let them soak overnight.

Fill a large stainless steel pot with enough water to cover the fabric and let the material move in the pot.

Add chopped loquat leaves and bring to a boil. Lower the heat to a simmer, and then simmer until the leaves turn the water a deep pink or red.

Once the dye has steeped, strain the leaves and discard or compost. Gently squeeze excess water from your soaked fabrics, then immerse in the dye bath. Let your fabric simmer on low in the dye bath for at least 20 to 40 minutes or turn off the heat and let sit overnight; the longer the fabric soaks, the more vibrant the pinks, peaches, and reds.

When the fabrics reach your desired shades, remove them from the dye pot with stainless steel tongs. Rinse in pH-neutral soap. Hang to dry out of direct sunlight.

MAKING LOQUAT NAPKINS

Once your loquat leaf-dyed napkins have fully dried, gently fray their edges by hand for a raw, natural look or hem.

To pattern and modify the colors, mix the iron powder with ½ cup hot water and, in another container, the lemon juice with ½ cup hot water to fully dissolve.

Wearing a dust mask, sprinkle the iron solution onto the napkins; a random pattern of dark gray and purple spots will emerge.

Now do the same with the lemon solution. This will create a bleaching effect as the acidic component of the lemon bleaches out the iron and creates a depth of acid wash. Let the napkins fully dry, and then rinse in pH-neutral soap and dry again.

hibiscus

SUMMER HAT

I have always had an affinity for hibiscus flowers. In the 1940s, my grandmother was a postcard model for a the McKee Jungle Garden in Vero Beach, Florida, and I have always adored a particular image of her seated by a lush botanical garden pond surrounded by multicolored hibiscus flowers.

Hibiscus has many uses as an ornamental, culinary, and dye plant. You can pick dark red and deep pink flowers or collect fallen ones for fresh color. Dried hibiscus can also easily be found in the bulk food and spice section of your local natural grocery store. The flower creates saturated shades from fuchsia and purple to steel blues and grays.

Red and dark pink hibiscus flowers work especially well when used as a dye on natural straw and raffia, making them a perfect way to infuse into this summer wardrobe staple. Uncoated natural straw and paper-straw hats work best for this project. You can soak the hat first in water to ready it for dyeing and premordant the hat with aluminum sulfate, tannic acid, and iron. You can also add your mordant directly to the dye bath to dip dye your hat. Depending on how much sun exposure your straw hat receives, you may want to periodically redip your hibiscus hat in color each season—and make a hibiscus-infused iced tea to enjoy in the summer shade at the same time!

SUMMER HAT

Natural light-colored, un-coated straw or raffia hat (4 ounces)

pH-neutral soap

¼ cup dried or fresh dark red, purple, deep pink, or red hibiscus flowers

1½ teaspoon aluminum sulfate

1 teaspoon soda ash

EQUIPMENT
Heat- and water-resistant gloves

Small stainless steel pot with lid

Medium to large stainless steel bowl or nonreactive vessel (plastic or glass bowl or bin)

Stainless steel stainer

Stirrer

Rinse your straw hat with pH-neutral soap and leave to soak until your dye bath is ready (scouring isn't necessary).

Add the hibiscus flowers to a small stainless steel pot filled halfway with water. Bring water to a boil and lower the heat to a low simmer. Simmer the hibiscus flowers for 20 to 30 minutes to extract the strongest color. Turn off heat and let steep until dye bath has cooled.

Depending on your desired design, pour cooled hibiscus dye liquid into a stainless steel bowl wide enough to allow for full immersion of the hat or to dip just the top while the brim is balanced on the rim of the bowl.

Add the aluminum sulfate to your dye bath (alum brightens the fuschia color), and then dip-dye the top of your straw hat in the liquid (for more on dip-dyeing, see page 240). Turn off the heat. Let the top of your hat soak for at least 20 to 40 minutes, or even leave it overnight for more saturated color. Remove the hat and, still holding it upside down, rinse with pH-neutral soap and water. Let the hat drip-dry.

Once the top of your hat has dried, its time to dip-dye the brim. Carefully tuck the edges of your hat back into the dye—off heat is okay—and let your hat steep for at least 20 to 40 minutes. Removing your hat from the dye and setting it aside (no need to rinse yet as your hat is going right back into the dye bath), add the soda ash to your dye bath. This will give a darker edge (blues, blacks, and dark greens) to your hat. Mix the soda ash into your solution. Now dip-dye the brim of your hat for an additional color change. When it is the desired shade, rinse your hat in temperate water with pH-neutral soap and air-dry out of direct sunlight.

THE SPECTRUM
OF NATURAL
COLOR

A plant-based palette can make incredibly varied and uncommon colors, and naturally derived colors are often more vibrationally attractive and soothing to the human eye than synthetic hues. Natural dyes also have an advantage in that you can easily shift natural dye shades from a single plant with a mordant or a pH modifier. This means that many hues can be made from one plant and with one dye bath.

There is no better way to learn about the true depth of color than to work with plant-based sources and to experiment with their interactions and the depth of a single plant source throughout the year. Working with natural dyes has significantly shifted and sharpened my sense of color. I now have an immense appreciation for all plant-derived colors, particularly the complex, layered, and utterly unique hues I never dreamed of.

Natural color can also shift in different lights, creating a dynamism unparalleled in the flat, synthetic color spectrum. This quality allows colors that you would expect to clash to instead harmonize, no matter what the hue, because the color is ever evolving. In fact, natural dyes contain not only the intended color but also its opposite, creating a complexity that can rarely be duplicated synthetically. An earthy red made from a pinecone, for instance, may contain hints of cool green tones, depending on the light.

As I've grown as a plant dyer and come to appreciate the vast array of shades both shockingly bright and sophisticatedly subdued, I have become a fan of both the natural neons and the natural neutrals that plant palettes provide—most specifically, plant-based grays. Many plants that contain tannic acid can be shifted to gray very easily with iron as a modifier. Plant-based grays hold shades from reds to yellows to blues and everything in between.

Color theory contends that colors evoke a physiological response. Plant-based colors can be both calming and intriguing, vital and soothing. Expanding the biodiversity of our daily color palettes by moving from synthetic to natural hues may also have evolutionary benefits. Just as the expansion of our taste, touch, and sense of smell can be beneficial for growth and intelligence, the expansion of our color palette allows us to feel more connected to our environment and thus more resilient, to feel more meaning and pleasure—in essence, to be truly and actively alive. It helps us be truly engaged in all that we can see and sense.

COLOR COORDINATED

The process of reviving plant dye recipes is not always straightforward, but it is exciting and can lead to many moments of awe and discovery. Each natural dye has its own particular chemistry, so the typical approach to overdyeing or mixing color with synthetics does not necessarily apply. For instance, a yellow made from oxalis and a blue from indigo will not produce a true green because oxalis is pH-sensitive and turns orange in an alkaline environment, and indigo needs an alkaline solution to work as a colorant.

Today plant dyers are not only discovering long-forgotten recipes for natural colors from singular sources of plants in general, but also trying new combinations of plant dyes to create colors that may never have been created before. As we reawaken this knowlege of useful plants for edible, medicinal, and dyeing purposes, we have also gained greater access to a wider array of plants than ever before. We are still very much at the beginning of a whole new era for natural colors: learning their color potentials, their full range of palettes, the way they combine with each other, and their contemporary applications.

THE SEASONAL COLOR WHEEL

A few years ago, through my ongoing work with Permacouture, I was inspired to create the Seasonal Color Wheel to organize local plants into a visual calendar of the colors that seasonally available plants in the Bay Area can make and generally when to harvest them. This tool not only gave me an at-a-glance sampling of the wide range of natural color from common sources, but also a guide to achieving the full color potential of the plants through the addition of mordants and modifiers.

Plant palettes can also tell us incredible tales of how their colors came to be. There are emblematic botanical color stories in every culture. Telling the various stories of where your plant colors come from—be they the colors made from the by-products of a midsummer's eve dinner, those from your favorite floral bouquet, weeds from your garden on a Sunday afternoon in spring, or fallen branches after a stormy walk in the woods—is an inspiring process, and the color stories may lend themselves to interesting palettes for a fashion collection, a color theme for home decorating, or one for a series of paintings.

I've started making color wheels for other cities and regions around the world. On the opposite page you can find the one for the San Francisco Bay Area.

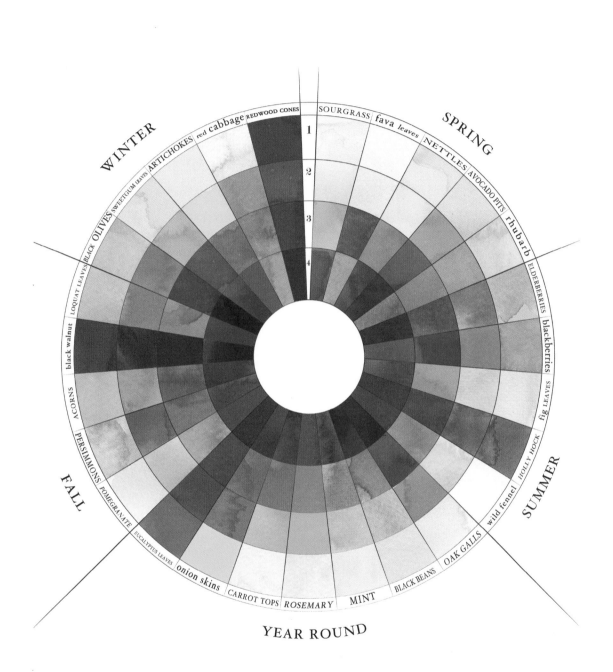

WINTER

SPRING

FALL

SUMMER

YEAR ROUND

REDWOOD CONES
red cabbage
ARTICHOKES
SWEETGUM LEAVES
BLACK OLIVES
LOQUAT LEAVES
black walnut
ACORNS
PERSIMMONS
POMEGRANATE
EUCALYPTUS LEAVES
onion skins
CARROT TOPS
ROSEMARY
MINT
BLACK BEANS
OAK GALLS
wild fennel
HOLLY HOCK
fig LEAVES
blackberries
ELDERBERRIES
rhubarb
AVOCADO PITS
NETTLES
fava leaves
SOURGRASS

1
2
3
4

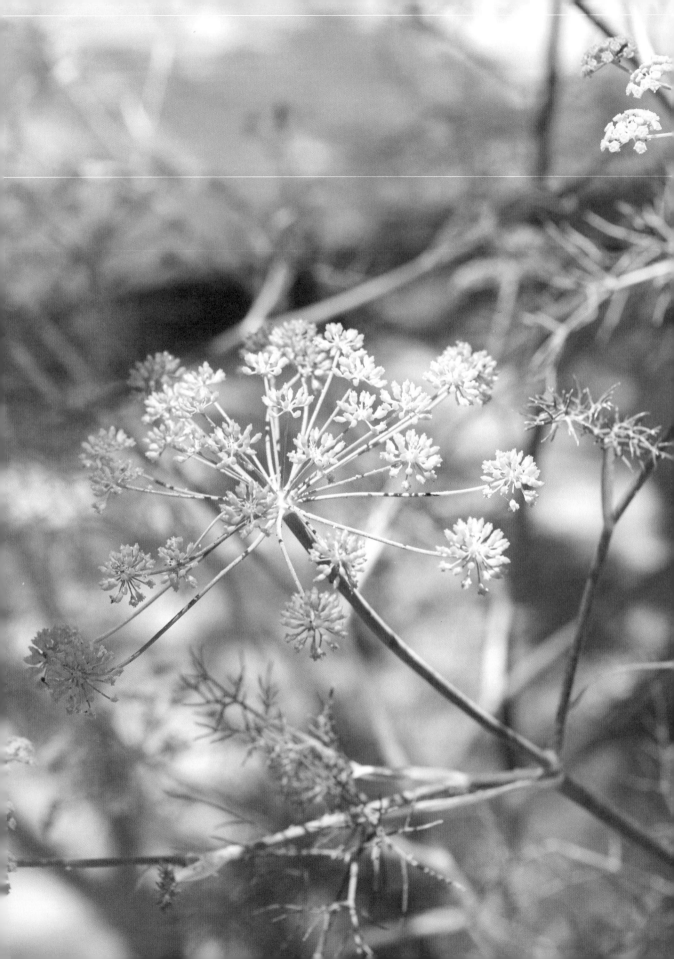

DYEING WITH

wild fennel

Wild fennel (*Foeniculum vulgare*) grows in abundance in the summer in the San Francisco Bay Area where I live. Fennel is an excellent natural dye source for creating shades of bright yellows and greens; it creates a gorgeous yellow-green on wool and silk fiber with an alum premordant, and with an iron modifier, it yields a deep forest green.

4 ounces silk
or wool fabric

1½ teaspoons
aluminum sulfate

1½ teaspoons cream of
tartar (optional)

4 ounces bright yellow
wild fennel flowers
and leaves

4 ounces wild fennel
stems, chopped into
1-inch pieces

pH-neutral soap

EQUIPMENT
Heat- and water-
resistant gloves

Medium stainless steel
pot with lid

Strainer

Scour you fabric (see page 36), and premordant with aluminum sulfate and cream of tartar, if using (see page 212).

Place the chopped fennel in a pot full of enough water to cover the fiber. Bring the water to a simmer and simmer for 20 minutes. Turn off the heat and let the plant material steep in the dye bath overnight, if desired, or simply strain out immediately.

Add the premordanted fiber to the dye pot and bring it back up to a simmer. Simmer for 15 to 20 minutes. For more saturated color, let the fiber steep overnight.

Remove the fiber from the dye bath. Gently wash it with pH-neutral soap, rinse thoroughly, and hang to dry out of direct sunlight.

DYEING WITH

weld

Weld (*Reseda luteola*) is an ancient primary source of a very lightfast and washfast yellow. It is easy to grow in your backyard and grows quickly but is noninvasive. In the summer, fresh weld flowers attract bees and butterflies to your garden (for more on weld, see page 92).

For this recipe, I use fresh weld flowers, leaves, and seeds, harvested when the weld reaches its peak in midsummer. The color is most concentrated in the flowers, leaves, and seeds. The brightness of yellow color from the fresh weld will depend on the soil it was grown in, your water, and even the plant itself. Weld tends to bloom more fully in an alkaline environment; if you do not get the bright, clear yellow you would like, it can help to add a teaspoon of chalk to the dye bath. Weld makes a bright, pure yellow on all fibers, and overdyed with indigo, it makes a true kelly green.

4 ounces silk or wool fabric

1½ teaspoons alum

1½ teaspoons cream of tartar (optional)

4 ounces fresh weld flowers, seeds, and leaves, chopped into 1-inch pieces

1 teaspoon of chalk (calcium carbonate) (optional)

pH-neutral soap

EQUIPMENT
Heat- and water-resistant gloves

Medium stainless steel pot with lid

Strainer

Scour your fiber (see page 36) and premordant with aluminum sulfate and cream of tartar, if using (see page 212).

Add the weld to a medium stainless steel pot two-thirds full of water. Bring to a boil and then simmer on low for at least 1 hour and up to 2 hours. Keep the simmer low as excessive heat can dull the colors.

Use a strainer to scoop out the plant material.

Add the fabric and simmer on low for 20 to 40 minutes, until your desired shade has been reached. Or take the dye off the heat, let the dye bath cool, add the fabric, and then let it steep for several hours.

Remove the fabric from the dye bath and rinse with pH-neutral soap. Hang it to dry out of direct sunlight.

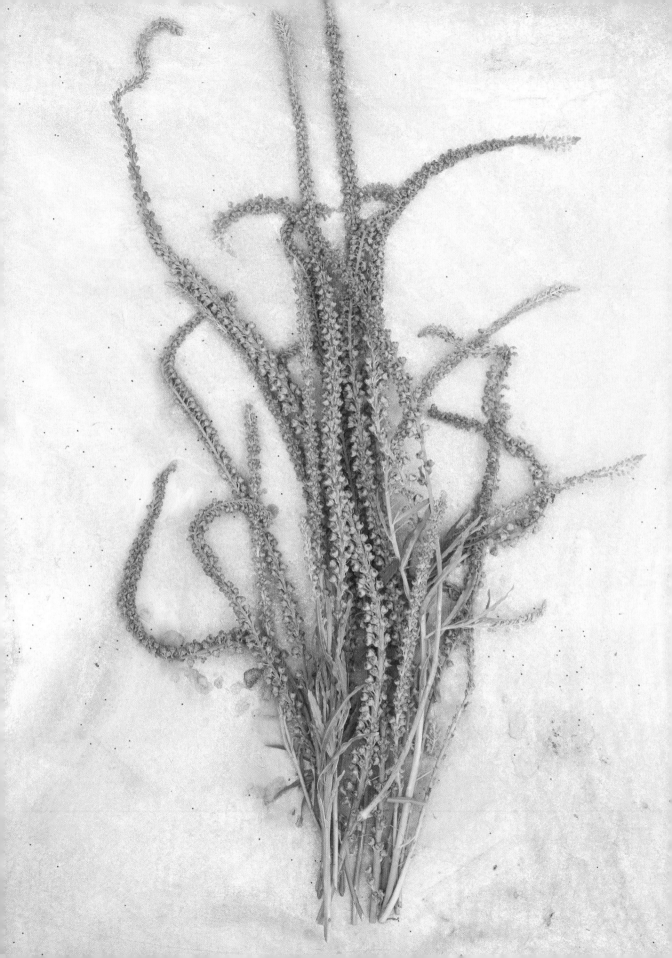

FALL

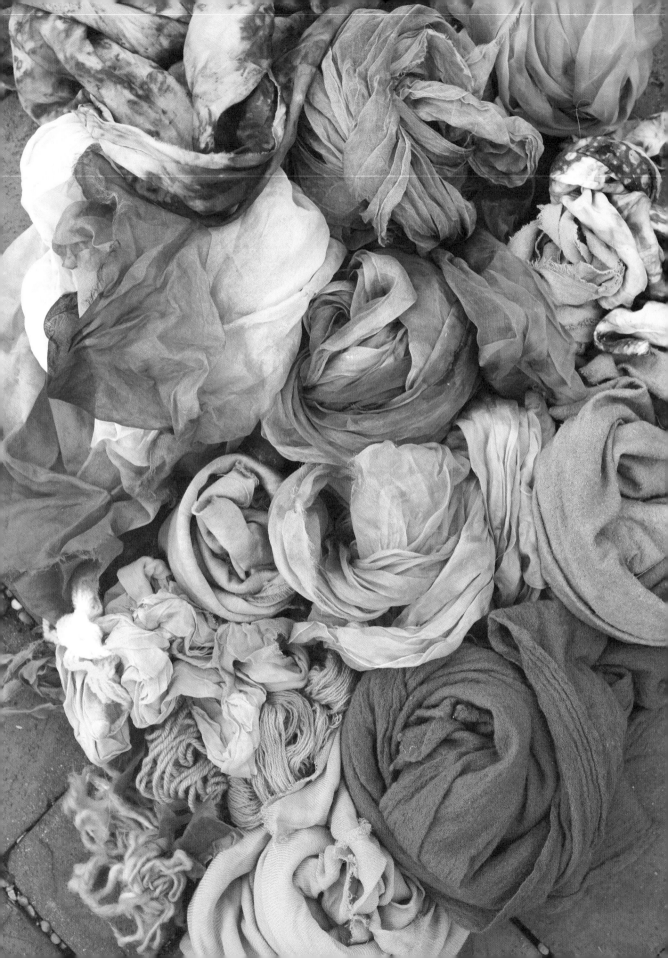

THE FALL PALETTE

ONION SKINS · BLACK BEANS · SUNFLOWER SEEDS · PERSIMMON
· ROSEMARY · BLACK WALNUT · MADDER ROOT

Many fallen leaves in autumn, as well as husks, nuts, and roots, can be collected and used to make vibrant natural dye palettes. As you put away your summer clothes and bring out your fall and winter wear, the time is ripe for autumn color projects. This is a great time to reap a full fall harvest of dye plants or color by-products from your garden.

Fall brings many vibrant hues for natural dyes: the deep reds of freshly harvested madder roots and the rich oranges from onion skins as well as the outer casings of root vegetables; peach, green, gold, and black, from fallen fall leaves; and perfect burnt umbers from foraged walnut hulls. Hopi black sunflower seeds produce deep, rich purples and blacks—and saving your seeds allows you to plan for next year's dye garden and to share seeds with your family, friends, and community.

Fall is also the time for digging up roots for drying and storing before the ground freezes, and this also applies to some important dye plants in the garden. Madder root can take several years to reach harvest size, so when you finally do dig it up, it is a small miracle of earthy hues.

Working with local wool is a great way to begin your fall dye practice. There's something incomparably satisfying about finding regional wool and fiber from heirloom sheep, alpaca, and even Angora rabbits to use as a canvas for seasonal fall color. Many small farms take part in harvest festivals, and by buying fiber from the farmers who grow it, you're supporting the local fiber and dye economy. Those in city environments can also seek out these fibers at urban farmer's markets.

Making natural color is always a gratifying way to bring the outside in—as you make hues from your autumn harvest, you can fully savor the color and taste palette of fall and the joy of gathering family and friends together.

FALL
DYE PLANTS

GREEN PERSIMMONS

YELLOW ONION
SKINS

LICHEN

BLACK BEANS

HOPI BLACK
SUNFLOWER
SEEDS

MADDER ROOT

BLACK WALNUT
HULLS

ROSEMARY

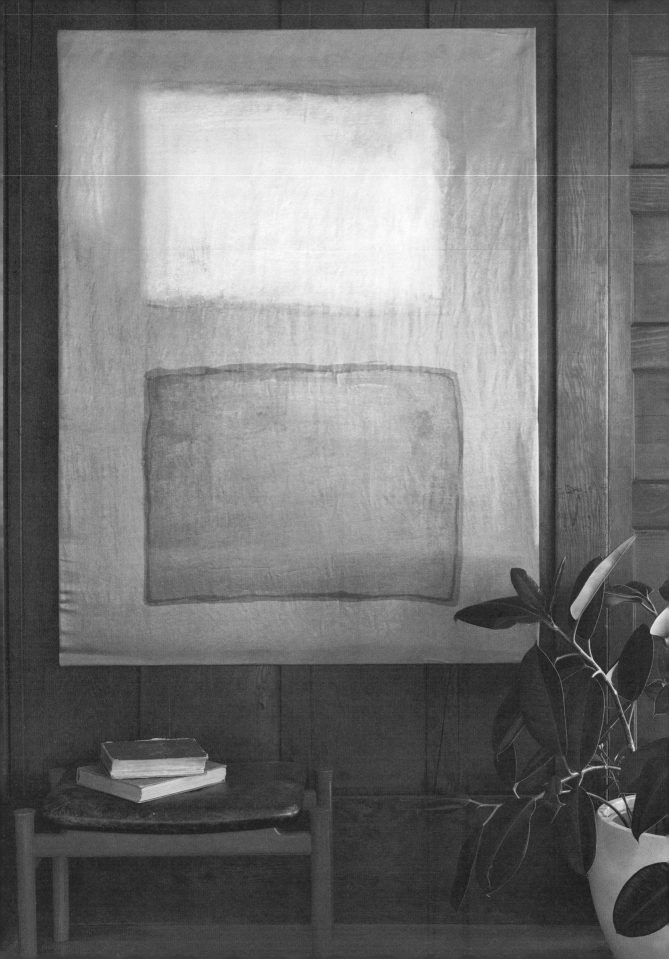

ROTHKO-INSPIRED CANVAS

Onion skins are one of the most wondrous "compost" colors. Their beauty lies in how easily accessible they are and how often they are overlooked as waste in grocery stores, restaurants, and even your own kitchen. Onion skins, both yellow and red, contain the potential of deep saturated oranges, golds, ochre, and dark green. With a concentrated dye bath and enough time for the fibers to steep in the dye, these earthy hues truly glow.

Collect yellow onion skins from your local grocery store's onion bins; grocers are usually happy to hand you the sloughed-off paper skins, but it's always good to check first. Farms, farmer's markets, and restaurants are also great places to gather in bulk.

The saturated tones of yellow onion skins lend themselves to experimentation with the depth of color you can achieve with a simple mordant and pH changes. This project is a combination of dyeing and painting with mordant and modifying guar gum pastes to create extrasaturated and layered painterly color effects—creating a natural onion skin-dyed Rothko-inspired painting. I chose to used hemp-silk as a canvas. The silk helps you achieve glowing golden saturated tones, and the hemp is both strong and UV resistant, ensuring your canvas doesn't fade.

ROTHKO INSPIRED CANVAS

2 yards hemp-silk fabric,
54 inches wide
(about 2 pounds)

1 tablespoon
aluminum sulfate

4 tablespoons
guar gum powder

1 teaspoon iron powder

2 pounds yellow onion
skins (more skins will yield
more saturated color)

pH-neutral soap

EQUIPMENT
Heat- and water-
resistant gloves

Dust mask

Large stainless steel
pot with lid

2 small stainless steel
bowls or Mason jars
for mixing pastes

Cotton canvas drop cloth

T-pins for stretching fabric

2 large housepainting
brushes

Stainless steel strainer

Heavy-duty wood
stretcher bars large
enough for finished
canvas and crossbeams

Staple gun

Spray bottle

Hammer (optional)

Scour your hemp-silk fabric (see page 36) and allow to dry completely.

Wearing a dust mask, make 1 cup of Alum Mordant Paste and 1 cup of Iron Mordant Paste (see page 248) and set aside.

Remove your scoured hemp-silk fabric and let it dry completely before painting mordant pastes.

Add the onion skins to a large stainless steel pot two-thirds full of water, and bring to a low boil. Continue to simmer for 40 to 60 minutes. Then turn off heat and let your onion skin dye steep overnight.

Lay your clean cotton drop cloth onto a large flat surface. Stretch your hemp/silk fabric and pin it (with T-pins) to the canvas drop cloth to hold your fabric in place while you paint your alum and iron squares.

Using your prepared alum and iron mordant pastes, paint two large squares in the center of your hemp-silk fabric— one square with the alum paste and one with the iron paste. You can trace large pieces of wood, as I did, or eyeball it for a more painterly effect. You won't see much of the alum paste after it dries as it will be clear, so be careful in this process to keep the pastes separate with different brushes to be painted only in their designated zones. Let your hemp-silk fabric completely dry while still laid out flat.

When your fabric pastes have completely dried, strain the onion skins from your dye bath and put your onion skin dye back on the heat.

Take the fabric off the drop cloth and add it to the dye liquid and simmer on low heat for at least 40 minutes. Turn off the heat and let your canvas steep. The longer it steeps, the stronger the color you will get.

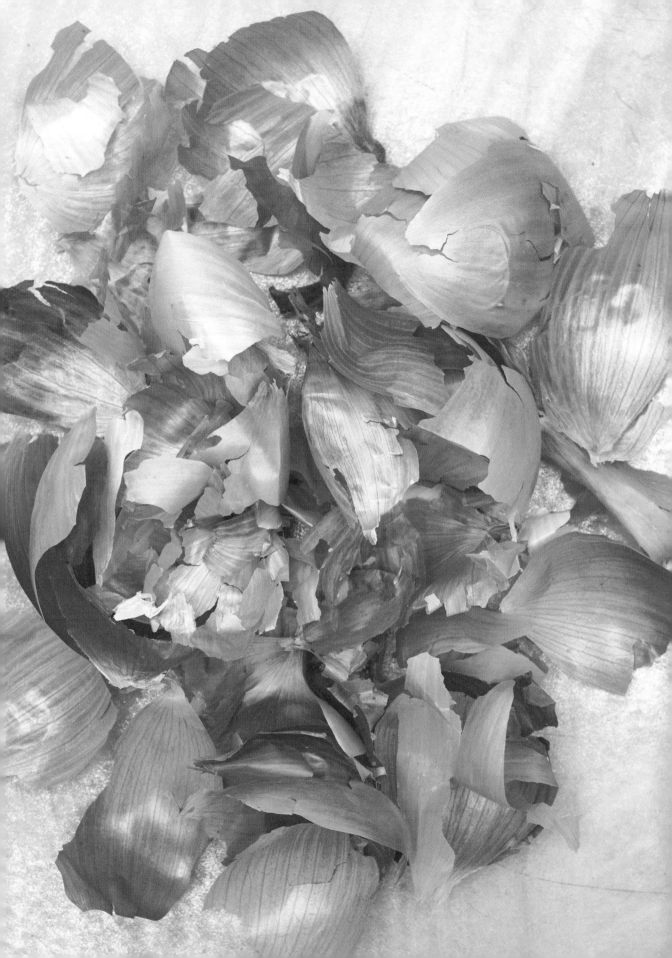

When your fabric has reached its desired shades, rinse it gently in pH-neutral soap and hang it to dry out of direct sunlight.

STRETCHING FABRIC ONTO A FRAME

Stretcher bars are wooden bars that create the frame onto which the cotton or linen canvas is stretched. These wooden bars can be easily bought from your local art store and come with grooves that will fit squarely into each other. For this large painting, buy heavy-duty stretcher bars. Also purchase supporting crossbeams to provide extra support so that your canvas won't twist and warp.

Join your 4 stretcher bars to each other snugly.

Lay your frame onto one of your canvases and trim around the frame so that you have several extra inches to work with beyond your frame on each side. (Making a clean cut and then tearing your canvas will create a straighter line than cutting it will.)

Center your frame on the back of your canvas. Take a minute to smooth your canvas as much as possible before you begin stapling. Make sure that the grain of your hemp-silk canvas fabric is aligned with the stretcher bars.

Beginning with the longest side, fold your fabric over the frame and staple it down in the center. Now repeat on the opposite parallel long side—pulling and straightening as you go.

Using a spray bottle filled with plain water, spray the back of your canvas—this will allow the canvas to shrink further as it drys, creating a tighter stretch.

Rotate to the shorter sides of the canvas and staple, pulling and straightening the fabric as you go.

Using equal tension, go to the corners of your frame and fold and staple your fabric rotating on opposite sides.

Finish stapling by going around each side of the whole frame and making sure that your staples are firmly pressed into the wood—you can even use a hammer for this part. As your canvas for this project will be a large one, you may need additional back-beam support to keep your painting as square as possible on the wall. Crossbeams should be the same length as your stretcher bars and can be bought to fit.

When you have finished stretching your canvas, stand back and admire your Rothko-inspired masterpiece.

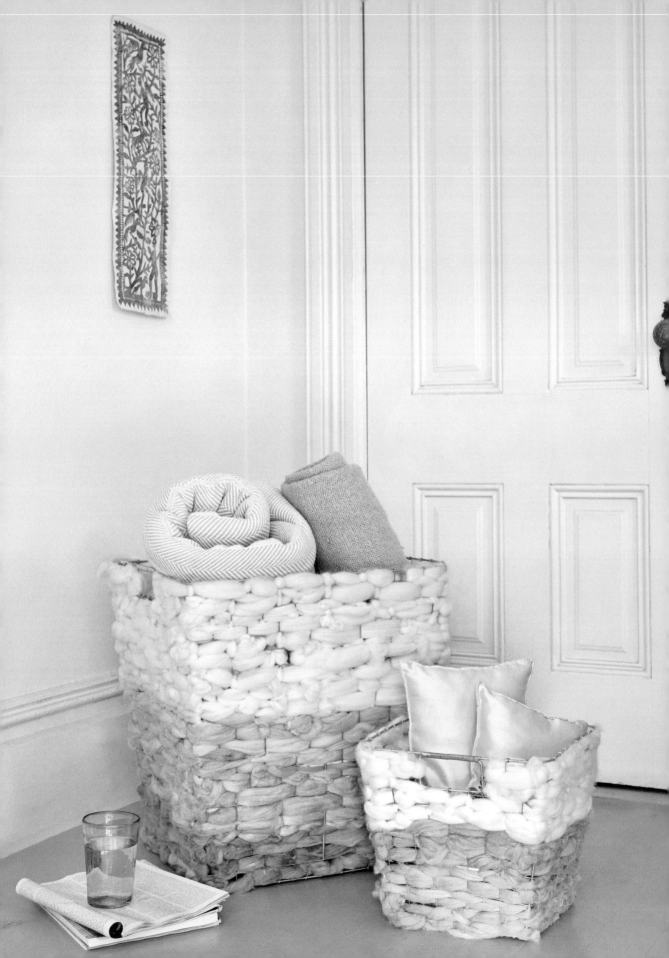

black bean

WOOL AND WIRE BASKETS

Beans are herbaceous annual plants grown on every continent except Antarctica. When you drain your dried black beans after soaking them overnight for cooking, you can use this rich and dark natural dye to color some beautiful local wool.

The water left after soaking dried black beans is a fantastic natural colorant, creating hues that range from dark blues and teals to steel grays, pinks, and purple, depending on the mordants used and the pH modifier added to adjust the color range. For this project, I wove dyed wool roving through wire mesh baskets—making for both an easy weaving project and beautiful storage baskets for all your plant-dyed textiles.

I've found that beluga lentils also work well in place of black beans.

WOOL AND WIRE BASKETS

2 pounds wool roving

2½ tablespoons aluminum sulfate

2½ tablespoons cream of tartar (optional)

2 cups leftover water from soaking 2 cups dried black beans

¾ teaspoon iron powder

1 teaspoon soda ash

pH-neutral soap

2 stainless steel wire mesh baskets of varied sizes (such as one 20 by 16 by 20 inches and one 12 by 11 by 10 inches)

EQUIPMENT
Heat- and water-resistant gloves

Large stainless steel pot with lid

Important Note: Dyeing unspun wool must be done carefully at a temperature that gradually rises and gradually cools to avoid matting and felting the soft wool roving.

With clean, prescoured wool roving (make sure you have already purchased scoured roving), premordant 1 pound of the wool with aluminum sulfate and cream of tartar (see page 212), if using.

Add the black bean water to a large stainless steel pot two-thirds full of water.

Add the wool to the bath and raise the temperature gradually. Simmer on low for 20 to 40 minutes. You can turn off the heat and let the wool steep until it reaches room temperature, or even overnight.

Remove the wool and lay it flat to dry out of direct sunlight.

Add the iron powder to a pot of lukewarm water as an after-mordant. Divide the dyed wool into thirds. Add one-third to the after-mordant. The color will turn a darker blue or purple.

Add the soda ash to a pot of lukewarm water as an after-mordant. Add another one-third of the dyed wool. The color will turn a darker blue-green.

Rinse the wool in lukewarm water and pH-neutral soap—do not wring the fiber or agitate it, as the wool will felt. Let the wool dry out of direct sunlight.

When fully dry, weave the three colors of wool roving in and out of the base of the baskets, creating a color change per base of each basket. Add the remaining 1 pound of undyed white wool roving around the basket rims to create a color contrast.

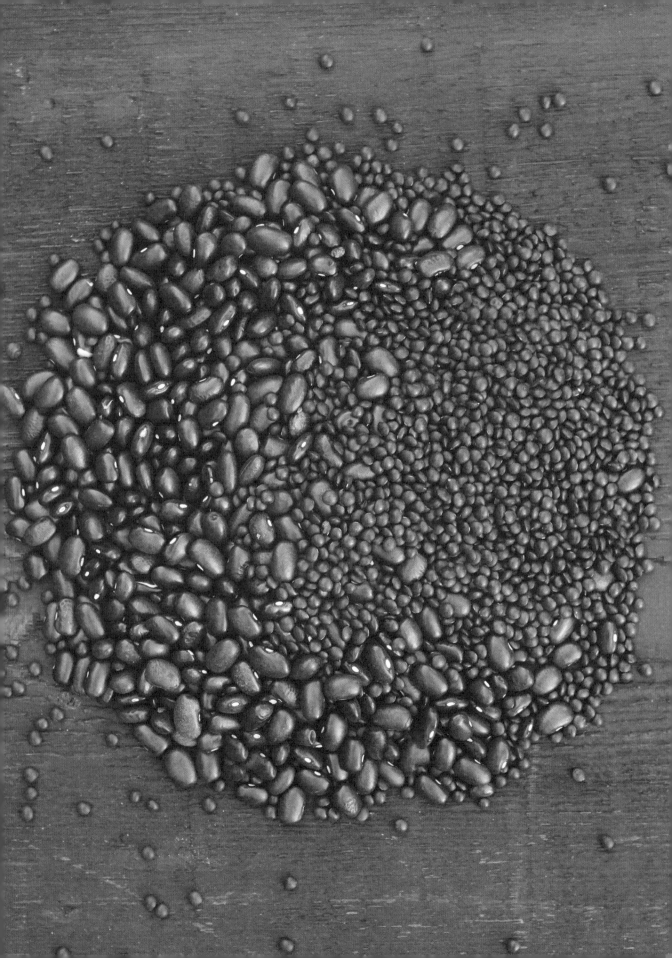

sunflower seed

Hopi black sunflowers (*Helianthus annuus "Hopi Black Dye"*) are an heirloom variety that is easy to grow in your own backyard dye garden. Sunflowers are excellent for attracting pollinators, and the blooms are stunning as an early fall bouquet. All parts of the plant create dye color, but it is the flower's dark purple seeds that produce shades from fuchsia to deep purples, blues, and blacks. You can harvest the seeds of your Hopi black sunflower well into late summer and early fall and then save them all year for your dyeing projects and to plant new sources of dye next spring. The seeds can be used fresh or dried in the dye bath.

When you grow this beautiful variety, make sure you plant your Hopi black sunflowers at least three months before you plan on harvesting their seeds for color.

The saturated jewel tones produced by Hopi black sunflower seeds lend themselves to experiments with the depth of color and pH changes that can occur with mordants and modifiers. For this project, I chose a 4- by 6-foot wool rug to take the dyes as dark as possible. (Before dyeing, you'll need to soak and clean the rug fiber to remove any excess effluents.)

You will want to use the absolute largest pot you can find for this. The largest pot in my studio is approximately 180 quarts. You can of course dye smaller rugs or strategically dip-dye in smaller pots.

You can also create a wide range of beautiful designs by dip-dyeing the edges of your rug in smaller pots. Or make a concentrated dye bath of the seeds and pour it into a galvanized steel or nonreactive plastic bin and let the rug steep in a cool bath. This will result in a less saturated dye color as it will be off heat, but it will still be gorgeous.

WOOL RUG

Wool rug, 4 by 6 feet (about 22 pounds)

pH-neutral soap

3½ cups aluminum sulfate

3½ cups cream of tartar (optional)

Purple seeds from 3 to 5 large Hopi black sunflower heads (10 to 12 inches in diameter)

EQUIPMENT
Heat- and water-resistant gloves

Garden hose

Extra large stainless steel pot (80- to 180-quart capacity) with lid

Low outdoor burner

Dust mask

5-gallon bucket

Large drop cloth

Strainer

Large flat surface for drying or heavy-duty strong railing to hang and drip-dry

Extra large and strong stirrer (heavy-duty long wood stick works great!)

Using a garden hose, rinse your rug with pH-neutral soap to remove any excess dirt and effluents.

Place your pot on a low outdoor burner. Fill the pot two-thirds full with water to allow enough room to submerge (at least partially) your rug.

Wearing a dust mask, add alum and cream of tartar, if using, to the water and stir well to fully dissolve. Fold and add your wool rug and premordant (see page 212). Turn off the heat and let the rug sit in mordant overnight.

Wearing gloves, remove the rug. Dispose of the mordant mixture (see page 212) or save it for another project. (Use the bucket to bail our the mordant mixture). Hang the rug or lean it to dry on a drop cloth and allow to dry while you prepare the dye bath.

Fill the pot two-thirds full of water. Add the sunflower seeds and bring to a simmer. Simmer the seeds for 40 to 60 minutes. Turn off the heat and let steep overnight to extract the darkest color as well as let the dye bath cool before adding the wool rug.

Use a strainer to scoop up the seeds. It is okay to leave a few seeds in and they will be easy to clean off your rug later.

Add your rug to your dye bath. It may not all fit in, so you can choose to leave a portion of the top white to create a further dip-dyed effect. Simmer for 40 to 60 minutes.

Turn off the heat and let the rug steep overnight in the dye while it cools to room temperature.

Rinse the rug with pH-neutral soap and water at a temperature similar to the dye bath from which you're removing it, so as not to shock the fiber.

Lay the rug on a *VERY* strong and sturdy railing, or lean it on a large and strong surface flat to drip dry on a drop cloth out of direct sunlight.

NATURAL
COLOR FROM
PERSIMMON

The most commonly cultivated persimmon tree (*Diospyros kaki*) is native to Japan, China, Burma, and northern India. It is a deciduous tree with wide, stiff leaves and many fruits, which are fibrous, very astringent, and filled with tannins until they are fully ripe, when they become soft and sweet. The green persimmons of early fall are the most astringent and tannic. The heart-shaped Hachiya is the most common variety of astringent persimmon. It is one of 200 known species of persimmons—but there are over 1,000 types of persimmons actually documented.

The fermented juice of a green unripe persimmon produces a color traditionally used in textiles and clothing in many parts of China, Korea, and Japan. Beyond its beautiful color, the juice has been used as a waterproofing agent for textiles, as an insect repellent for wood and fiber, and as an antibacterial. It is also a UV and rain protectant well suited for outdoor use, especially when applied to traditional work clothing. Because of their strong tannin content, persimmons, both green and ripe, also have a long history of use as a mordant.

The Japanese word *kakishibu* can be translated as "persimmon" (kaki) and "tannin" (shibu). The dye made of the fermented juice of wild inedible green persimmons often makes the best kakishibu. Shibu is often equated with the term *wabi-sabi*; although hard to translate exactly, it often refers to the kind of imperfect and unbalanced beauty that speaks for itself.

When the juice is extracted from unripe, astringent persimmons, the color is made as the tannin molecules link together and form a coating. The art of kakishibu from scratch requires great patience as the extracted juice must be aged for at least a year before you can use it, although you can buy kakishibu (from specialty suppliers or even sometimes from Asian markets) that you can use immediately if not making your own fermented brew.

Persimmon is wellsuited for coloring plant-based fibers because of its strong tannic acid, which binds well to cellulose materials. This is a particularly interesting plant dye to work with because, rather than fading, it actually requires sunlight to grow darker in color saturation. It's also a wonderful fall activity to catch the last of the sun before the days start getting shorter, perhaps to create a large all-weather wrap to keep you protected from rain, sun, or cold.

The easiest way to create persimmon dye is to simply grate it, squeeze the pulp, and paint the sticky, tannin-heavy juice directly onto whatever you wish to color. The fermented liquid should soak deeply into the material or it will

simply flake off after a few hours in the sun. After coating the juice in or on the fiber, simply place it in the direct sunlight and wait until it turns golden brown. You can hang the textile you wish to color in place or lay it flat on the ground. You want it to absorb as much of the direct UV rays of the sun as possible and heat your pattern as efficiently as possible to cure the color.

Kakishibu is suitable for plant-based fibers and silk, and because it "coats" the fiber and doesn't dye it. It can also be used in a cold rather than heated vat. Because kakishibu is a coating, the color is affected not only by fiber content but also by the weave structure. If you have several different types of cloth and weave structure, you can get several different types of colors. Coloring items with kakishibu can be much simpler than using most dyes, because you can do kakishibu dipping and painting at room temperature—no additional heat is needed. With kakishibu you don't have any waste water; the dye bath or paint is exhausted when all the liquid is gone, so you can keep using your kakishibu until the very last drop.

DYEING WITH

persimmon

You can harvest green persimmons in early fall; note that it's essential to crush the persimmons within the first day of harvest. I suggest harvesting at least twenty green persimmons to make the long wait—a week of fermentation and a year of aging—worth your while and to leave you with plenty of dye to play with.

20 astringent green persimmons

Fabric

EQUIPMENT
Heat- and water-resistant gloves

Mortar and pestle

Cheesecloth

Ceramic fermentation container

Stainless steel bowl

Crush the persimmons with a large mortar and pestle and use a cheesecloth to squeeze as much juice as you are able.

Place the crushed persimmons and their juice in a container, add water to cover, and let ferment for a week.

Extract the juice again from the fermented persimmon by straining it through a cheesecloth bag.

Place the strained juice in a large fermentation container. Let it age at least 1 year, until the color of the juice turns from green to dark reddish brown.

When the kakishibu has aged, place it in a stainless steel bowl. To dye fabric, dilute with 2 parts water to 1 part kakishibu. For stenciling or painting darker tones, use the full-strength juice.

Work the kakishibu into the fabric and repeat as necessary per your design.

After one day in the sun, the cloth will be pink; after 5 to 7 days with direct sun exposure, the color will become a dark burnt orange.

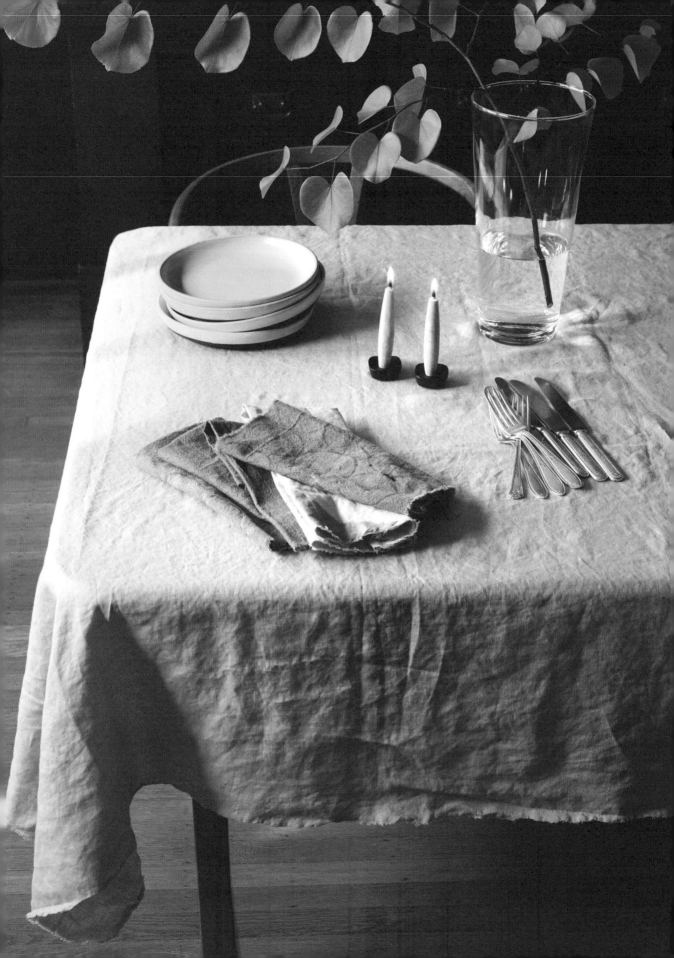

rosemary

TABLECLOTH
AND NAPKINS

Rosemary (*Rosmarinus officinalis*) is a woody perennial herb with fragrant, evergreen, needlelike leaves and white, pink, purple, or blue flowers, native to the Mediterranean region. It's a lovely plant for many reasons: fragrance, taste, drought tolerance, and ease of cultivation. It also creates gorgeous hues, from teals to dark grays and greens.

In ancient lore, rosemary was said to help memory. Historically it was used as a reminder of loved ones and for special occasions and happy gatherings such as weddings in medieval times; it was even considered a love charm. For all these reasons, it's a beautiful plant to work with—here, to grace the table at holiday season gatherings.

TABLECLOTH AND NAPKINS

4½ yards linen fabric, 54 inches wide (1 pound)

1 pound fresh rosemary sprigs, leaves and stems, cut or broken into pieces

2 teaspoons iron powder

pH-neutral soap

EQUIPMENT
Heat- and water-resistant gloves

Dust mask

Large stainless steel pot with lid

Strainer

Scour your linen fabric (see page 36). Soak linen in water, keeping it wet until ready for the dye pot.

Put the rosemary into a large stainless steel pot two-thirds full of water, enough to fully submerge the fabric.

Bring the rosemary and water to a low boil and simmer on low for approximately 40 minutes, depending on the desired intensity of your color.

Scoop or strain out the rosemary; it can be composted or reserved to be used again.

Wearing a dust mask, add the iron powder to the dye bath and mix well.

Add the soaked fabric to the dye bath and simmer on low for approximately 20 to 40 minutes.

Let cool and rinse the fabric in pH-neutral soap. Hang or lay the fabric flat to dry out of direct sun. When dry, cut into a 3-yard-long by 54-inch-wide tablecloth; cut the remaining 1½ yards of fabric into 6 equal-size napkins.

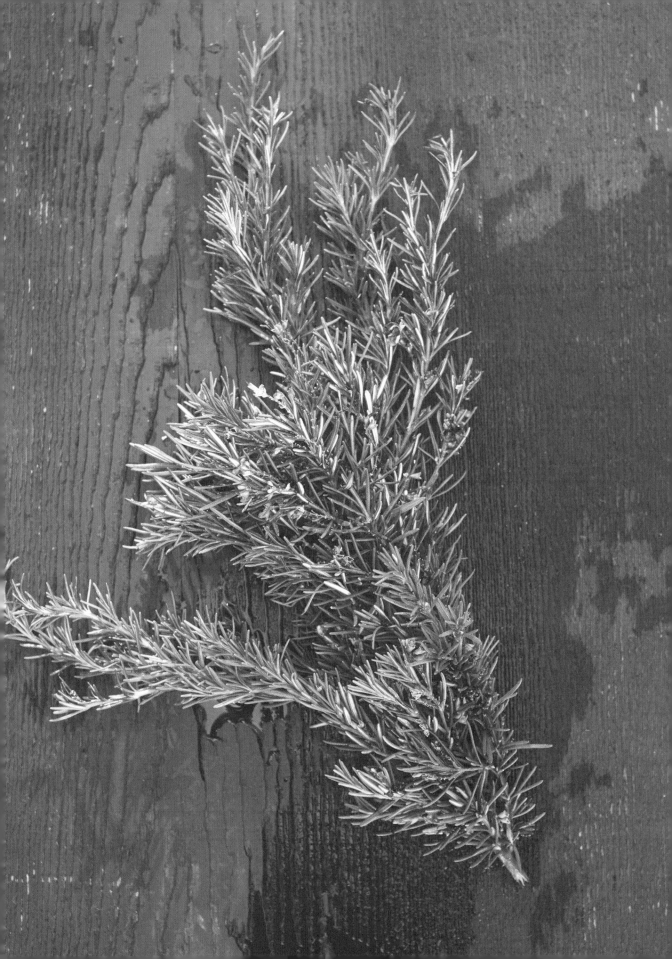

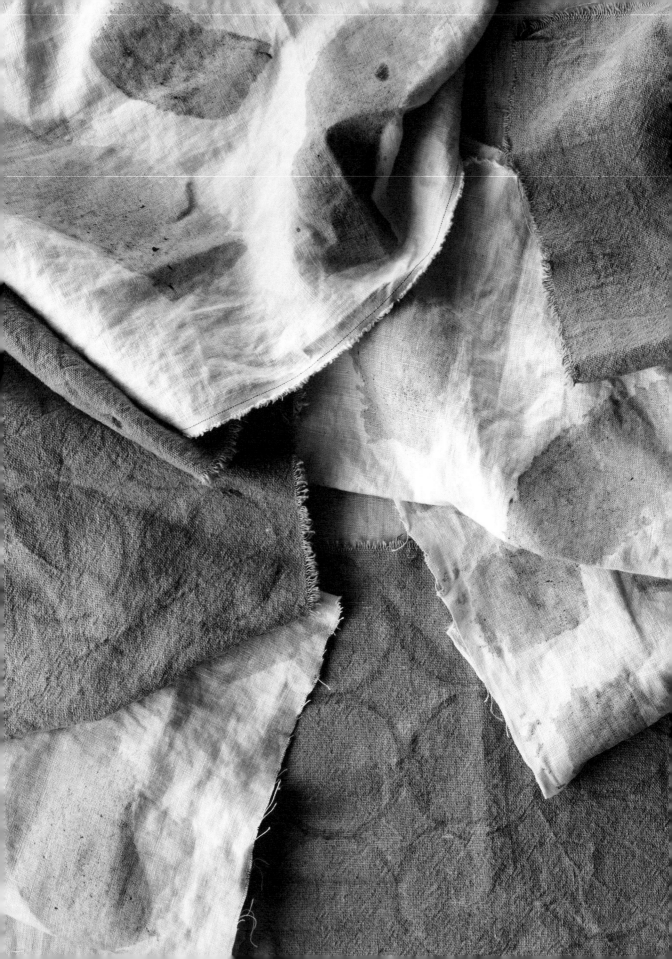

PAINTING AND PRINTING WITH

black walnut

The black walnut (*Juglans nigra*) is a common deciduous tree found along roadsides and undeveloped land in the eastern United States. Native to America, the black walnut was introduced to Europe in the 1600s. All parts of the black walnut tree have uses, including the valuable wood; not only are the walnut meats delicious and nutritious, but the outer hull is used as a neutral abrasive and cosmetic and even for water filtration. The green outer hull is not only medicinal but also one of the darkest and most lightfast and washfast dyes known. Walnut hulls can be gathered in early or midfall when you start to see the fruits fall from the trees.

Black walnut hulls do not require a mordant to produce rich shades of caramel, deep brown, and black. Black walnuts contain tannins that naturally bind the colors to plant-based fibers like cotton and linen. It's essential to wear gloves when working with walnut hulls—the dye is so strong that it can stain your hands for up to two weeks.

When the dye extracted from black walnut hulls is reduced by boiling down to a syrup and a food thickener like guar gum is added, this creates a deep, dark inky paste. This paste works especially well on cotton and linen, and being both nonreactive and washfast, it is a perfect, highly durable natural color for home and table.

CAUTION: If you are allergic to walnuts, or anyone else in your family or home is, this is not a recipe to use! You can easily substitute oak galls for walnut hulls in this recipe. Oak galls tend to produce more blue, purple, and black shades, but still make beautiful inks and pastes.

BLACK WALNUT DYE

4 to 8 fresh green walnut hulls (more can increase the strength of the color)

2 tablespoons guar gum powder

1½ yards fabric predyed in rosemary and iron (page 158)

pH-neutral soap

EQUIPMENT
Heat- and water-resistant gloves

Small stainless steel pot with lid

Rubber gloves

Strainer

Glass jars or yogurt containers

Dedicated Dye Blender

Large canvas drop cloth

Large, smooth flat surface

T-pins

Block-printing materials (page 251)

Steam iron

To make dark brown and black ink, peel off and chop the walnut hulls from the nut into smaller pieces.

Simmer the hulls in a small stainless steel pot one-quarter full of water to reduce the dye until it starts to get syrupy; this can take at least 1 hour.

Strain the walnut hull ink through a strainer, removing any hulls—the yield should be roughly 3 cups of ink, and you can store any ink you don't use in well-labeled glass jars or yogurt containers with lids in the refrigerator.

Add the still-hot (but not boiling) ink to the dedicated dye blender.

Add the guar gum powder in one-third increments, blending after each addition to make sure the paste thickens evenly. At this point you have a nice, dark printing ink with which to block print or paint.

Stretch the dry rosemary-dyed fabric flat on a large canvas drop cloth on a smooth, stable surface. Pin the edges of the fabric to the drop cloth with T-pins to keep the surface smooth and taut.

Make simple blocks and print a repeat design, following the directions on page 251. When you have printed all the fabric, let the ink dry completely.

Top the fabric with another clean piece of cotton canvas or drop cloth as a buffer and then use a steam iron to further set the block print into the fabric (see page 252).

Your block-print design is now ready for gentle washing; use pH-neutral soap and line-dry out of direct sunlight. Then cut the napkins into 27- by 18-inch rectangles.

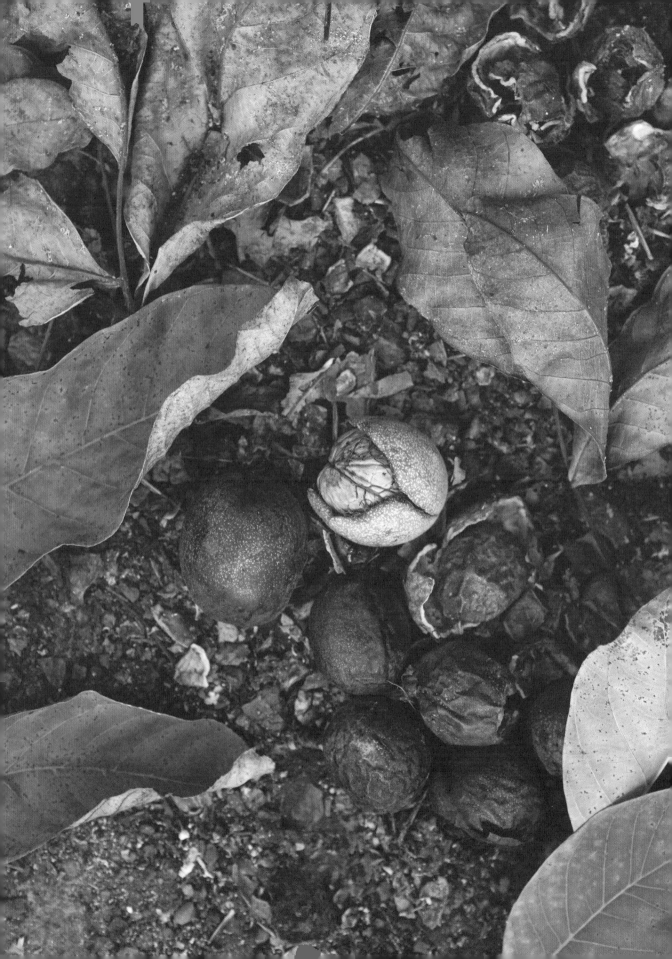

madder root

SCARF

Madder (*Rubia tinctorum*) is one of the ancient primary dye plants, unsurpassed for its glowing, earthy warm hues and potential to make rich, clear plant-based reds otherwise difficult to find in nature. Common madder can grow to five feet high. The roots, the source of the dye, can be over three feet long. I grow madder root both in my urban home dye garden and with my students at our Oakland community garden. It is easy to grow from seed. I recommend planting in deep planter boxes or a designated section of your garden, as madder roots deepen and expand and the plant sends out sticky vines that can move quickly and threaten neighboring plants. Growing madder root can be an exercise in patience; however, it is pure joy to dig them from earth once they've matured after two to four years. For more on madder root, see page 91.

Madder root creates rich, vibrant reds, oranges, and pinks, depending on the pH of your water, the mordant you use, and processing time. You can continue to use one madder root bath to get lighter shades of red, coral, and pink.

Dyeing with madder root is satisfying any time of year, but its vital oranges and deep reds are especially suited for fall. These are perfect shades to dye any thick woolens in your closet, as I've done here, to warm the darker, cooler days.

Harvest fresh madder root by digging up entire roots from mature plants (at least two to four years old). Soak and gently brush any dirt off of the roots.

Dried madder root can also be bought from a specialty dye supplier to experiment with while you wait for your own madder roots to mature!

As so many beautiful garments throughout history have been dyed with madder root, using this warm palette from deep in the earth to keep you cozy is a fine way to connect with and honor all your fellow practitioners of this ancient art—creating an heirloom textile from an heirloom color.

MADDER ROOT DYE

Woven wool scarf,
22 by 90 inches
(about 8 ounces)

3 teaspoons
aluminum sulfate

3 teaspoons cream of
tartar (optional)

8 ounces madder root,
chopped into ½-inch
pieces and soaked
overnight

pH-neutral soap

EQUIPMENT
Heat- and water-
resistant gloves

Mortar and pestle or
dedicated dye blender

Medium stainless
steel pot with lid

Scour your wool scarf (see page 36). Premordant your scarf
with alum and cream of tartar (see page 212), if using.

Grind your madder root pieces, using a mortar and pestle
or dedicated blender.

In a medium stainless steel pot two-thirds full of water, heat
the madder root to a low simmer and simmer for 40 minutes.
Turn off the heat and let the dye bath steep; leave it
overnight for stronger color.

Warm the dye bath to lukewarm, add the wet scarf, and
slowly raise the heat to a low simmer. Gently simmer your
scarf for 40 to 60 minutes, then turn off the heat and let
your scarf steep overnight.

Gently rinse your scarf with pH-neutral soap and water at
a temperature similar to the dye bath from which you've
removed it, so as not to shock the fiber. Without squeezing
out any water, hang or lay the scarf to dry out of direct
sunlight. Despite these precautions, it is normal to have
some shrinkage during the dyeing process.

THE ART OF
MEDICINAL
DYEING

As I've learned more about the wide range and depth of natural dyes in the plant world, I've simultaneously become interested in their medicinal properties—another quality that sets plant palettes apart from synthetic dyes.

The art of medicinal dyeing came about because anything that comes into contact with your skin—your largest and most porous organ—for an extended period can potentially be absorbed and affect your health. (A number of pharmaceuticals take advantage of this to deliver drugs through adhesive patches.) Think of your skin's pores as millions of tiny mouths. We know that toxic chemicals can be absorbed through our pores, especially when combined with sweat when the pores open. Therefore, coloring the textiles that will be close to our bodies with healthy substances—like chamomile for soothing, cinnamon for energy boosting, turmeric for its anti-inflammatory and circulation-enhancing properties—can positively affect your body's physiology.

When you wash your black synthetically dyed shirt and you see the extra black dye go down the drain, that dye is not only going back into our water systems but has also been absorbed by your pores.

Extracting color from calendula flowers, aloe leaves, or green persimmons and dyeing cloth with them can produce similar topical properties, but in this case may also have the ability to be absorbed into the skin. Dyeing your most-worn garments, for instance your undergarments and your bedding, is another great way to infuse medicinal plant dyes into fabrics that you have next to your skin, day in and day out.

Many of our most common natural dye plants also have powerful biochemical properties that are medicinal. Natural indigo, for instance, not only produces the deepest blue dye available, but is also a powerful healing plant. In traditional Chinese medicine, indigo has been used as a pain reliever and to purify the liver and bloodstream. It has also been used for centuries to cure depression as well as respiratory problems, and topically as a paste, is used to relieve sores, ulcers, and hemorrhoids; an indigo poultice was also known as an antivenom to relieve pain and stings. Many centuries ago, Japanese samurai wore indigo-dyed garments; in addition to fending off snakes and mosquitoes, the botanical dye would help heal their wounds, allowing them to continue traveling even after being injured and to protect them from infection as the dye is highly anti-inflammatory. Firefighters in Japan have worn uniforms of indigo to protect them from burns. To this day in Japan, babies are gifted with indigo-dyed blankets; the belief is that the dye will protect them from illness.

Black walnut hulls have also been used throughout history for treatment of intestinal problems, wounds, ulcers, and scurvy, among other ailments. And the root, leaves, and seeds of black walnuts, madder root, and weld—three of our most ancient primary plant dyes—are all reputed to be medicinally active. Even some of the most mundane plants and flowers like cabbages and roses have been upheld for their great medicinal value since ancient times.

Ayurvedic textiles are produced through a South Indian–based technique that uses medicinal herbs and spices as fabric dyes. While many cultures used plants as natural dyestuffs before the advent of chemical dyes, artisans in India took it a step further, choosing plants not just for their color but also for their healing benefits. These centuries-old methods of curing and dyeing textiles are still practiced in India today.

Other cultures have also continued the important tradition of medicinal plant dye practices. Persimmon dye (*kakishibu*) is one such dye used most commonly in Japan, Korea, and other parts of Asia. The dye, made from astringent green persimmons, imbues cloth with the plant's strengthening, antibacterial, UV-resistant, and waterproofing properties—making it a great nontoxic dye for traditional work clothes, which become more durable and protective as well as beautiful and nontoxic over time. And the soothing vibrancy of these natural color palettes can be inherently healing.

I first became consciously aware of the application of plant dyes for medicinal usage commercially at one of the first natural dye workshops I ever taught, at Mayum Ode's Ginger Hill organic farm on the Big Island of Hawaii. We used freshly dug turmeric root, and many of the students visiting the farm from Japan excitedly showed me printed images of clothing companies in Japan that were creating undergarments dyed with turmeric, which would be topically healthy for the skin, organs, and circulation. The design and healing applications of dye plants never ceases to amaze and inspire. Hawaiians used turmeric—considered as a plant important enough to carry in canoes from the South Pacific to their new home—as a spice, medicine, and dye.

Medicinal dyeing can boost our health and immunity at different times of the year as we enjoy seasonal fruits and vegetables and use their by-products to make beautiful colors. For instance, citrus peels (which make gorgeous yellows, golds, and light greens) make a wonderful winter dye recipe—and deliver an infusion of vitamin C. Pomegranate juice is a vital and powerful antioxidant, and pomegranate peels in the dye pot give us beautiful colors and a natural mordant. (For more about plant-based mordants, see page 221.)

You may have some of the many common medicinal plants that are also staple dye plants in your own herbal or medicinal garden. Medicinal dyes are also easy to obtain from your local apothecary. All plants are well worth the effort of getting to know more fully, as you'll often be surprised at their inherent medicinal properties.

SOME COMMON MEDICINAL PLANTS AND THE COLORS THEY MAKE

Aloe (*Aloe vera*) yellows, pinks, and coral. Aloe has been cultivated for so many centuries that this succulent plant can be found all over the word. Aloe's fresh gel can be applied directly to small cuts and burns, helping to heal and soothe the skin. Alexander the Great is said to have conquered the island of Succotra, where aloe grew in great abundance, just to secure a supply to heal his soldiers' wounds. Cleopatra also used the plant prolifically as a medicinal beauty product. Aloe is also a natural sunscreen, blocking 20 to 30 percent of the sun's ultraviolet rays—and its pH also perfectly matches our skin's. As a dye plant, aloe creates a range of beautiful sunset colors, depending on the pH of the dye bath.

Calendula (*Calendula officinalis*) yellow and light green to grays. Calendula can be used topically or internally. Topically, it can ward off infections; it is a common ingredient in creams, salves, and ointments for its ability to soothe and heal bruises, sores, skin ulcers, infections, and rashes. It is also a common remedy for babies' rashes, as the plant is very gentle yet effective on sensitive skin.

Comfrey (*Symphytum officinale*) light greens to dark greens and gray. Comfrey, often called the "bone knitter," has been used as a skin poultice to heal broken bones, bruises, sprains, and rheumatism. The genus name is derived from *symphyo*, "to unite," which confirms comfrey's ancient use as a unifying herb.

Dyer's chamomile (*Anthemis tinctoria*) golden yellows and greens. Dyer's chamomile is an excellent bright dyer and, although not used as a medicinal soothing tea as we think of with other varieties of chamomile, it is applied topically to the skin to soothe insect bites and other skin irritations.

Lavender (*Lavandula angustifolia*) yellow, gray, and teal. Lavender has long been known for its calming effects and is one of the world's most popular fragrances. The plant's essential oils are both antiseptic and disinfectant. It produces both a beautiful and medicinal dye and a natural insect repellent, so dyeing wool and silk with lavender helps prevent moth damage. Lavender has been traditionally used to wash hands and linens and even to cover floors.

Sage (*Salvia officinalis*) yellows, golden greens, and deep browns. The Greeks and Romans used sage as a general tonic for mind and body, believing that it extended longevity and could protect against all ills. Sage is also an excellent plant for lowering cholesterol, reducing stress, and rebuilding vitality after long illness. Sage is also a well-known cold and flu fighter and a traditional remedy for inflammation.

Saint-John's-wort (*Hypericum perforatum*) yellow, green, pink, and red. Saint-John's wort can be very effective for treating mild depression, anxiety, and stress. Although its usage as an antidepressant was discovered only in modern times, in medieval times, Saint-John's-wort was said to be effective for warding off evil spirits and bringing protection. The flowering tops of Saint-John's-wort can be steeped in oil to relieve skin inflammation and heal wounds. Particularly when picked at their peak of flowering, they produce a deep blood-red color. Depending on how the dye bath is prepared, what fibers are used, and how the pH and mordants are applied, St. John's wort can also yield a full spectrum of colors from yellows to greens, reds, and pinks.

Stinging nettle (*Urtica dioica*) light green to deep green. Wild stinging nettle is known for its highly nutritious edible greens (they lose their sting when cooked), medicinal qualities, and ability to create both dye and a strong, beautiful linenlike fiber. The plant used to make herbal beer and as an astringent, diuretic, and tonic. When the fresh juice is rubbed directly on the scalp, it is purported to help hair growth as well.

Turmeric (*Curcuma longa*) bright yellow to dark green. Closely related to ginger, turmeric is native to India and other parts of South Asia. It has been and is used prolifically as a medicinal spice and a medicinal dye for centuries in its native regions, but only recently have turmeric's powerful healing properties been noted in the rest of the world. Turmeric is considered to be one of the most antioxidant-rich, anti-inflammatory, and immune-enhancing herbs.

Yarrow (*Achillea millefolium*) yellows, bronze, green, and gray. Yarrow is an anti-inflammatory, has powerful astringent properties, and is well known for its healing properties on wounds, bruises, and sprains. Yarrow stimulates blood flow, and poultices can also help reduce it. The Navajo considered it to be a "life medicine"; they chewed it for toothaches and poured an infusion into ears for earaches. The Miwok of California used the plant as an analgesic and head cold remedy.

MAKE FRIENDS WITH AN HERBALIST

An important aspect of working with powerful plants is knowing what doses are healthy for you, whether used intentionally as medicine or unintentionally in your dye practice. In large doses, some plants that would otherwise be helpful can be harmful. Each person can have individual reactions to plants, so always remember to take the necessary precautions: start small before working bigger; keep gloves on in case you have any allergies; work with cross ventilation or even better, outside; and definitely make sure you properly identify your plant if working from wild sources. Poison hemlock can look a lot like Queen Anne's lace, and that is a mistake that no one wants to make—especially for the sake of dyeing a dress. Knowledge is key in keeping your dye practice healthy and safe—even when working with healing sources.

Seek out skilled herbalists (as well as botanists) to identify those dye plants that are especially medicinal to work with and to explain the ways in which they are healing—they can be invaluable to mastering your plant dye practice. As many medicinal color recipes have been lost or carefully kept secret through the centuries, it is especially important for those who love and work with these plants to share with each other as we revive the old best practices, collaborate on new ones, and cultivate growth and knowledge for ourselves and our communities.

WINTER

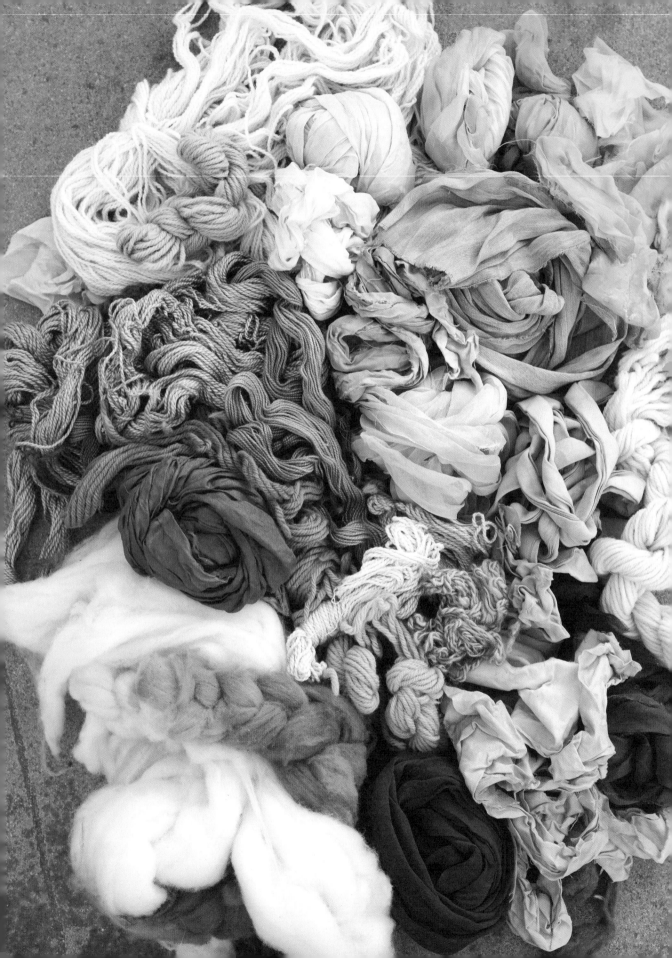

THE WINTER PALETTE

POMEGRANATE · RED CABBAGE · BLUE SPRUCE · REDWOOD CONES · SWEET GUM LEAVES · CITRUS PEELS

Winter is the season to look to root vegetables in your cellar, to the warmth and light of your hearth, and to evergreens for bright and beautiful color on the darkest days. To capture the colors of the winter season, you can use the castoffs from a wood stove or fireplace to change the alkalinity and depth of your natural palettes. Black and a deep, rich burnt umber dye can be created from the sweepings of chopped wood from the fireplace, and the ash is used the change the pH of dye baths to create brighter or darker colors.

Winter is a time to celebrate the completion of a full growing and harvesting cycle as well as time to begin again. The cold winter months are also a wonderful time to experiment with "outside as inside" interior notes—bringing bold strokes of natural color inside—even trying direct-paint applications and watercolor washes on your walls. It's a time for giving—and creating color palettes from sources meaningful to the giver and the recipient is a good place to start. Those who live in snowy climates can melt snow in the dye pot as a great source of soft water without harsh chemicals or hard minerals, adding to the elemental alchemy of the dye bath.

Many celebratory, seasonal edibles have by-products that can make gorgeous hues and support the gift of reuse. When holiday cocktails call for the use of pomegranate seeds, you'll have pomegranate rinds that create golden yellow and chartreuse colors perfect for holiday home textiles. Winter citrus fruits are at their peak sweetness, and their fruit peels can make beautiful golds and soft greens.

The cones of pine, fir, spruce, and redwood all can conjure up mauves, deep crimson, blacks, and grays. Winter evergreens—such as juniper, spruce, balsam, and redwood branches—can create gorgeous hues after they are used as holiday decor. You can even dye your New Year's dress from your December wreath—a great way to start the new year with a resolution to wear more natural color.

WINTER
DYE PLANTS

BLUE SPRUCE

SPRUCE
CONES

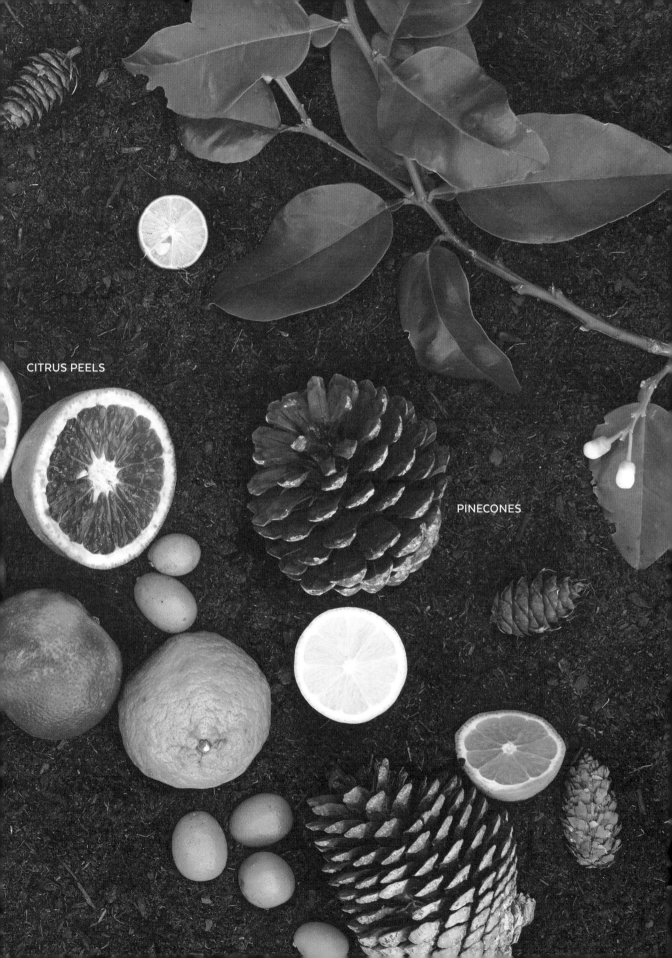

CITRUS PEELS

PINECONES

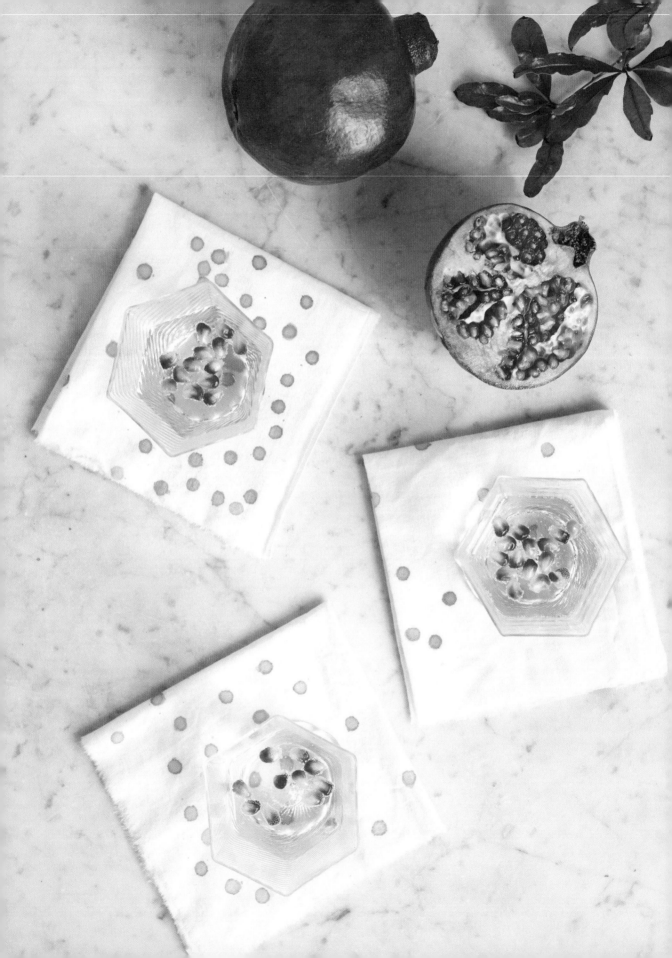

pomegranate rind

COCKTAIL NAPKINS

What I love about natural dyes is how truly surprising the source of the color can be. For instance, one would think that pomegranate seeds hold a treasure trove of dye color, but it is actually the pomegranate rind that holds the true color potential and has been used for millennia as both a dye and a mordant for the intensity of its tannin. In my opinion, this is just another way that nature continues to provide—you get to enjoy the pomegranate fruit and at the same time make gorgeous shades with its leftover rinds.

The pomegranate (*Punica granatum*) is a fruit-bearing deciduous shrub. Its fruit comes into season in the fall and winter months in drier climates. Pomegranate is native to Iran and northeast Turkey and has been cultivated throughout the Middle East, South Asia, and the Mediterranean region for thousands of years. The pomegranate also thrives in the drier climates of California and other areas of the southwestern United States. It has been considered a symbol of fertility in multiple cultures throughout history, including in Persia, China, and India. Pomegranates are a beautiful and colorful fruit to add to any celebratory gathering.

Pomegranate rinds can also provide golden winter color without a mordant or an even brighter tone with aluminum sulfate. Adding iron turns the color more ochre, green, and even black. By using fresh pomegranates, you can enjoy a holiday pomegranate cocktail with the seeds and then use the rinds to dye the confetti-print cocktail napkins.

POMEGRANATE RIND DYE

16 cotton cocktail napkins,
about 8 by 8 inches
(4 ounces)

Rinds from 1 to 3 large
pomegranates,
cleaned well and cut
into ½-inch pieces

1 teaspoon
guar gum powder

1 teaspoon
aluminum sulfate

EQUIPMENT
Heat- and water-
resistant gloves

Medium stainless steel
pot with lid

Strainer

Cheesecloth

Stainless steel bowl

Dedicated dye blender

Pencil with round eraser
for stamping

Steam iron

Piece of cotton canvas

Scour your cotton cocktail napkins (see page 36).

Put the chopped pomegranate rinds in a medium stainless steel dye pot one-third full of water to create a concentrated dye liquid. Bring to a slow boil and simmer for 1 hour. Turn off the heat and let the dye steep. You can also let your dye steep overnight for deeper, richer colors.

Scoop the pomegranate rinds out of the dye bath with a strainer; you can save the rinds and create another dye bath or compost them. Using a cheesecloth, strain the cooled liquid through cheesecloth into a stainless steel bowl. Pour liquid back into dye pot and heat on low.

Turn off heat and let cool slightly, and then pour 1 cup of the heated dye liquid into a blender reserved just for dyeing. (If you have any leftover dye liquid, you can save this for later projects or use it to dip-dye extra party linens.) With the liquid still warm, add the guar gum and alum mordant powders in thirds. Blend evenly each time to remove lumps and to make sure that the paste is as smooth as possible.

When your printing paste is ready and cooled to room temperature, wear gloves and use the round eraser on the end of a pencil to stamp circles in a random pattern on the napkins. Let the pomegranate rind paste fully dry. Lightly steam the fabric with an iron with a piece of cotton canvas in between.

For additional block-printing instructions, see page 251.

You can use your napkins immediately. When necessary, wash them gently with pH-neutral soap and hang to dry out of direct sunlight.

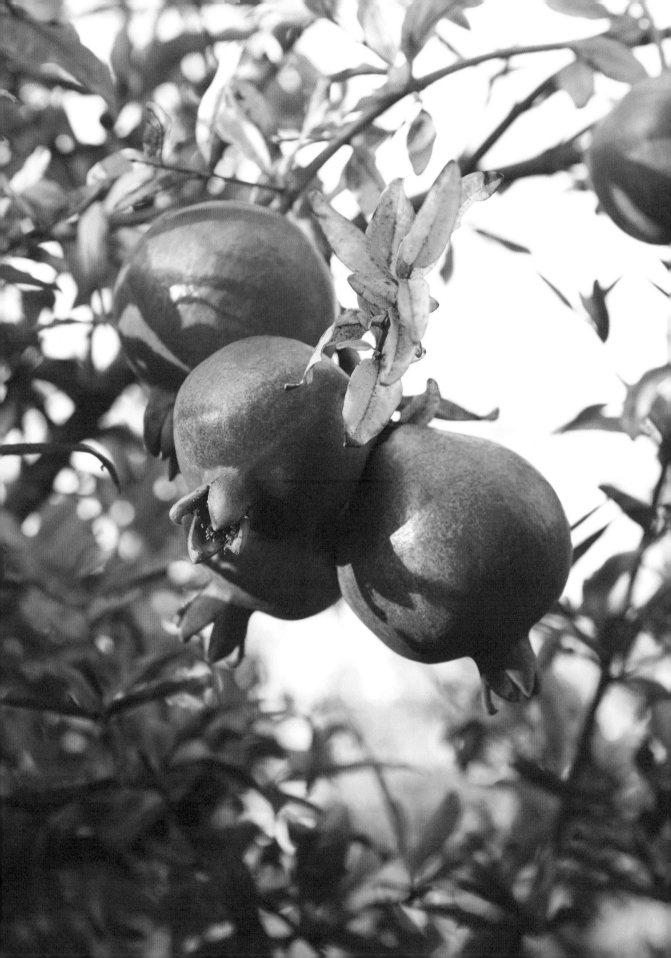

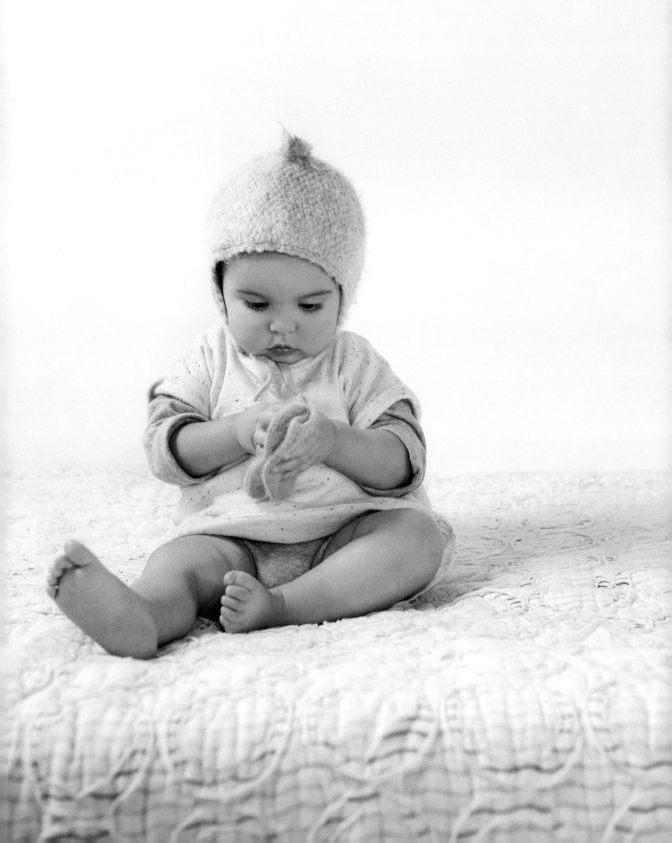

red cabbage

BABY HAT AND MITTENS

Red cabbage was one of the first natural dyes I fell in love with; this mundane vegetable, with its gorgeous range of natural colors, was used by our great-grandparents as a way to simply dye and re-dye items at home that needed refreshing. Cabbage is an easy-to-grow, medicinal, healthy crop. I continue to enjoy using it for dyeing projects with children; it is a great introduction to the wonder of natural dyes, and the cabbage easily turns color—depending on the pH of the soil it was grown in, the water used as dye, and whether you add an acid or a base. Red cabbage is also an excellent seed-saving project, if you choose to grow your own.

Red and purple winter cabbages make beautiful pastel lavenders, blues, and light greens on soft merino and angora wools—a wonderful way to naturally color a baby's winter hat and mittens. With this project, you not only work with heirloom knits, but also refresh your little one's garments with natural color recipes from an heirloom plant that can be passed on from generation to generation. Also, because the cabbage color can be so easily modified, it can be a wonderful way to simply change the color or pattern of your hat and mittens from baby to baby, adding a new layer of creativity and special hue for each new addition to the family.

BABY HAT AND MITTENS

Natural Angora wool
baby hat and mittens
(about 4 ounces)

pH-neutral soap

1½ teaspoons
aluminum sulfate

1½ teaspoons
cream of tartar (optional)

¼ head of red cabbage, cut
into 1- to 2-inch chunks

¼ teaspoon white vinegar
(optional)

¼ teaspoon baking soda
(optional)

EQUIPMENT
Heat- and water-
resistant gloves

Small stainless
steel pot with lid

Strainer

Gently wash the hat and mittens with pH-neutral soap.
Premordant them with aluminum sulfate and cream of tartar
(see page 212), if using.

Add the red cabbage to your small pot and bring your water
to a boil and then to a low simmer. Simmer for 40 minutes,
or until the leaves begin to lose their original color and the
liquid is a deep purple or blue.

Scoop out the red cabbage with a strainer; it can then
be composted.

Add the hat and mittens and simmer them gently for at least
40 minutes to 1 hour. Hat and mittens should now be dyed
solid. Turn off the heat and let the hat and mittens steep
overnight, or until you reach your desired shade. Depending
on the pH of your water and even the soil that your cabbage
was grown in, your hat and mittens will be either a warm or
cool lavender color.

Gently rinse the hat and mittens with pH-neutral soap.
Lay them flat to dry out of direct sunlight.

MODIFYING YOUR CABBAGE COLOR
To Pink/Purple Add the vinegar and watch your red cabbage
color change on your hat and mittens to a soft shade from
lavender-blue to light pink to purple.

To Blue/Green Add the baking soda and dye your hat and
mittens from lavender-blue to green-blue.

Gently rinse your baby hat and mittens with lukewarm water
and pH-neutral soap and lay flat to dry out of direct sunlight.

As this dye is pH sensitive, you'll want to treat these little
woolens as delicately as you would the little one wearing
them. To store these heirlooms, keep them in a box with
lavender and it will naturally keep them safe from moths
(and smell gorgeous)!

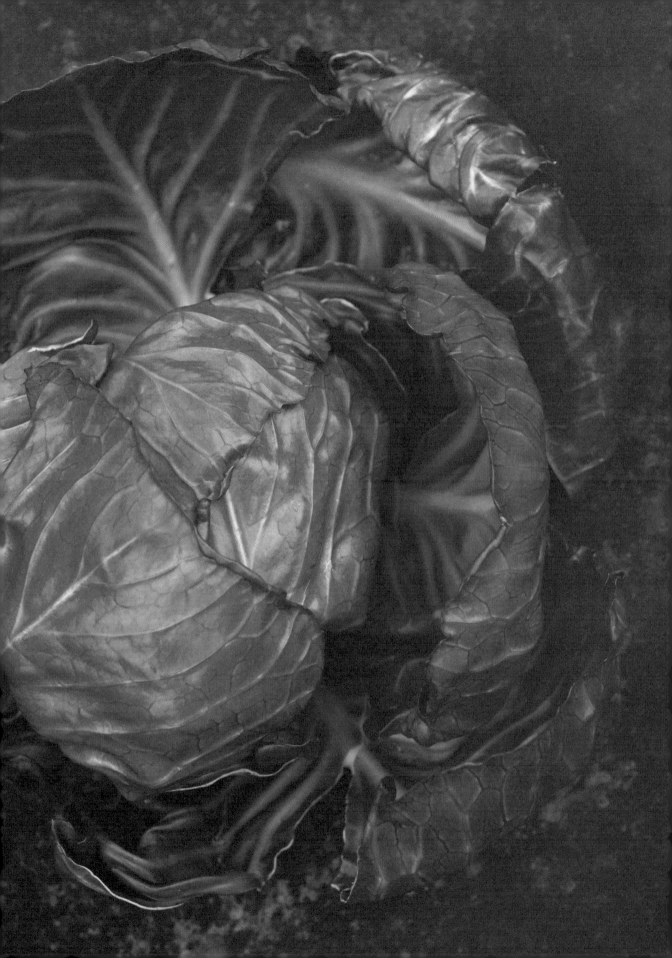

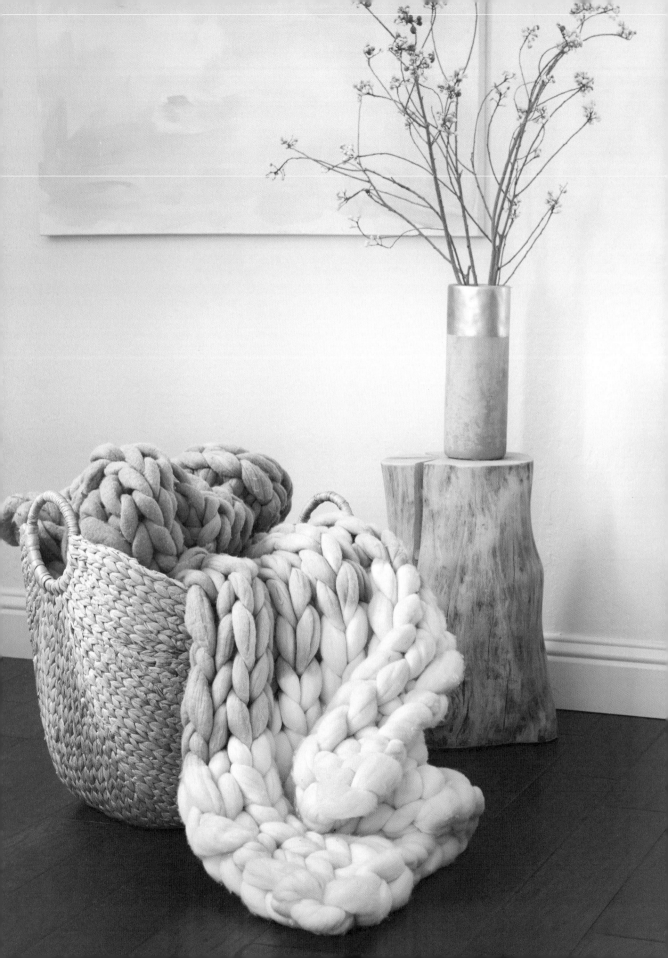

blue spruce

CHUNKY WOOL BLANKET

Blue spruce (*Picea glauca*) branches (and other spruce varieties) create colors from light to dark teal-greens and grays. As an evergreen, popular for holiday decor, it is an excellent source for a winter dye. The color produced by blue spruce is especially stunning on wool, and winter is a good time to dip-dye an extra thick knitted woolen winter blanket to bring the essence of outdoor evergreens into your home.

Spruce produces an aromatic and visually wondrous dye bath. This ombre dyeing project is a great way to spruce up your home by reusing your holiday tree and winter celebration decor. Melted snow water can be a great extra element to work with if you live in a snowy climate; it is a softer water containing fewer minerals and chemicals than tap water.

CHUNKY WOOL BLANKET

Chunky knitted
100-percent wool blanket
(about 5 pounds)

pH-neutral soap

2½ pounds pruned
blue spruce branches and
needles, chopped into
1- to 3-inch pieces

⅓ cup aluminum sulfate

⅓ cup cream of tartar
(optional)

¾ tablespoon iron powder

EQUIPMENT
Heat- and water-
resistant gloves

Large stainless steel
pot with lid

Strainer

Make sure that your woolen blanket is knitted from clean 100-percent natural wool, ready to absorb dye.

Soak half of the blanket you wish to dye in lukewarm pH-neutral soap. Do this close to the dye pot, as the chunky wet wool will be heavy and you won't want to squeeze or wring it since that could felt your blanket.

Gently premordant the soaked half of your blanket with aluminum sulfate and cream of tartar, if using (see page 212).

Add the spruce pieces and all needles to a large stainless steel pot two-thirds full of water. Simmer for 40 minutes to 1 hour to draw out as much color from the branches as possible. At this point, you can turn off the heat and let cool to lukewarm temperature—again, to avoid felting the blanket.

When the dye bath is lukewarm, scoop out the branches and needles with a strainer. Add the iron powder. The dye bath will turn teal-green.

With the partly wetted blanket supported on a nearby surface, gently squeeze out excess water. Raise the heat to a low simmer to dip-dye the edges (per instructions, page 240). Lower the edges into the dye bath. You'll need to hold the blanket so only the edges rest in the dye bath, and keep an eye on it for 20 minutes or more to get stable color. The longer you let the edge of the blanket steep, the more saturated the color. You can also turn off the heat entirely after 15 minutes and let the blanket slowly steep overnight. Be aware that the dye may wick up farther into the woolen blanket, however, so anticipate this when you dip the edges and leave some room for the color to spread higher.

When the desired color is reached, carefully remove the blanket from the dye and gently rinse with pH-neutral soap and water at the same temperature as the dye bath. Press your blanket gently with your hands to remove excess water and lay flat to dry, out of direct sunlight.

redwood cone

SWEATER

Making local color and getting to know the trees that grow well where you live can be a gift on both counts. Redwood cones are a particularly good example of a bioregional dye color of Northern California. I love working with redwood cones, not only for their dusky pinks, mauves, and blacks, but also for how aromatic the dye bath can be—the smell is akin to a rainy walk in a coastal redwood forest.

Redwood cones hold color when collected at any time of year, both the dried cones found on the forest floor as well as the bright green fresh cones. Redwood trees are also some of the most ancient on earth. The trees can reach an age of two thousand years and regularly reach six hundred years. Redwood trees flower during the rainy months of December and January. They produce cones that mature the following fall. While each tree can produce a hundred thousand seeds annually, the germination rate is very low. Most redwoods grow more successfully from sprouts that form around the base of a tree, utilizing the nutrients and root system of the mature tree. When the parent tree dies, a new generation of trees rises, creating a circle of trees that is often called a fairy ring.

Green redwood cones can be found throughout late fall and early winter—and recently ripened brown cones in the middle of winter also hold amazing color. Redwood cones also store and dry easily, so you can keep them in your dye pantry for varied shades at other times of the year.

In addition to redwood cones, spruce, fir, and pine cones are incredible sources of dye hues, and you can explore those that you have access to or that you may already be using in winter decor. Knowing what trees grow in your area and learning more about them and the best time to collect materials is a wonderful way to get in sync with your region and to conjure colors that speak directly of the alchemy of place.

SWEATER

100-percent wool
or cotton sweater
(about 8 ounces)

pH-neutral soap

At least ½ cup green
redwood cones, or 1 cup
dried redwood cones

EQUIPMENT
Heat- and water-
resistant gloves

Medium stainless
steel pot with lid

Strainer

Stainless steel tongs

Wash your wool or cotton sweater with pH-neutral soap and let it soak for at least 1 hour; keep it wet until ready for dyeing.

Place the cones in a stainless steel dye pot three-quarters full of water. Bring to a boil over high heat. Lower the heat to medium and simmer for 30 to 40 minutes. Turn off the heat and let the dye bath cool and steep, even overnight.

Strain the redwood cones from the dye bath and add the wet sweater. The dye bath should be the same temperature as the sweater, to prevent felting. Slowly bring the dye bath back up to a low simmer.

Simmer for 20 minutes or longer. You can remove your sweater from the dye pot with tongs or turn off the heat and let it sit for a more saturated darker color.

Rinse your garment in pH-neutral soap and lay flat to dry out of direct sunlight.

Note: Redwood cones—in fact, all cones—hold dense color, so reuse the dye bath for other dyeing projects.

sweet gum leaf

WATERCOLOR WALL WASH

The sweet gum (*Liquidambar species*) is a common deciduous tree in the southeastern United States and in most temperate regions in the United States, Mexico, and Central America. In Mexico and Central America, the sweet gum is a common tree of temperate-zone cloud forests. It is easily recognized by its five-pointed, maplelike leaves and its hard, spiky fruits that fall in abundance. Sweet gum leaves are dark green and glossy, turning brilliant orange, red, and purple in autumn. The leaves contain substantial amounts of tannin, and the bark also has medicinal properties; it has been used as a tonic and an antiseptic. In the dye bath, sweet gum leaves smell amazing, with an undertone aroma that hints of nutmeg.

Red sweet gum leaves processed without a mordant will create a cool pink; with iron added, the color can go dark purple or black. Use the leaves when they turn red in the fall and throughout the winter and early spring in Northern California. The darker red the leaves, the stronger the shades of pinks; if you add iron powder (see page 219), it will create blues, purples, and a deep black.

Sweet gum leaves can add a beautiful pink glow to clean, flat walls that are painted white. For a more ambitious natural color project, sweet gum dye can be reduced to thicker solutions for making inks and paints. Iron added to a thickened reduction of the leaves can make a striking black ink and gorgeous watercolor washes on walls—a dramatic imprint of natural color and a stunning accent to any room. If you aren't ready to paint directly on your walls, the ink can instead be used to work on textiles or paper panels as wall art (sweet gum leaves also produce a great stain for natural wood). You can decide how to apply the color—for this project, I used a large paint brush and absorbent sponge to make the sweeping watercolor stripes; just know that the more open and engaged you are with the process, the more satisfying the results.

This recipe makes enough dye for a multilayered, wall-size watercolor painting 12 by 14 feet.

WATERCOLOR WALL WASH

1 pound red sweet
gum leaves

3 tablespoons iron powder

EQUIPMENT
Heat- and water-
resistant gloves

Dust mask

Large stainless steel
pot and lid

Strainer

Nonreactive plastic
bucket or large
stainless steel bowl

Drop cloth large enough
to cover the floor surface
under the painting area

Old clothes, shoes,
and protective rubber
gloves for painting

Watercolor paper or
newsprint (optional)

Mop or large
paintbrush and absorbent
natural sponge

Put the sweet gum leaves in a large stainless steel pot with enough water to cover the plant material.

Bring the water to a boil, then reduce the heat, and slowly simmer for 40 minutes to make a strong reduction.

When the water looks bright ruby red and the leaves have turned from red to brown, you can turn off the heat and strain out the leaves, or let them continue to steep overnight.

To darken the dye, add iron powder. Transfer your dye to a nonreactive container large enough for your sponges or brushes, like a large stainless steel bowl or plastic bucket.

Make sure that you and your floors are protected from splashing and dripping. Use a drop cloth and wear old clothes and shoes to protect yourself from getting dyed in the process!

Depending on how you want to approach the project, you can work on oversized pieces of watercolor paper (which can be bought on large rolls from art stores) rather than experimenting directly on the wall. Or you can wash your white matte-painted wall and it is ready to accept the paint. You can start with a small test that can be repainted later. If you wish to layer your wash, you can use a large mop with a flat sponge that is easy to control, or large flathouse paint brushes and natural sponges for sweeping watercolor effects and texture. Brush thinly or build up layers as you wish; you can cover the whole wall or just a part of it.

Allow your dye to dry overnight, and then your watercolor wall wash is complete.

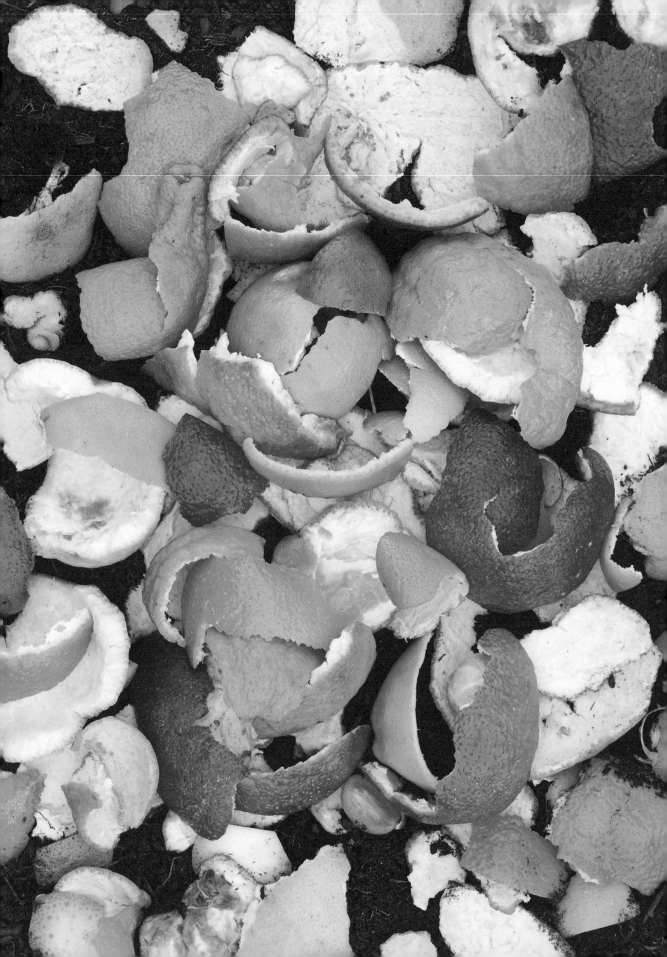

DYEING WITH
citrus peels

In winter, citrus fruits are often at their sweetest and juiciest—and the abundance of citrus peels they generate can create effervescent hues of yellows, golds, and greens. The colors are especially beautiful on wool and silk. Clementines, satsumas, mandarins, tangerines, oranges, and kumquats with their darker orange skins can create some gorgeous aromatic shades. Pomelo, grapefruit, and Meyer lemon peels work as well, with shades a little more cool yellow rather than golden yellow.

4 ounces wool or silk fabric

1½ teaspoons aluminum sulfate

1½ teaspoons cream of tartar (optional)

4 ounces citrus peels

pH-neutral soap

EQUIPMENT
Medium stainless steel pot with lid

Strainer

Scour your fabric (see page 36), and premordant your fabric with aluminum sulfate and cream of tartar (see page 212), if using.

Soak your fabric in water until ready to dye.

Place the citrus peels in a medium stainless steel pot two-thirds full of water. Bring the water to a boil, turn down the heat, and let the peels simmer for 15 to 20 minutes, or until the water starts to change color. Strain out the peels and discard or compost. Add the premordanted fabric and let it simmer on low for 20 to 40 minutes.

Remove the fabric or let it steep overnight, off the heat, until it is your desired color.

Rinse your fabric with a gentle pH-neutral soap. Hang it to dry out of direct sunlight.

WEEDING YOUR WARDROBE

Some of the most invasive plants in your garden can be sources of both color and beauty before being sent to the green waste pile. Aspiring textile designers, lovers of color, or appreciators of plants are delighted to learn that so-called weeds can hold unique dye color properties. The most common weeds, such as oxalis, can be used for dye, food, medicine, and even cut flowers and garnishes. Getting to know the hidden capabilities of a plant can be a powerful way to generate creative ideas and innovative sourcing of materials to work with. Research the weeds that volunteer in your garden; you'll find a treasure trove of color possibilities.

Finding out where plants came from, how they got to where you live, and why they grow well in your soil will help you to better understand your garden's ecosystem, why certain cultivated plants thrive in your soil, and how to amend your soil to grow other plants you'd like to add. Mapping and getting to know your own neighborhood and botanical region is another way of cultivating your natural dye practice, caring for the landscape, and working in harmony with ecological systems.

Working with natural color can inspire you to take on authentic stewardship of the land itself. There are many ways to cultivate a curated dye practice centered on permaculture and regenerative design practices that support the natural ecosystem. Cultivating natural color can also provide you with a deeper aesthetic in your garden and landscape design.

A SAMPLING OF COLOR-PRODUCING WEEDS

- Dandelions (*Taraxacum officinale*)—yellows, greens, and grays from leaves; reds and pinks from roots
- Goldenrod (*Asteraceae* family)—yellows and greens
- Oxalis (*Oxalidaceae* family)—bright yellows and bronze
- Queen Anne's lace (*Daucus carota*)—light yellow to grays and greens
- Tansy (*Tanacetum vulgare*)—bright yellow to bronze
- Wild fennel (*Foeniculum vulgare*)—bright yellow to dark green

FORAGING FOR FASHION

As you learn more about the plants in your garden, your neighborhood, and your regional planting zone, you learn how to care for them and to glean color palettes while nourishing the ecology of the sources you draw from.

Foraging for natural dye plants can be a great way to tend to your garden and your neighbor's garden (with permission) and to repurpose plant branches and debris in urban and municipal areas that might otherwise be slated for the green waste bin. I often collect leaves under the sweet gum trees in my neighborhood as well as purple-leaf plum branches that have come down in wind and rainstorms.

When you get to know where the acorns fall and the dandelion weeds come up through the sidewalks in your neighborhood, you see the landscape in a whole new light.

Setting up exchanges with friends and neighbors is also an incredible way to extend the dyer's palette. Many foraging projects have popped up in which neighbors exchange fruits and edible plants; one person's overabundance is welcomed by those who will put them to good use. Neighbors can similarly find and share useful dye plants, collecting weeds and waste from each other's yards to create textile beauties. Teaming up with other foragers in your community can often yield good dye materials. Urban forage groups are also excellent for sharing the many ways a plant can be used.

IF YOU CHOOSE TO FORAGE

- You should be sure of what you are picking, as many plants have poisonous look-alikes. Carefully identify with field guides, and confer with plant experts—be they herbalists, botanists, or other natural dyers—who know their plant sources.

- Make sure that you are foraging on property where it is allowed; if there is any doubt, ask for permission before picking.

- For a safer, cleaner dye pot, avoid foraging close to main roads and parking lots, in commercially sprayed areas (including agriculture, especially corn fields), and near old houses that could be contaminated with lead and other toxins. Avoid foraging in unfamiliar lots or fields, near lawns that have been treated chemically, or downstream from factories or agribusiness that do not have sustainable practices.

- It is equally important to gather with awareness, prior permission, and thanks.

- Harvest only in abundant stands of naturalized plants or native flowers and leaves, and take no more than one-third. Choose plants that appear healthy,

but leave the strongest, out of respect and to encourage a future supply. Leave plants on the tops of hillsides so they can seed down the slope.

- Never gather wild endangered species. Many of these plants can be cultivated for medicinal use, or you can research other plants with similar properties that are not threatened. United Plant Savers (unitedplantsavers.org/species-at-risk) provides a list of endangered and at-risk plants.

- If possible, harvest only the necessary part of the plant. Digging up the root kills the whole plant; avoid this unless the plant is being eradicated or the root is needed for a dye.

- Develop a relationship with the plants you are gathering. Know the plants that grow around them and the kind of soil in which they appear healthiest; watch them mature through an entire season.

- Harvest humbly and give thanks to both the plants and the people who made it possible.

Ethical foraging and harvesting in the wild depends not only on knowing the type of plant you seek and how to identify it properly, but also on getting to know your native and seasonal plants; with that knowledge, you can help keep the natural landscape resilient and healthy.

NATIVE PLANT COLOR

Native plants are those that have evolved in a specific region over a long time period. These are the plants that native peoples of a particular region knew and depended on for food, clothing, and shelter. Working with native plants is often beneficial for many reasons; for one, it is often easier to identify their uses in your particular area because historical societies, local plant experts, and local libraries may already have information on how these plants were used and cultivated in your area. Of course, native plants are not just beneficial to humans; they are often well adapted to your region's climate, insects, and other natural conditions, so they are easy to grow with minimal care (and, often, minimal water).

As you get to know the wild and cultivated trees and plants you harvest from, you'll tune in to changes in the climate and soil quality as well as changes in the plants as they grow and age. Knowing your plants sharpens your senses; as you become attuned to nuances of seasons and weather, you learn to read

natural patterns. As you watch plants grow from season to season, you not only are prepared to collect the leaves and bark as they fall from deciduous trees but also come to know larger patterns and cycles at play with weather and climate change from year to year. For me, watching the wild fennel return each year in the Bay Area is always a true marker of summer.

Tending the landscape and even, more broadly, restoring our ecosystems are a natural extension of gathering and maintaining the sources of our color palettes.

PHYTOREMEDIATION PALETTES

Beyond their self-regenerating capability, many dye plants are also *phytoremediators*, meaning that they can pull metals out of contaminated soil, especially in urban and industrial areas. Because many metals can actually affect the dye color as additives, these plants hold the potential of adding the metals they have drawn into their roots, stems, and leaves—in effect, adding natural mordants and modifiers to the dye pot. The genus *Symplocos*, for example, hyperaccumulates—meaning it can absorb metals through its roots and into its leaves, which can then be processed into a plant-based mordant that contains alum to brighten and fix dye colors. One North American species is *Symplocos tinctoria* (sweetleaf, horse-sugar, yellowwood); an Asian species is *Symplocos paniculata* (sapphire-berry).

Sunflowers accumulate metals in the soil and therefore have the capability of actively amending toxic soil and can be a great plant for transitioning polluted urban spaces; they make an array of deep and vibrant colors.

Knowing the soil in your own garden and wherever you harvest your plants is important for nurturing a healthy environment—and staying safe. When you consider foraging for plants for your natural colors in vacant lots and along highways and freeways, be aware that the soil could be toxic. Avoid harvesting and processing dye plants for home use from potentially toxic sites; leave sites with possible toxic hyperaccumulation of heavy metals to the professionals who know how to safely dispose of heavily contaminated plants.

WORKBOOK

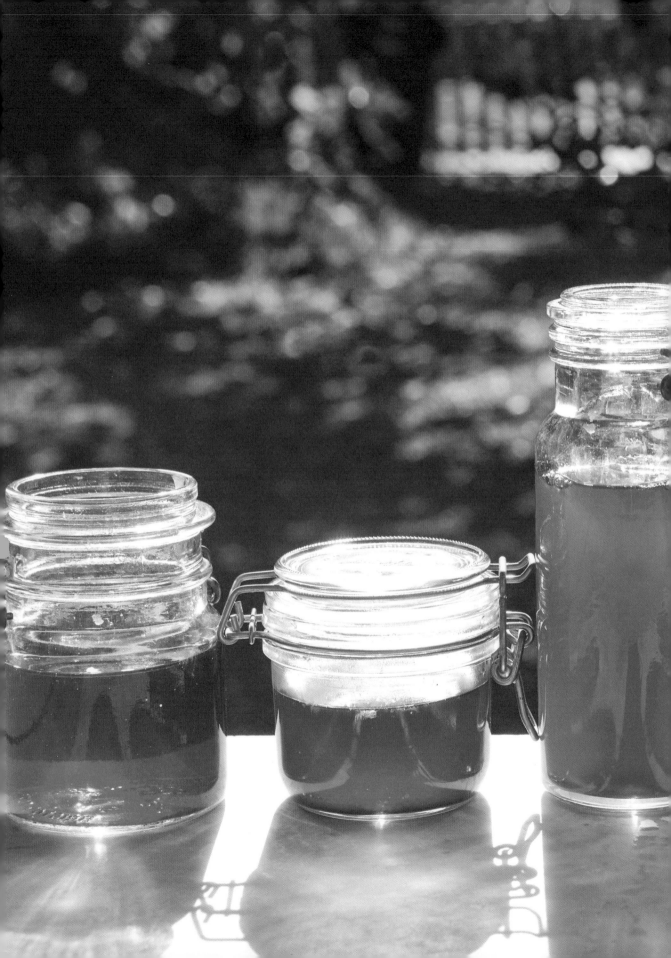

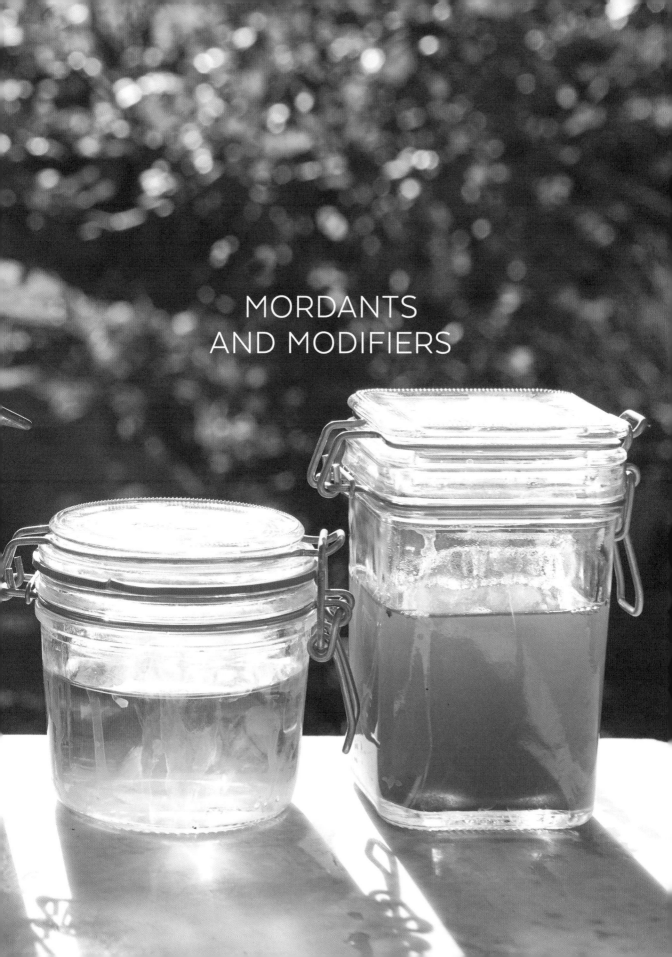

MORDANTS
AND MODIFIERS

METAL-BASED MORDANTS

BASIC ALUM MORDANT FOR WOOL

I've given measurements assuming four ounces of fabric, but you can easily scale this recipe up or down by weighing the fiber you are going to dye when it is dry, and then measure the aluminum sulfate as a percentage of the fiber's dry weight and using 8 percent aluminum sulfate to WOF.

When using wool fiber, make sure the water temperature gradually rises or lowers so the fiber is not shocked by a sudden change.

Cream of tartar can also be used an an additional agent in brightening and helping to assist dyes to bind with fibers in the process.

4 ounces wool fiber

1½ teaspoons aluminum sulfate

1½ teaspoons cream of tartar (optional)

Scour your wool fiber (see page 36)

Soak the wool fiber in water for at least 1 hour.

Place the aluminum sulfate and optional cream of tartar in a cup, add some boiling water, and stir to dissolve. Add the mordant mixture to a dye pot full of enough water to cover your fiber, and stir. Add the previously soaked fiber to the dye pot.

Place the dye pot on your burner. Bring the mordant solution to a low simmer, and simmer for 1 hour. Turn off the heat under the dye pot and remove the fiber, or allow the fibers to steep overnight.

Wash the fiber in water that is the same temperature as the dye bath; use pH-neutral soap to remove unfixed mordant. Gently rinse the fiber thoroughly until the water runs clear. For delicate fibers like knitted wool sweaters and other garments, it's best to lay them flat to dry so they keep their shape and don't stretch or felt.

The spent alum bath can be disposed of down the drain (unless it flows to a septic tank), along with plenty of running water. You can also pour the alum bath into the soil around your acid-loving plants.

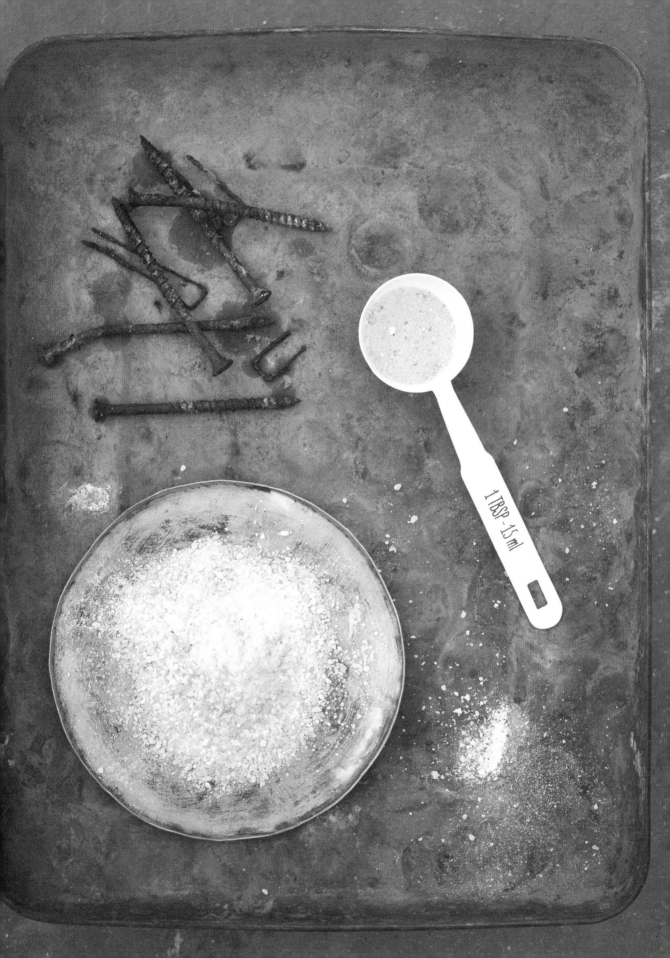

BASIC ALUM MORDANT FOR SILK

You can process silk fabric with a mordant the same way you would wool and other natural animal fibers.

This recipe calls for four ounces of silk. For other amounts, you'll need to weigh the silk before measuring the alum, which should equal 8 percent of the weight of the fiber. For silk, you can use either a cold-water or a hot-water dye method. If using hot water, follow directions on page 212. This recipe is for the cold-water premordant method.

4 ounces silk fabric

1½ teaspoons aluminum sulfate

1½ teaspoons cream of tartar (optional)

Scour your silk fabric (see page 36).

Soak the silk fiber in water.

Put the aluminum sulfate and optional cream of tartar in a cup, add 1 cup of hot water, and stir to dissolve. Add this mordant mixture to a bucket of lukewarm water and stir.

Put the wet silk fabric into the mordant bath and gently move it around in the bath for a few minutes. Leave the fabric to soak overnight.

Wash the fabric in cool water with pH-neutral soap to remove any unfixed mordant. Hang to dry.

ALUMINUM ACETATE MORDANT FOR PLANT-BASED FIBERS

You can also mordant your plant-based fibers (cotton, linen, hemp, etc.) with finer-grade aluminum acetate powder. A benefit of premordanting with aluminum acetate is that if you are not adding tannin (as you would in other plant-based mordanting recipes), you can get brighter and clearer colors on fibers and fabrics like cotton, linen, ramie, and hemp. (You'll want to wear a dust mask for this fine powder!) This recipe is for the cold-water dye method. For weights more than four ounces, use 8 percent of aluminium acetate per weight of fiber.

4 ounces plant-based fiber

1½ teaspoons aluminum acetate

Soak your plant-based fiber in water for at least 1 hour.

Put the aluminum acetate in a cup, add 1 cup hot water, and stir to dissolve. Add this mordant mixture to a bucket of lukewarm water (with enough water to fully cover your fibers) and stir.

Put your wet plant-based fabric into the mordant bath and gently move it around in the bath for a few minutes. Leave the fabric to soak overnight.

Wash the fabric in cool water with pH-neutral soap to remove any unfixed mordant. Hang to dry.

USING IRON AS A MORDANT

When iron is used as a mordant to bind color to fiber, it often also turns dye colors darker. Dyers use it in powder form (ferrous sulfate) so that it can be carefully weighed. You can order it from dye specialty stores; a little goes a long way. Iron can be used as a premordant and works equally well as an after-mordant. Either way, it can extend or alter the color from the initial dye bath. Iron usually takes effect very quickly, darkening the color or sometimes changing it completely.

Iron is also a natural color modifier. Modifiers are usually applied to the dye bath to alter the color after the initial dyeing has occurred. Some modifiers, like iron, can also be mordants, but most modifiers change the color but do not help bind the color to the fiber; this requires a mordant. You can create the iron solution ahead of time and store it in clearly labeled, glass jars until usage.

CAUTION: Iron mordants should be labeled and safely stored. Iron is nontoxic in very small doses, but can be potentially harmful and even fatal if swallowed in large quantities or with continued exposure, especially for children and pets. Small amounts of iron are all you will ever use with fabric, since certain fibers, like wool and silk, have been known to fall apart over time if they have been treated with too much iron.

It is important to always clean your pots well after mordanting fibers with iron. Iron mordant can leave a residue that can affect later dye baths by creating a duller or modified color, and it can create unwanted spots on your fibers or textiles. Even a little bit of iron can make colors more dull or gray. For these reasons, you might want to keep a dedicated dye pot just for iron mordanting.

BASIC IRON MORDANT FOR ANIMAL AND PLANT FIBERS

Before dyeing your fiber, weigh the dry fiber and record its weight; the iron powder will be measured in proportion to it.

4 ounces fiber

½ teaspoon iron powder (ferrous sulfate)

Soak the fiber in lukewarm water for at least 1 hour or overnight.

Fill a large stainless steel pot with enough water to cover the fiber and give it plenty of room so it takes the mordant evenly.

Bring the water to a simmer. Put the iron powder in a cup, add some hot water, and stir to dissolve. Add the dissolved iron solution to the simmering water and stir. Turn off the heat and let the water cool down.

Remove the fiber from the soaking water and add it to the dye pot. Heat to a simmer. Put a lid on the pot to keep any fumes from causing irritation to your eyes and lungs. Occasionally remove the pot lid and gently stir the fiber, allowing it to absorb the iron evenly. Simmer for 15 to 20 minutes.

Remove the dye pot from the heat and allow the fiber to cool before washing.

Wash the fiber with pH-neutral soap and rinse thoroughly to get rid of any remaining iron particles. Hang to dry.

IRON POWDER AFTER-MORDANT OR MODIFIER

Iron is also a good after-mordant for darkening or modifying dye color and can be used without heat. An iron modifier can be added directly to the dye bath after you've removed it from the heat and before adding the fiber. Measure the dry weight of your fiber before soaking. Use 2 percent of iron per WOF.

4 ounces dyed fiber

½ teaspoon iron powder (ferrous sulfate)

Soak the predyed fiber in water for at least 1 hour and set aside.

Prepare the dye bath you wish to use, according to any recipe in this book.

Remove the fiber from the soaking water and add it to the dye bath. Dye the fiber according to your chosen recipe. Remove the dye pot from the heat and let the fiber cool. Remove the fiber from the dye bath and hang it to reach room temperature.

Put the iron powder in a cup, add some hot water, and stir to dissolve. Add the iron solution to the dye bath and stir. The dye bath may be cool at this point— it's better to have the bath well below the boiling point to avoid breathing vapors. You should notice an immediate change of color for dyes that are sensitive to iron.

Return the dyed fiber to the dye pot. Stir gently so the fiber achieves even coloring. Let the fiber soak in the dye bath for at least 15 to 20 minutes.

Remove the fiber, wash well with pH-neutral soap, and rinse thoroughly. Hang to dry.

HOMEMADE IRON MORDANT SOLUTION

You can easily create an iron mordant solution, or iron liquor, by soaking rusty found objects like nails in white vinegar and water sealed in a 1 quart jar; just let time work its magic. You can keep it stored indefinitely in a lidded, labeled jar for your projects. A little can go a long way.

10 large rusty nails or other rusty iron objects
Water
White vinegar

Put the rusty iron objects into a jar. Add 2 parts water to 1 part vinegar to the jar, enough to cover the iron objects. Put the lid on the jar and seal tightly. The water will turn a rusty orange color in 1 to 2 weeks. You can let this iron mordant liquor sit for as long as you like.

Presoak the already dyed fiber for at least 1 hour before mordanting with the iron liquor.

The iron liquor can be used as a mordant by adding it to a nonreactive dye pot and adding enough water to cover your fibers. Add the presoaked dyed fiber, bring the iron bath to a simmer, and gently simmer for 10 minutes.

Remove the dye pot from the heat and let the fiber cool. Remove the fiber from the pot and squeeze excess iron solution back into the dye bath, which can be stored as iron mordant for later use.

Thoroughly wash the fiber with pH-neutral soap and rinse until the water runs clear to remove all iron particles. Hang the fiber to dry.

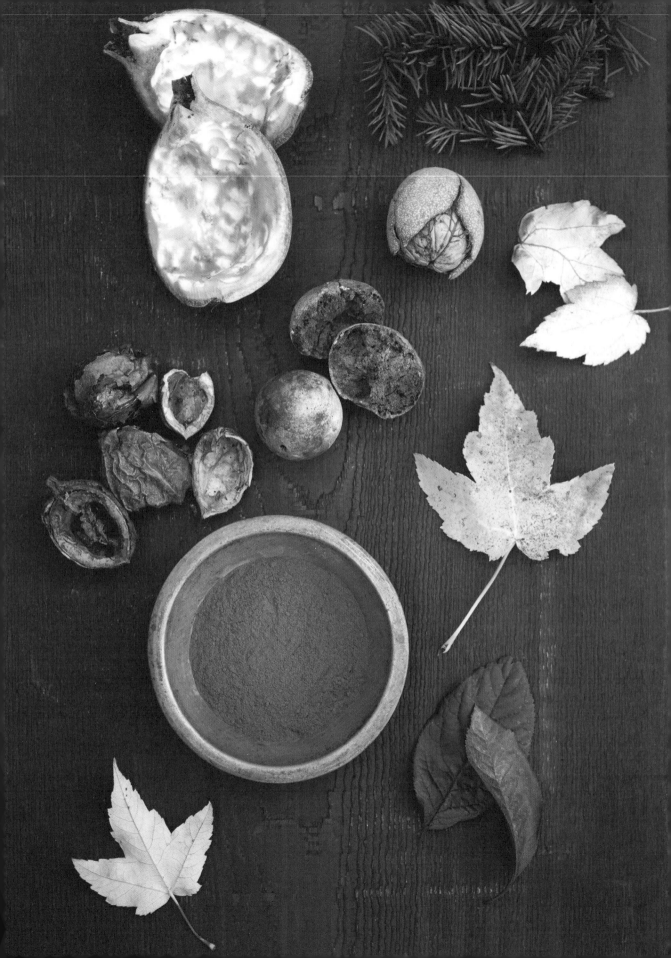

PLANT-BASED MORDANTS

As you have learned, certain plant materials contain high concentrations of tannin, which works well as a natural mordant to bond color to plant-based fibers. Tannin is a nontoxic substance found in many plant sources like bark and leaves. Tannin in combination with alum can provide greater color ranges with more successful results than with tannin alone on most plant fibers.

Certain tannin-bearing plant materials work especially well as mordants; these include acorns, oak galls, pomegranate rinds, juniper needles, and sumac leaves. Some tannin substances like oak galls will bind to the fiber and stay clear, allowing the true color of the dye source to saturate the fiber. Other tannins can alter the color by making it dull, especially if the dyes are yellow, pink, or brown tones.

Acorns Acorns can be collected under oak trees in autumn, or you can buy acorn powder from specialty herbal or grocery stores. Remove the shells and grind foraged acorns to a powder. Soak the acorn material in water for several days to get the full color intensity. Acorns create colors from light beiges to grays and teal-blues.

Juniper needles A natural mordant can be made from the needles of the juniper tree (*Juniperus communis*). Gather the dry branches and burn them over a wide basin. Catch only the needle ashes, and add 1 cup of ashes to 2 cups of boiling water. Stir and strain. The liquid is the mordant.

CAUTION: Be careful with this homemade mordant. Since the ashes and water can form a type of lye, which is highly alkaline and can cause burns, use gloves and other protective measures when working with it.

Oak galls Oak galls are formed where wasps have laid their eggs on oak tree branches. The galls look like balls sticking to the branch. Among the plant-based mordants, oak galls contain the highest amount of tannic acid; it enhances the dye color and improves colorfastness, especially for plant fibers. Galls can be collected from many kinds of trees, particularly oak trees (*Quercus* species).

Pomegranate rinds The rind or skin of the pomegranate fruit (*Punica granatum*) can be used as a tannin mordant as well as a dye to obtain peachy yellow (with alum mordant) and to create gray to moss green and black (with iron mordant). The age of the fruit affects the color of the dye: the less ripe the fruit, the greener the yellow.

Sumac leaves The leaves of sumac (*Rhus* species) are rich in tannin, making them a good natural mordant. Sumac as a mordant brightens and extends colorfastness for most plant-based fibers. When using tannin mordants with plant fibers like cotton, linen, or hemp, allow extra time for the process; it can take up to two or three days.

Symplocos The leaves of the symplocos plant (*Symplocos* species) can be powdered and used as a substitute for alum as a mordant; the plant is an active bioaccumulator of metals such as aluminum straight from the soil it grows in. Symplocos mordant can be bought in powdered form and used to make some exciting new colors on both plant- and animal-based fibers.

BASIC TANNIN MORDANT WITH PLANT-BASED FIBERS

Two popular sources for making a tannin mordant that won't dull your dyes are oak galls (from *Quercus* species) and sumac leaves (*Rhus* species). This recipe is for oak galls, but you may substitute sumac leaves of the same fiber weight.

4 ounces plant-based fiber

1 teaspoon powdered oak galls (tannic acid)

Scour your plant-based fiber (see page 36).

Soak the fiber overnight in cool water.

To make a tannin bath, put the oak gall powder in a stainless steel pot with 4 to 6 gallons of water; stir to dissolve. Bring the solution to a simmer, and simmer for 30 to 60 minutes. Remove the pot from the heat. Allow the tannin bath to cool down from hot to warm. Lift the wet fiber out of its soaking pot and submerge it in the tannin bath. Let it steep for 8 to 24 hours.

Remove the fiber from the tannin bath. Rinse the fiber in lukewarm to cool water, wash with a pH-neutral soap, rinse again thoroughly, and hang to dry.

ALUM MORDANT WITH TANNIN-TREATED PLANT-BASED FIBER

After processing your plant-based fiber with a tannin bath before dyeing, you may want to use aluminum sulfate as an additional mordant to make your color even brighter. When you have rinsed the tannin out of the fiber, apply an alum premordant once (or twice for even brighter results from your dye).

4 ounces plant-based fiber

Basic Tannin Mordant (page 223)

4 teaspoons aluminum sulfate

1½ teaspoons soda ash

Scour your plant-based fiber (see page 36).

Soak the fiber in water for at least 1 hour. Premordant the fiber in tannin solution, rinse, and hang it to drip while you make the alum mordant solution. Put the aluminum sulfate and the soda ash in a stainless steel pot half full of water and stir well to dissolve. Add more water to the pot, enough to cover the fiber you will be treating, and then add the wet, tannin-treated fiber to the pot.

Bring the pot to a simmer. Turn off the heat and let the fiber steep for 4 to 8 hours, making sure to stir occasionally so the fiber absorbs the mordant evenly. Remove the fiber and gently squeeze the mordant solution back into the pot.

For darker dye color results on plant-based fibers, you can premordant your fibers twice before dyeing. You can use the same water, and there's no need to rinse the fibers between processes.

Wash with a pH-neutral soap, rinse thoroughly, and hang to dry.

DYEING AND MORDANTING TOGETHER: ALL-IN-ONE METHOD

For a quicker, more energy-efficient method of dyeing and mordanting, you can extract the dye and then add the mordant directly to the dye bath before adding your fiber. This is the all-in-one method.

Scour your fiber (see page 36).

Rinse and soak the fiber for at least 1 hour prior to dyeing and mordanting.

Follow a dye recipe to extract dye from the plant material. Strain the plant material from the dye bath. Let the dye bath cool down.

If you are working with a cold-water dye bath: Put the appropriate amount of mordant in a cup, add some hot water, and stir to dissolve. Add mordant to dye pot and then add fiber and let steep for several hours until the desired shade is reached.

If you are working with a hot-water dye bath: Add the measured mordant directly to the extracted color in the dye pot and stir well. Add the fiber to the dye pot, bring the bath up to a simmer, 185°F, and simmer for 20 to 30 minutes, or until the desired shade has been reached.

Remove the fiber from the dye pot, cold or hot. Wash it gently in lukewarm water with a pH-neutral soap and rinse well until the water runs clear. Hang to dry.

USING YOUR POT AS A MORDANT

Using an iron, copper, or aluminum pot as a mordanting vessel can be an efficient way of saving one step in dyeing. The dye color results will be less easy to measure, but the experimentation and ease of the pot-as-mordant method can make for artistic results. You can stock your dye studio with pots that are made out of these metals.

Scour and then soak the fiber in water. Place the fiber in a metal mordanting pot (either iron, copper, or aluminum) either full of water for premordanting, or the dye itself for an all-in-one method of dyeing and mordanting. Bring the bath up to a simmer, and simmer for 30 to 60 minutes. Turn off the heat and let the fibers soak overnight.

Remove the fiber from the dye pot. Wash gently with pH-neutral soap and rinse well. Hang or lay flat to dry out of direct sunlight.

SAFELY DISPOSING OF YOUR MORDANTS AND DYE BATHS

Responsible disposal of your materials is an important part of sustainable practices. Leftover mordant solutions made with alum, iron, and tannin, if absorbed effectively by the fiber, can be safely poured down the drain or poured onto the soil in your garden. Cooled alum and iron mordant baths can also be poured around the base of acid-loving plants like conifers, mountain laurels, azaleas, hydrangeas, and blueberries. These metallic compounds are often used to fertilize these plants in higher concentrations. Be careful, however, to not disturb the pH balance of your soil or compost pile by pouring too much acid or alkali into your garden and hurting your plants—dispose of your mordant in moderation and in different spots in your garden over time.

To neutralize the pH of your dye bath before disposing of it down your drain or in your garden, you can do a quick pH strip test of how acidic or alkaline your dye bath is. To increase acidity, add plain white vinegar; and to increase alkalinity, add baking soda.

Making Stock Mordant

If you plan on making lots of natural color—and trust me, once you delve into the realm of making color from scratch, it's hard to stop—there's an easy and safer way of working with mordants: in liquid solutions rather than in powder form. This minimizes your exposure to potentially harmful inhalation of the mordant powders. Making mordant solutions can also save a lot of time, as you can store your solutions indefinitely and don't need to weigh your mordant every time you work with it. To make a mordant solution, dissolve the crystals in boiling water. Four ounces of mordant crystals powder will make 2 pints of liquid solution. Store the liquid solution in a nonreactive glass or plastic container. Every time you use the solution, make sure that you stir and shake it well to redistribute the mordant. To use the liquid solution, measure 2 teaspoons of liquid for every 0.04 ounce needed per weight of your dry fiber. Sixteen teaspoons is equal to 0.32 ounces of powder mordant needed when you make your calculations based on dry WOF.

USING MODIFIERS

Some mordants, like iron, can also double as a modifier. A modifier can be used after the initial dye process to change the color you've created on a fiber. Modifiers can also be used to create variegated colors on a single piece of fabric. For instance, you can dip one end of a red cabbage-dyed piece of fabric in an acid modifier and the other end in an alkaline modifier and get two strikingly different color changes. White vinegar and citric acid are easy acid modifiers to experiment with. Wood ash and baking soda are alkaline modifiers that can also provide striking results.

SOME COMMON PH MODIFIERS FOR NATURAL COLOR

ACIDS	ALKALIS
Citric acid	Ammonia
Cream of tartar	Chalk (calcium carbonate)
Lemon juice	Lime (calcium hydroxide)
Tartaric acid	Lye (sodium hydroxide)
Vinegar	Soda ash (sodium carbonate)
	Wood ash

You can also add modifiers directly to certain plant dye baths to change the color before or after you add the fiber you wish to dye.

Plant-based fibers can handle more alkaline dye baths than animal-based fibers, so be aware when pushing your pH higher in alkalinity. It is always great to start small with fiber sample before working on bigger projects.

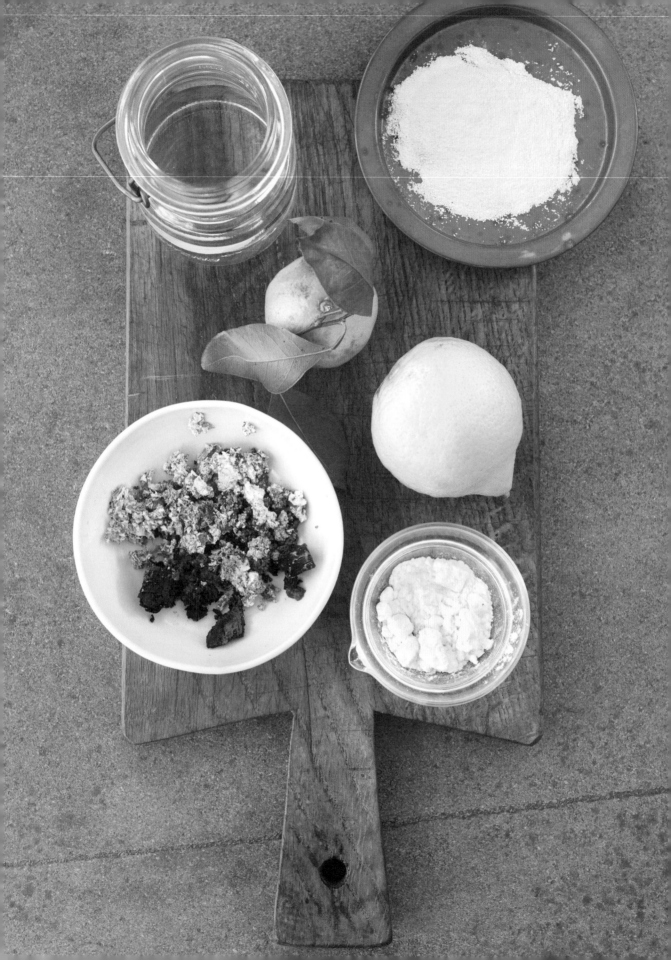

FIRE PIT OR FIREPLACE WOOD ASH: ALKALINE MODIFIER TO CHANGE AND EXTEND COLORS

Collecting wood ash from your fire pit in summer or fall, or from your fireplace in winter or early spring, is a smart way to take advantage of a common by-product. You can also make friends with your local wood-fired pizza restaurant if you are looking for large amounts of ash, which comes in handy for organic indigo vats.

If you wish to do an alkaline after-bath to shift your dye colors, collect approximately 1 teaspoon of wood ash for every 4 ounces of fiber. To make a concentrate, squeeze wood ash through a cheesecloth immersed in warm water; repeat over several days. Then submerge your predyed fibers and fabrics into the solution for approximately 15 to 20 minutes. You can sometimes see dramatic changes—for instance, with more pH-sensitive dyes like hibiscus, red roses, and Hopi black sunflower seed, the dye will shift from fuchsia and pinks to greens, blues, and blacks. It also shifts oxalis flower dyes from yellow to rusty orange.

THE NATURAL COLOR PALETTE

Using mordants to intensify, or even radically alter, your natural dye bath is a fun and creative process. Here are swatches showing the range of colors possible with the dye plant alone, and with the addition of the mordants alum, iron, or both together.

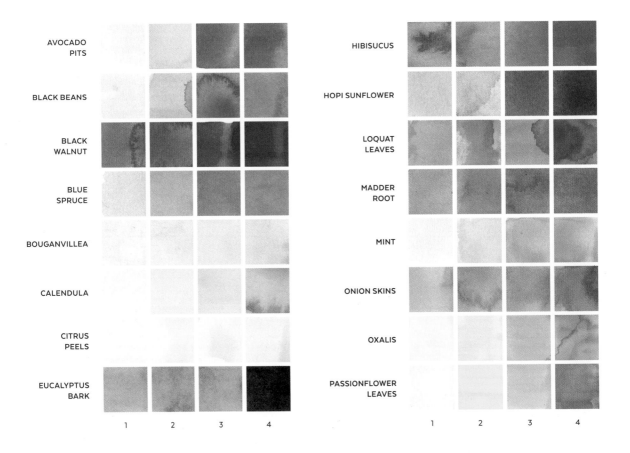

AVOCADO PITS
BLACK BEANS
BLACK WALNUT
BLUE SPRUCE
BOUGANVILLEA
CALENDULA
CITRUS PEELS
EUCALYPTUS BARK

HIBISUCUS
HOPI SUNFLOWER
LOQUAT LEAVES
MADDER ROOT
MINT
ONION SKINS
OXALIS
PASSIONFLOWER LEAVES

1 2 3 4

1 2 3 4

MORDANTS
1: SOLO, 2: ALUM, 3: ALUM + IRON, 4: IRON

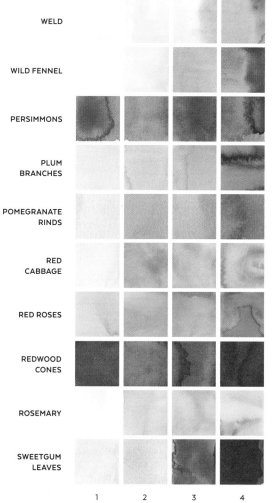

WELD

WILD FENNEL

PERSIMMONS

PLUM
BRANCHES

POMEGRANATE
RINDS

RED
CABBAGE

RED ROSES

REDWOOD
CONES

ROSEMARY

SWEETGUM
LEAVES

1 2 3 4

Some plant dyes are unaffected
by mordants but can still achieve
a range of hues by other means.
For indigo, it's number of dips,
and for aloe, it's the addition of
soda ash that yields a pinkish coral.

ALOE

FRESH INDIGO

INDIGO

TECHNIQUES

SHIBORI

Shibori is a Japanese technique of folding, wrapping, sewing, clamping, and tying fabric to resist dye thereby creating patterns. There are many ways of creating shibori patterns on textiles; here, I share two of my favorite methods. Because the process is so much about the variability of the dye used and the hand making of the patterns, there are infinite ways to create resist patterns with this method. It is also super easy to innovate and create your own unique patterns.

ITAJIME SHIBORI

This technique calls for pleating the fabric in equal panels, back and forth (as you would a paper fan), folding it again the other way, and then binding it with the clamps before you dye it. This can produce some intriguing gridlike patterns. You can also fold it back and forth in a triangle shape for stunning radial effects.

Fold the dry fabric back and forth like a fan. Then turn 90 degrees and fold it back and forth again to create a square.

Bind the fabric square or triangle with twine or tie pieces of clean wood on each side of the folded fabric securely with cooking twine or rubber bands.

Soak the bound fabric in water for at least 10 minutes.

Add the bound fabric to a dye bath of your choice. Let the fabric simmer in the dye bath for at least 20 minutes, or long enough to completely saturate the fabric.

Remove the bound fabric from the dye bath. While it is still folded and bound, rinse in clear water. Untie the fabric, and admire the beautiful pattern you have made.

Wash the fabric with pH-neutral soap, rinse thoroughly, and hang to dry.

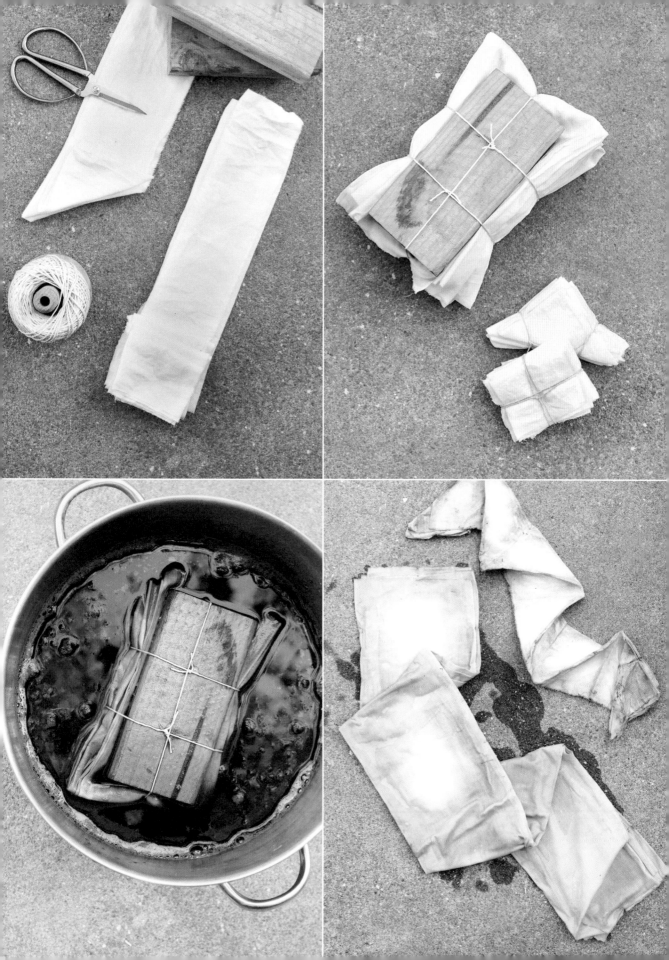

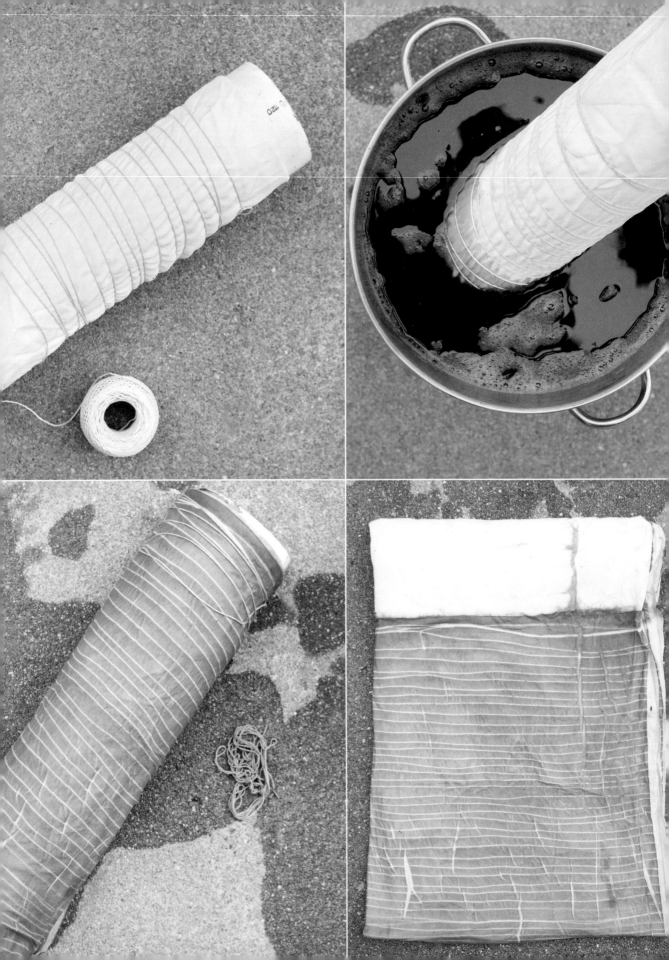

ARASHI SHIBORI

Arashi is the Japanese word for "storm," and the pattern is thought to evoke driving rain and wind. *Arashi* shibori is also known as pole-wrapping shibori. In this method, the cloth is wrapped straight or on the diagonal around a pole and then very tightly bound by winding thread or twine up and down the pole. You can also scrunch the cloth on the pole after binding it. The result is a pleated textile with a design on the diagonal.

Fold clean, presoured, and if necessary premordanted fabric, suitable for the dye bath you are working with, around a pole of the right size (for king-sized bed pillowcases, I used a PVC pipe with a diameter of 5 inches) that can be safely submerged in the dye bath. PVC or stainless steel pipe comes in appropriate diameters and is nonreactive; you can have a length cut at most hardware stores or visit a reuse salvage shop or yard. I love working with arashi in a bucket or larger indigo vat, as these deeper vessels accommodate longer poles when off the heat.

Depending on the thickness of the lines you wish to repeat, you can bind the fabric with sewing thread, cotton twine, or rope. Make sure that the thread is strong and long enough to wrap in the complete desired pattern. Waterproof masking tape can help you hold the fabric in place while you get the best, most even wrapping around your pole.

Once you are done wrapping, you can push all the fabric (still wrapped with thread) tightly into a bunch and secure it with an extra knot or piece of masking tape before submerging the wrapped pole into the dye bath/color of choice.

For indigo dyeing, submerge the pole in room-temperature dye for 3 minutes. Take it out for 3 minutes to expose the fabric to air, thereby oxidizing the blue. Then redip according to how dark you want the fabric. For other plant-based natural dye baths, submerge the arashi shibori for at least 15 minutes or more. You can take the dye bath off the heat and leave the wrapped pole submerged overnight for more saturated colors.

When the desired shade has been achieved, remove the pole from the dye bath. While it is still wrapped and bound, rinse it in clear water.

Unwrap the fabric and admire the beautiful pattern you have made. Wash the arashi-patterned fabric with pH-neutral soap, rinse thoroughly, and hang to dry. You may use the extra dyed string that made the pattern to embroider, knit, or crochet—or even use it to tie up the fabric you've dyed as a gift!

DIP-DYE

Creating an ombre or gradient effect by dip-dyeing fabric is one of my favorite ways to create simple and minimal surface design. I especially love this technique because it shows the gradient color potential of the plants themselves, the base color of the fabric, and how multiple shades can combine and contrast to really highlight the color and its potential. Martha Stewart once described ombre as "the transition from wakefulness to slumber." I agree!

Scour your fiber (see page 36), and premordant as needed.

Soak the part of your fiber that you wish to dip-dye in lukewarm water.

Dip the fiber into the dye bath. Each successive lowering of the fiber into the bath will create deeper color on the section submerged longest; by dipping the fiber for different lengths of time, you'll create gradients of the same color.

You can hold the project by hand if you are patient, or rig up a support to make sure it can't move as you dip each band of color. This is safer if the dye is off the heat so you can avoid accidentally coming in contact with a flame.

Each layer benefits from a dip of at least 15 to 20 minutes, unless it's indigo, in which case it's 30 seconds to 3 minutes. These dip times ensure that the dye and fiber molecules have had enough time to bond securely.

Wash the dip-dyed section of the material in temperate water with pH-neutral soap, rinse, and dry it out of direct sunlight.

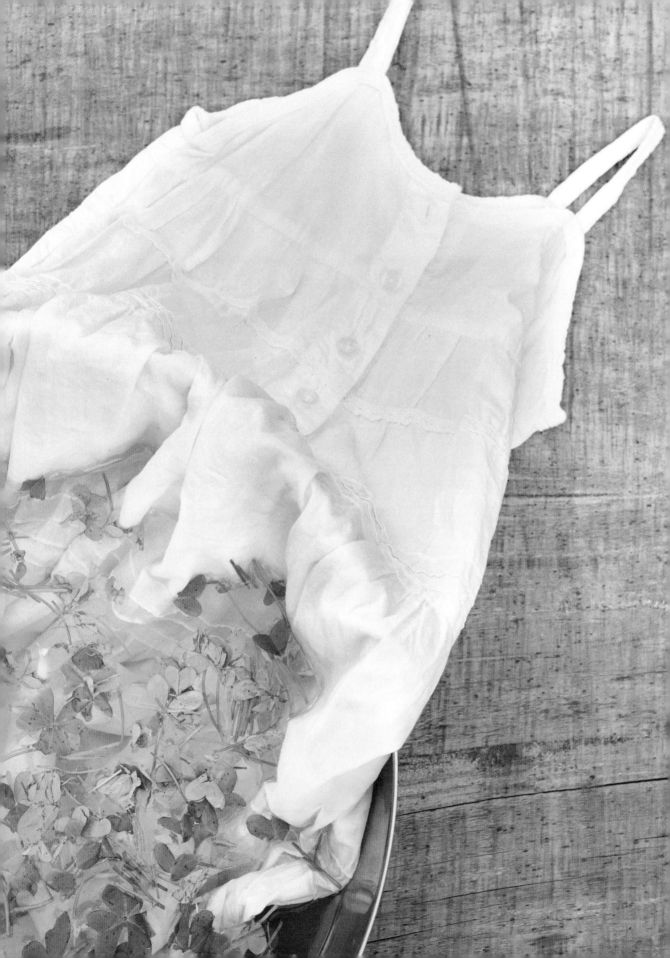

STEAM PRINTING

One of my natural dye heroes is Australian plant alchemist and artisan India Flint. India, a gifted natural dyer, has pioneered the use of bundles and steam prints that apply color and pattern in one fell swoop.

My favorite part of steam printing is how the fabric looks as the plants are being layered onto the cloth itself—it is an incredibly satisfying process with gorgeous results. Over the past few years at California College of the Arts, students have explored and experimented with this process, finding that it works well for transferring color and images more directly onto fabric and fibers than can be done with immersion dyeing; it can also imprint much darker versions of the plant dye on fabric. With steaming you can capture a plant or leaf print so directly that it looks like a photo image on the fabric.

In choosing plants to try with this technique, it is best to work with those that you have properly identified as strong color producers—one of my favorite plants to work with are dark rose petals, not only for the colors they make, but for the aroma of dye bath.

Scour the fabric (see page 36) and premordant, if neccesary. Then, lay out the plants on the material chosen in your desired arrangement. Roll the fabric carefully around the plants, as you would when making a spring roll. Tie the roll with strong butcher string to ensure that it won't break under the steam.

Next, prepare a steam bath for dyeing. You can use a vegetable steamer or a crock pot; for larger projects I use my bayou cooking steamer, a large pot with a special perforated insert (like a pot-shaped colander) to allow for maximum steaming potential and large projects.

Fill the bottom of the steamer with water, and heat to low boil. Carefully place rolled fabric in the steamer basket and put on the lid.

The steaming process can take 1 to 3 hours, depending on your chosen plants and fibers.

Be careful when lifting the lid to check on the steam bundles: the heat and water vapor, especially in a large pot, can be scalding. Always use potholders and wear long sleeves and heat- and water-resistant gloves and boots. Keep your face away from the first release of steam.

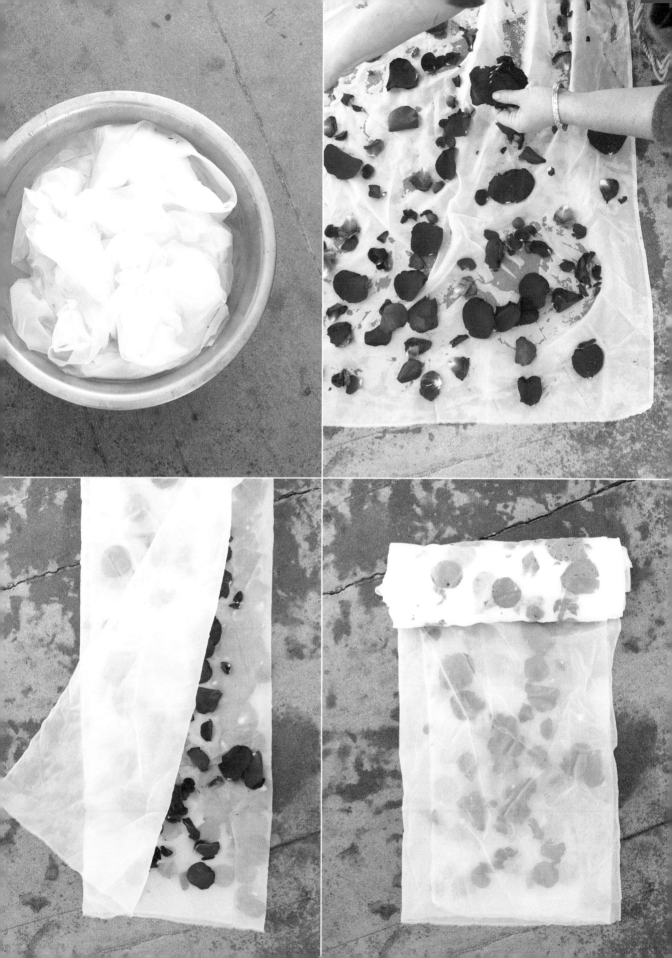

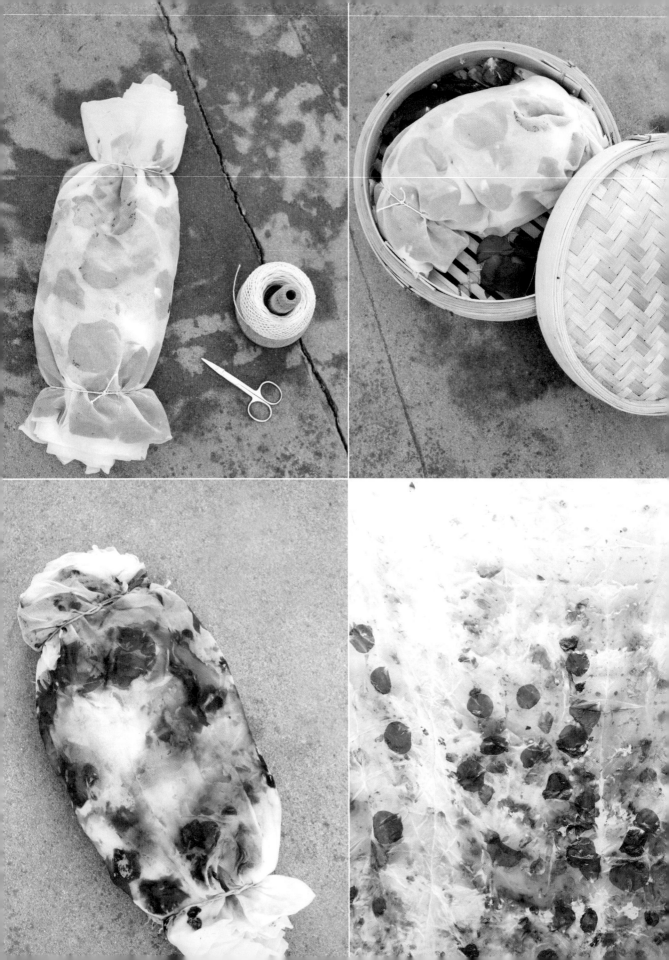

Once you have finished steaming, whether you have premordanted, sprayed, or directly applied mordants and modifiers after the initial steaming of your fabric, unfasten the bundles and carefully unroll them.

Rinse your steam-printed textile in pH-neutral soap and hang it to dry out of direct sunlight.

After your plant has steamed into the fiber, you can also fill spray bottles with iron, alum, lemon, and soda ash solutions and spray onto the rolled fabric; with this method you can realize the full potential of the possible pH and mordant changes.

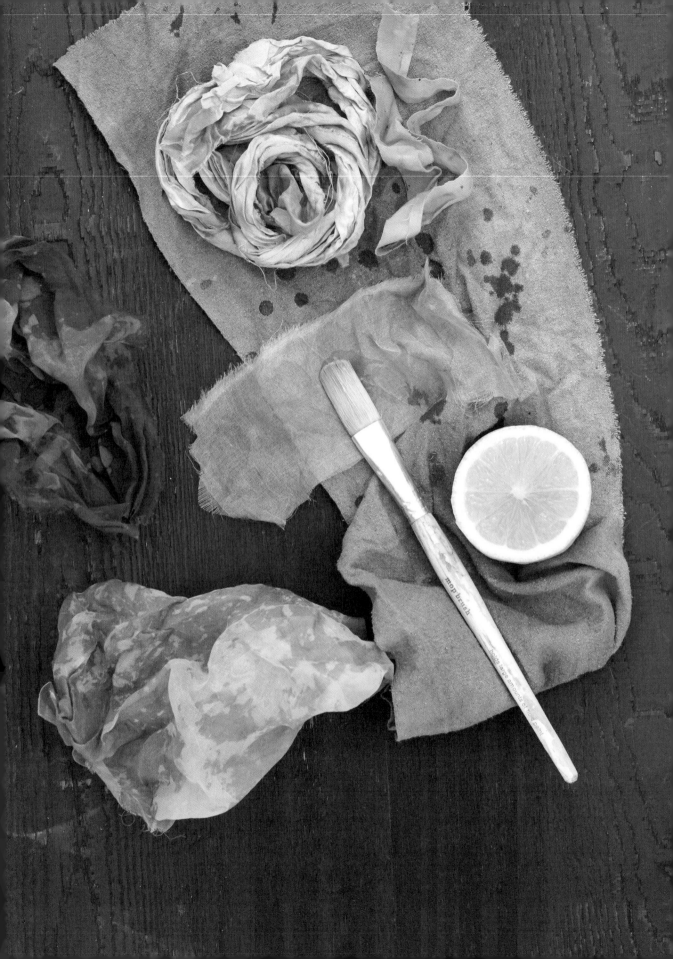

CITRUS BLEACH RESIST

I learned about the bleaching power of citrus firsthand: I accidentally squeezed a lemon that sprayed onto a dark gray dress dyed with Japanese maple, which was instantly bleached out. Many natural dye books don't divulge just how pH-sensitive certain dyes can be—then, of course, the garment becomes a walking candidate for environmental interaction! Deep dark colors dyed with plants that contain tannins and react heavily with iron are particularly vulnerable. One spritz of a lemon, splash of salad dressing, or other highly acidic element can bleach out that dark color on the spot. This can be devastating if unexpected, but if you know about this, you can purposefully create a citric acid resist paste or paint—an incredible design tool to make patterns and to take out unwanted iron spots, much like commercial bleach but much safer.

Lemon juice is a natural, nontoxic bleach and can very effectively remove iron from fiber, so remember this when working with iron as a mordant with certain plant dyes. You can, in fact, create some interesting patterning effects with lemon juice placed artfully on iron-mordanted fabric.

To create a citrus bleach resist, simply squeeze lemon juice into a jar and apply directly to fabric with a paintbrush. You can also dilute the lemon juice with water as needed to create a more subtle effect.

PASTES FOR PRINTING AND PAINTING

Direct application of natural dyes and mordants can be extremely rewarding. Pastes give you more precise control and can be used by painting, block printing, and screen printing. I use guar gum powder, available at most health food stores as a natural food thickener, to thicken dye solutions.

Here are some simple guidelines when working with pastes:

- Make sure the fibers are scoured before you begin. You can also choose to premordant the fiber, but take into account that the mordant will affect the colors of the dyes you are using.

- Remember that different fibers "like" different mordants. Plant-based fibers (like cotton, hemp, and linen) prefer a premordant of tannic acid or aluminum acetate. Animal fibers, such as silk, wool, and leather, prefer aluminum sulfate. Many mordants are already in powdered form that makes it easy to mix them evenly into a paste.

- CAUTION: Wearing a dust mask for mixing mordants is a must to block the fine particles that could irritate your nose, throat, and lungs.

MAKING MORDANT, MODIFIER, AND RESIST PASTES

These general recipes for mordants, modifiers and resist-printing pastes will yield 1 cup of paste.

Alum Mordant Paste

2 tablespoons guar gum powder

1 tablespoon alum

Acidic Modifier

2 tablespoons guar gum powder

1 teaspoon lemon juice

Iron Mordant Paste

2 tablespoons guar gum powder

1 teaspoon iron powder

Alkaline Modifier

2 tablespoons guar gum powder

1 teaspoon soda ash

Begin by using a blender reserved just for plant dyeing. Pour 1 cup of hot water into the blender, add your desired mordant or modifier, and then add 2 tablespoons of guar gum powder in thirds, blending evenly. If you don't have a blender, you can use a small whisk and 1 cup of hot water in a glass mason jar and then add your guar gum to the mixture, also in thirds so that it doesn't clump. Whisk vigorously until the guar gum has been fully and evenly dissolved in the hot water.

You can make weaker and stronger versions of the mordant powder and gum mixture depending on the shade you want to create. You can use mordant powders (iron, alum, or tannic acid powder), resists (lemon), or pH and color modifiers like an acid (lemon, vinegar, or citric acid powder) or alkaline (soda ash, baking soda, or lime) to adjust your color.

MAKING PLANT DYE PASTES

DYE REDUCTION FROM FRESH PLANT MATERIAL

If you are making natural color paints and pastes from fresh materials, you will want to make sure that you extract the darkest color possible from the plant you've chosen. To create the most concentrated dye, use just enough water to cover your material. Bring your liquid to a boil and then gently simmer your dye material to create a darker dye stock (as you would if making a syrup). You want the water to evaporate from your dye solution, at the same time leaving more of the concentrated dye and pigment.

To turn your natural dye into a paste, take 1 cup of heated, concentrated plant dye liquid (the heat will help dissolve guar gum thoroughly) and 2 tablespoons of guar gum powder.

Using a blender reserved just for dyeing, or a handwhisk in a glass jar, add guar gum in thirds to make sure that you evenly dissolve the powder and make a smooth, thickened paste.

You can change the intensity of the color of your paste by adding more or less dye concentrate to the solutions.

If you are screenprinting with natural dye paste, you'll want to run at least 7 layers of your printing paste through your screen as compared to the typical 3 layers with synthetic print pastes.

FIXING THE DYE AFTER PAINTING AND PRINTING

To create the best bond and to further fix your dye to your fabric, it helps to steam your paste into the fabric, which sets the dye fiber molecules.

You can steam your projects by taking a clean piece of heavy cotton canvas and carefully rolling your dried patterned fabric into it. You can then secure the ends of your fabric role with rubber bands or heavy twine.

Place your fabric in a steamer and steam for approximately 40 to 60 minutes.

Unroll your fabric and let your textile cool and air dry out of direct sunlight.

Your fabric is now ready for use!

BLOCK PRINTING

Block printing is a fun way to create a simple pattern design on a textile. It is one of the oldest forms of printing, also known as relief printing. Block printing can add depth and pattern to your plant-dye projects on textiles, paper, and other porous surfaces. Although there are quite a few steps involved for creating more intricate printing patterns, it can be worth it. Once you have your printing block carved, you can continue to print with the same block, creating a handmade effect in multiples as well as experimenting with a different colors.

SIMPLE PRINTING WITH FOUND OBJECTS

Block printing with natural dye, mordant, and modifier pastes can be as simple as using objects you may already have in your kitchen, home, or studio.

A glass jar or cup of just about any size can be easily dipped into your paste and printed on fabric to make circle repeats.

The eraser head of a pencil can be a wonderful way to repeat smaller solid circles, (featured in the pomegranate rind confetti cocktail napkin printing project, page 181).

Sponges can be cut into simple shapes and used directly on the fabric.

Many plants, including bark, leaves, seeds, pinecones, and flowers, can be used directly as printing tools to repeat interesting organic shapes, textures, and designs.

Other items that make great readymade shapes include old doorknobs, fruit containers, potato mashers, and of course the potato itself for carving!

Note that once you've used an item to dye with, it should no longer be used in the kitchen.

MAKE BLOCKING STAMPS FROM SCRATCH:

You can buy linoleum blocks at art and craft stores.

Sketch Your Design The first step is to sketch a simple design on a piece of paper. You can then draw this directly onto your linoleum block and begin carving or use a piece of carbon paper so that you can transfer your image from the drawing directly onto your block as a transfer (keep in mind that with this method, your drawing will be reversed).

Carve Your Design Use a simple block-printing carving tool (available at your local art store) for carving away the parts of the linoleum that you do not want to print. What is left will become your stamp.

Printing Scour and premordant your fiber. Dollop a small amount of the paste onto your stamp. The ink should be thin and even on the block for the clearest translation of your design.

Next, take the evenly inked block and turn it over to position it for printing on the fiber. If printing on a large piece of fabric, it is helpful to first lay down a drop cloth on an even surface, then use T-pins on the fabric so that it stays flat and taut, without shifting. Press down and apply equal pressure across the block.

Setting the Block Print Let the ink fully dry so that the print will not smear. When dry, cover the printed surface with a clean cotton cloth and steam iron over the design to heat and set it, or roll your fabric together with thick cotton canvas (so your design will not smudge or reprint on itself!) and put the roll in a steamer for 40 to 60 minutes.

Your naturally printed textile should now be ready for gentle washing with pH-neutral soap to remove any lingering stiffness from the paste.

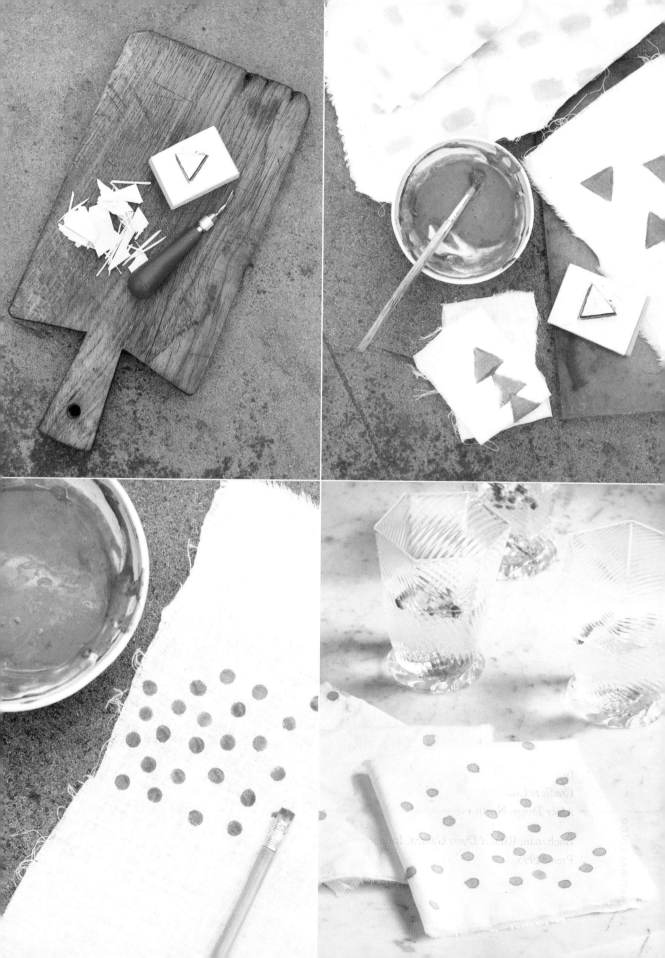

BIBLIOGRAPHY

Aftel, Mandy. *Fragrant: The Secret Life of Scent.* Riverhead Books. 2014

Albers, Joseph. *Interaction of Color: 50th Anniversary Edition.* Yale University Press. 2013

Anderson, M. Kat, *Tending the Wild: Native American Knowledge and the Management of California's Natural Resources.* University of California Press. 2006

Ashworth, Susanne, *Seed to Seed: Seed Saving and Growing Techniques for Vegetable Gardeners.* Seed Saver's Exchange. 2002

Balfour-Paul, Jenny, *Indigo: Egyptian Mummies to Blue Jeans.* Firefly Books. 2011

Barber, Elizabeth Wayland, *Women's Work: The First 20,000 Years- Women Cloth and Society in Early Times.* W. W. Norton and Company. 1995

Barlow, Zenobia, Capra, Fritjof, Stone, Michael K, *Ecological Literacy, Educating Our Children For A Sustainable World.* Sierra Club Books. 2005

Benyus, Janine. *Biomimicry: Innovation Inspired by Nature.* Harper Perennial. 2002

Bliss, Anne, *Weeds: a Guide for Dyer's and Herbalists.* Juniper House. 1978

Braungart, Michael, McDonough, William. *Cradle to Cradle: Remaking the Way we Make Things.* North Point Press. 2002

Buchanan, Rita. *A Dyers Garden.* Interweave Press. 1995

Burgess, Rebecca. *Harvesting Color.* Artisan. 2011

Cardon, Dominique, *Natural Dyes.* Antique Collectors Club Ltd. 2007

Chapman, Jonathan, *Emotionally Durable Design: Objects, Experiences and Empathy.* Routledge. 2015

Cline, Elizabeth, *Overdressed: The Shockingly High Cost of Fast Fashion.* Penguin. 2012

Conrad, Chris, *Kakishibu Traditional Persimmon Dye of Japan.* Chris Conrad. 2008

Corwin, Lena, *Printing by Hand: A Modern Guide to Printing with Handmade Stamps, Stencils, and Silk Screen.* Stewart, Tabori and Chang. 2008

Dean, Jenny, *Wild Color: The Complete Guide to Making and Using Natural Dyes.* Potter Craft. 2010

Duerr, Sasha, *The Handbook of Natural Plant Dyes: Personalize your Craft with Organic Colors from Acorns, Blackberries, Coffee and Other Everyday Ingredients.* Timber Press. 2011

Eckstut, Joann, Eckstut, Arielle, *Secret Language of Color: Science, Nature, History, Culture, Beauty of Red, Orange, Yellow, Green, Blue and Violet.* Black Dog and Leventhal. 2013

Ekarius, Carol, *The Fleece and Fiber Sourcebook: More than 200 Fibers, from Animal to Spun Yarn.* Storey Publishing. 2011

Finlay, Victoria, *Color: A Natural History of the Palette.* Random House. 2004

Fletcher, Kate, *Sustainable Fashion and Textiles: A Design Journey.* Earthscan. 2008

Fletcher, Kate, Grose, Lynda, *Fashion and Sustainability: Design for Change.* Laurence King Publishing. 2012

Flint, India, *Eco Colour: Botanical Dyes for Beautiful Textiles.* Interweave Press. 2010

Flint, India, *Second Skin: Choosing and Caring for Textiles.* Interweave Press. Murdoch Books. 2012

Galli, Andrew, *Natural Dye Workshop with Michel Garcia: Colors of Provence Using Sustainable Methods.* DVD. Slow Fiber Studios, Wada, Yoshiko. 2011

Gladstar, Rosemary, *Medicinal Herbs: A Beginners Guide.* Storey Publishing. 2012

Grae, Ida, *Nature's Colors: Dyes from Plants.* Robin and Russ Handweavers Inc. 1991

Holmgren, David. *Permaculture: Principles and Pathways Beyond Sustainability.* Holmgren Design Services. 2002

Ishii, Setsuko, *Dyes from Kitchen Produce: Easy Projects to Make at Home.* Images Publishing Dist AC. 2011

Johnson, Bea, *Zero Waste Home: The Ultimate Guide to Simplifying your Life by Reducing your Waste.* Scribner. 2013

Kerr, Kelsie, Waters, Alice, *Art of Simple Food II: Recipes, Flavor, and Inspiration from the New Kitchen Garden.* Clarkson Potter. 2013

Krohn-Ching, Val, *Hawaii Dye Plants and Dye Recipes,* University of Hawaii Press. 1980

Legrand, Catherine, *Indigo: The Color that Changed the World.* Thames and Hudson. 2013

Murphy, Brian, *The Root of Wild Madder: Chasing the History, Mystery and Lore and of the Persian Carpet.* Simon and Schuster. 2006

Pollan, Michael, *The Botany of Desire: A Plant's Eye View of the World.* Random House. 2001

Pursell, JJ, *The Herbal Apothecary: 100 Medicinal Herbs and How to Use Them.* Timber Press. 2015

Rice, Miriam, Bee, Dorothy. *Mushrooms for Color.* Mad River Press. 1980

Vejar, Kristine, *The Modern Natural Dyer: A Comprehensive Guide to Dyeing Silk, Wool, Linen and Cotton at Home.* Stewart, Tabori and Chang. 2015

Wada, Yoshiko, *Shibori: The Inventive Art of Japanese Resist Dyeing.* Kodansha USA. 2012

GLOSSARY

Acid A chemical that will produce a pH of less than 7 in a water solution.

Alkali A chemical that will produce a pH of greater than 7 in a water solution. Alkali is essentially the opposite of an acid. The most common alkalis used in dyeing include sodium carbonate (soda ash) and sodium bicarbonate (baking soda).

Alum mordant Several compounds called alum are used as a nontoxic mordant for dyeing, to help extract and modify dye color, including aluminum potassium sulfate, or pickling alum, and aluminum sulfate, which is the alum most used in textile arts and also used in municipal water filtration.

Aluminum acetate Can refer to a number of different salts of aluminum with acetic acid. A metallic mordant for cellulose or plant based fibers.

Aluminum sulfate A chemical compound with the formula $Al_2(SO_4)_3$ used for mordanting both animal and plant based fibers, as well as modifying the color of plant dyes.

Biodiversity The variety of different types of life found on earth. It is a measure of the variety of organisms present in different ecosystems.

Bioregion An ecologically and geographically defined area. Biodiversity of flora, fauna, and ecosystems of an area are usually defined by bioregions.

By-product A secondary result, unintended but inevitably produced in doing or producing something else. This is often the case with working with natural plant colors. Pomegranate rinds as a dye color can be a by-product used from the waste of making a fresh pomegranate seed cocktail for instance.

Calcium carbonate Also known as chalk, is formed by three main elements: carbon, oxygen, and calcium. It is a common substance found in common throughout the world, calcium carbonate is also found in shells, pearls, as well as eggshells.

Calcium hydroxide Also known as lime or pickling lime can be used as a reducing agent for indigo vats and as a pH modifier as it is highly alkaline.

Cellulose fiber Cellulose is a structural fiber made by plants. Units very similar to glucose are assembled into huge molecules that form strong fibers. Cellulose fibers, also known as vegetable fibers, include cotton, jute, hemp, and linen textiles among many others.

Cream of tartar An optional addition to an alum mordant bath and to some dye baths. It is often used to soften wool, and brighten shades as in the case of madder root dye baths.

Direct application A method by which a dye solution is applied to areas of fabric by techniques such as painting, spraying, or stamping your textiles or surfaces.

Dye in textile terms, a soluble colorant that attaches to fibers in molecular form.

Dye pot A dye pot is a regular cooking pot that is designated and used only for dyeing, and not for cooking food or other activities.

Extract A preparation containing the active ingredient of a substance in concentrated form.

Felting A method by which wool fibers interlock.

Fructose Concentrated form of sugar helpful in making an indigo vats.

Guar gum A non-toxic thickener useful in making printing pastes for natural dyes.

Iron mordant The use of iron powder or ferrous sulfate as a common mordant material to affect the color of natural dyes.

Lightfastness A measure of how resistant a dye material is to fading caused by exposure to light. Lightfastness mostly depends on the molecular structure of the dye itself, but can be influenced by the fiber or the presence of contaminants.

Lime Also known as calcium hydroxide and useful for reducing an indigo vat.

Mordant A chemical that aids attachment of a dyestuff to fibers by bonding to both the fiber and the dye, and affects the hue produced with certain dyestuffs. Mordants are necessary for dyes that have very low or no natural affinity for the fiber. Mordants can be applied before (premordant), with, or after (after-mordant) the dye, depending on the nature of the dye, the fiber, and the mordant.

Natural fiber A fiber obtained from a plant, animal, or mineral. The natural fibers may be classified by their origin as cellulose (from plants), protein (from animals), and mineral.

Organic textiles Textiles that are made from materials that are raised or grown without the use of chemicals in the form of pesticides and herbicides

Overdye To dye a naturally colored fiber, or to dye a fabric that has already been dyed.

pH A pH is a system of measurement of the concentration of hydronium in any given solution. Acid solutions have a pH less than 7; alkaline solutions have a pH greater than 7. A pH of 7 is neutral. The normal pH range is 0 to 14.

Pigment A colored substance that is insoluble in water, usually in the form of a fine powder. Pigments are used to color many types of paint, including some textile paints, and almost all inks used for silkscreen printing.

Protein fiber Biological polymers made up of amino acids. All hair-based fibers, like wool, mohair, and angora, are protein, or animal-based, fibers. Silk is also a protein fiber.

Scour to thoroughly wash fiber or fabric to remove contaminants before the dyeing process.

Shibori A Japanese tie-dyeing technique. In shibori, fabric is folded, twisted, tied, or wrapped, and then dyed. When unfolded, patterns emerge.

Simmer A low boil, where bubbles emerge from the bottom of the pot but the water doesn't roll, 185°F.

Soda ash Also known as washing soda, soda ash and soda crystals, Na_2CO_3, is the sodium salt of carbonic acid (soluble in water). It is a highly alkaline substance used as a modifying and cleansing agent for natural dyeing.

Stainless steel A broad class of corrosion-resistant metals. Stainless steel is often recommended for vessels for dyeing. It is made of iron alloyed with metals such as chromium, molybdenum, nickel, and others.

Substantive dye Substantive dye is a dye used in a process in which dye molecules are attracted by physical forces at the molecular level to the textile. The amount of this attraction is known as "substantivity": the higher the substantivity the greater the attraction of the dye for the fiber.

Tannic acid A mixture of compounds derived from oak bark, galls, acorns, and other natural sources. Tannic acid treatment is used to improve the wash-fastness of dyed fiber.

Vat dyes The vat dyes work the same way on protein and cellulose, by being introduced into the surface of the fiber while in soluble form and then converted into an insoluble form.

Washfastness A measure of the resistance of a dye to washing out of the fiber.

Washing soda Also known as a term for soda ash (Na_2CO_3) a highly alkaline substance used as modifying and cleansing agent in natural dyeing.

WOF (weight of fiber) An abbreviation for weight of dry fiber before it is soaked and the measurement for knowing how much dye plant material or mordant should be used for successful results, or even making the most of the concentration of your dye bath and how much poundage of fiber the color will connect to before exhausting.

WOG (weight of goods) An abbreviation for weight of goods, or materials used to dye with.

NATURAL COLOR RESOURCES

Besides gleaning and harvesting materials from your own backyard, kitchen, or local herbal section of your local health food store, you can also purchase mordants, natural dye extracts, and textile fibers and fabric supplies directly from the following:

ALR Dyeing
www.alrdyeing.com

A Verb for Keeping Warm
www.averbforkeepingwarm.com

Aurora Silk
www.aurorasilk.com

Botanical Colors
www.botanicalcolors.com

Dharma Trading Company
www.dharmatrading.com

Bio Hues
www.biohue.myshopify.com

Fibershed Marketplace
www.fibershed.com

Habu Textiles
www.habutextiles.com

Maiwa Handprints
www.maiwa.com

Woolery
www.woolery.com

HEIRLOOM AND NATURAL DYE SEEDS

Baker Creek Heirloom Seeds
www.rareseeds.com

Strictly Medicinal Seeds
www.strictlymedicinalseeds.com

EDUCATIONAL RESOURCES

California College Of The Arts
Textile Program
www.cca.edu/academics/textiles

Center For Ecoliteracy
www.ecoliteracy.org

Centre For Sustainable Fashion
www.sustainable-fashion.com

Couleur Garance
www.couleur-garance.com

Lost In Fiber
www.abigaildoan.com

Rowland and Chinami Ricketts
www.rickettsindigo.com

Fibershed
www.fibershed.org

India Flint
www.indiaflint.com

Permacouture
www.permacouture.org

Permaculture Principles
www.permacultureprinciples.com

Textile Arts Center
www.textileartscenter.com

Local Wisdom
www.localwisdom.info

Slow Fibers Studio
www.slowfiberstudios.com

The Edible Schoolyard
www.edibleschoolyard.com

Voices Of Industry
www.voicesofindustry.com

Wildcraft Studio School
www.wildcraftstudioschool.com

UC Botanical Garden At Berkeley
www.botanicalgarden.berkeley.edu

ACKNOWLEDGEMENTS

I am deeply grateful for the incredible opportunity to have written this book, and I am especially thankful for all the love, support, and encouragement along the way from my family, friends, and community.

To my sweet family, Scott, Finn, Bergamot, and Beckett—you will always be my best foragers, urban dye farmers, and cheering support team. Thank you for the colorful life we share. You make this journey a holistic and joyful one!

To my mom, dad, Lissa, Cael, Kit, and Martha, you are the source. Mom and Dad—thank you for choosing and creating environments that have nurtured us from the start . . . you two are always my inspiration.

To my amazing editor, Jenny Wapner, your wit and wisdom assembled the best dream team I could have ever hoped for this project. This book is dedicated to your vision and belief from the beginning. To my equally amazing agent, Lindsay Edgecombe, I am always appreciative of how much you give to the process, your guidance, and how you expertly help to refine my ideas and allow them to shine. You were with me on this book every step of the way. Ashley Lima, I am very lucky to benefit from your gifts and artistic genius (as well as impeccable organizational and styling skills!) Your art direction is pure brilliance, you listened closely, designed this book creatively, and kept us well directed throughout the seasons…Thank you! Clara Sankey, your sense of humor and attention to detail is always spot on. Thank you for being my editing doula. (You are gifted at it!) Aya Brackett, my incredibly talented photographer, words cannot express how satisfying collaborating on this book has been. You have made these living color palettes glow with immense beauty.

Katelyn Toth-Fejel and Deepa Natarajan, deepest gratitude for your kindred and creative spirits—and our shared joy of cooking with natural color. Kelsie Kerr, thank you for your love for biodiversity. You have always been an inspiration, a true friend, and collaborator. I am so grateful for all I have learned from you! To Bronwen and the Murch Family at Gospel Flat Farm, thank you for your hospitality

and lending your land to our exploration of seasonal color over these years. I look forward to more collaborations to come! To Lissa and Amanda, your work at the Edible Schoolyard so many years ago helped to build solid ground for this book. Thank you for your early vision and for helping to grow this movement holistically, and from the ground-up, literally.

To the Textile Program at California College of the Arts, as well as to my plant dyeing colleagues, students, and community over these many years, this book is in gratitude to you! To Kate Fletcher and Lynda Grose, your insights and ideas are always inspiring and speak the truth. To Nicole Markoff, thank you for lending your supreme graphic design skills to help lay out the first Seasonal Color Wheel. Abigail Doan and Casey Larkin, you have both always encouraged me in finding just the right balance of natural color within both the contemporary art and fashion worlds.

Martha, my drifter sister, thanks for assisting me through writing and designing projects

for this book, for laughing at my one-liners, helping me sort through the creative process, and generally being my inspiration board go-to always! Because of you, I always heard "You got this girl!" at just the right time.

To my Natural Color models- Meredith, Jenny, and Miya, thank you for lending your gorgeous glow to these pages and wearing natural color so well! To those that helped by providing their beautiful homes and gardens for this book- Emma, Ashley, Jenny, Aya, and Alice.

Deep thanks to those who helped me collect dye materials from their produce bins, kitchens, backyards, and trees and gardens. I am especially grateful to my dear friends, Suzanne and Rivkah, as well as the good people of Avontopia for letting us feature cuttings from your vibrant Oakland plants in these recipes and lay-downs.

Lastly, thank you to Bunbun the most patient angora bunny on and off set and a loyal and fluffy friend.

INDEX

Library of Congress Cataloging-in-Publication Data
Names: Duerr, Sasha, author.
Title: Natural color / Sasha Duerr.
Description: First edition. | Berkeley : Watson-Guptill Publications, [2016]
Identifiers: LCCN 2016002216|
Subjects: LCSH: Dyes and dyeing—Textile fibers. | Dyes and dyeing, Domestic.
 | Dye plants.
Classification: LCC TT854.3 .D923 2016 | DDC 746.6—dc23
LC record available at http://lccn.loc.gov/2016002216

Hardcover ISBN: 978-1-60774-936-3
eBook ISBN: 978-1-60774-937-0

Printed in China

Design by Ashley Lima

10 9 8 7 6 5 4 3 2 1

First Edition